S●NNY
ASSU

S O N N Y

A SELECTIVE HIST◦RY

ASSU

Sonny Assu *with* Candice Hopkins, Marianne Nicolson,
Richard Van Camp, Ellyn Walker

Foreword by Janet Rogers

UNIVERSITY OF WASHINGTON PRESS

SEATTLE

Heritage House Publishing Company Ltd.
heritagehouse.ca

Published simultaneously in the United States of America
by University of Washington Press
washington.edu/uwpress

ISBN 978-0-295-74211-3

Edited by Lara Kordic
Proofread by Lenore Hietkamp
Cover and interior book design by Jacqui Thomas
Front cover: Sonny Assu, *Grawlixes* (diptych), 2013, acrylic on panel, 11.5 x 36 inches each; photo by Dayna Danger
Back cover: Sonny Assu, *Coke-Salish*, 2006, duratrans and lightbox, 24 x 35 inches; photo by Chris Meier

The interior of this book was produced on FSC®-certified, acid-free paper,
processed chlorine free and printed with vegetable-based inks.

22 21 20 19 18 1 2 3 4 5

Printed in Canada

To Sara, Lily, and Eli,

there is no inspiration stronger than your love.

* DOOR PRIZES * NAMES * HBC BLANKETS * FEAST * ALL AGES *

BILLY AND THE CHIEFS

BANNED BY CANADIAN GOV'T

STRICT SLAW TOUR '21

WINTER POTLATCH * VILLAGE ISLAND

FEATURING MWET MUST DANCE!

* * * * * *

THE KWAK SISTERS

* * * * * *

THE WAR CANOES

APPEARANCES BY
* THE HAMATSA *
* SPECIAL GUESTS *

FREE ADMISSION

CONTENTS

FOREWORD

JANET ROGERS

There is a bit of Trickster that lives inside the works of Sonny Assu. They are playful pieces full of fun, with potent, dynamic, and brutally honest messages that pop up like a jack-in-the-box from his hiding place.

Assu, a young man of forty-one who became conscious of his Indigenous heritage at the impressionable age of eight, speaks the language of his people fluently—not through dialect but through digital images, installation, graphics, sculpture, and pigment. Paints infused with neon tones, graphite, and attitude produce depth and dimension to draw attention, an invitation to listen. He befriends light and partners with this natural force to invoke playful interactions with colour and contour.

And there is always story. Sonny Assu does not dare to initiate his practice without first asking *why*? Henceforth we are treated to a thoroughly detailed defence of each brush stroke, each form, and every item put in place. His style is close to pop art, and from this foundation he produces new and meaningful visual territory for current and future generations to claim and occupy. Assu's territory rises from his ancestral Ligwiłda'xw/Kwakwaka'wakw culture, despite the many attempts to see it sunk. Sonny flips the script on a historical narrative often written in victim voice; he shows us humour and satire, laughing in the face of racism and cultural prejudice. When challenged on these statements he need only turn to his images, where all the proof is chronicled.

Assu describes his palette as modern. He is a fan of mixing interference colours together to create depth, and with this self-invented dimensional perspective he speaks in a visual voice honed in tone and a vocabulary that is necessary for the important statements he needs to make. Lawrence Paul Yuxweluptun, one of Assu's greatest artistic influences, talks about the role of Northwest Coast tradition in contemporary art: "You can't ignore design and expect to find style. You have to learn the rules of Northwest Coast art, then break the rules to find your style," he says, before alluding to some young artists who "want the right to have a place among traditional art without first learning design." Assu, according to Yuxweluptun, "is a modernist.

9

← *We Come to Witness,* 2014, digital intervention on an Emily Carr painting (*Silhouette No. 2,* 1930), archival pigment print, 22.5 x 34 inches SONNY ASSU

He's responding to contemporary issues, so [his art] can't fit into traditions of Northwest Coast art that sleeps in museums."[1] While those traditions definitely shape and inform his practice in myriad ways, Assu's art breathes new life into the traditional, fuelling a dialogue between generations, cultures, and schools of artistic thought.

Unlike introvert artists who prefer to let their images speak for themselves, Sonny charges towards the chance to promote his work from concept to practice and back again, through written and verbal interpretation. He creates a zero-degree separation experience between his work and the viewer.

>>>

Assu's family, both current and ancestral, is also high on the list of influences. With an antique school desk gilded in copper leaf and placed in the centre of a gallery, he tells the story of his grandmother Leila (*Leila's Desk*, 2013). She, through the effects of late-onset dementia, repeated her story as an Indian day school survivor, over and over. "Can you believe that happened?" she concluded each time, accented with inflections of anger, disbelief, and inquisitive humour. Through *Leila's Desk*, Assu validates his grandmother's suffering. His great-great-grandfather Chief Billy Assu's history and influence shows up in Sonny's work *Ellipsis* (2012). This wall installation consisting of 136 copper LPs references both the potlatch ban (during which Chief Assu was allowed to record traditional songs for anthropological purposes but was not legally permitted to perform them in ceremony) and the country's oppressive Indian Act, which was introduced 136 years before the installation was created. Billy and the Chiefs: The Complete Banned Collection (2012–13) shows sixty-seven painted drums resembling twelve-inch LPs, also referencing the sixty-seven years of the potlatch ban, which Chief Billy Assu lived through. Sonny delivers these clever responses as his ancestor's last words on the matter.

Sonny's own story is that of a gifted artist coming home, in every sense of the word. *Sonny Assu: A Selective History* follows the evolution of his practice over the last fifteen years, which stands as a testament to a culture that has not only survived many attempts to see it buried or harnessed into something it is not, but also lives on beyond limited notions of survival. New traditions, new language, vibrant, vital, and meaningful culture. This is Sonny Assu's art and medicine offerings for the people.

1. Lawrence Paul Yuxweluptun interview with Janet Rogers, March 2017.

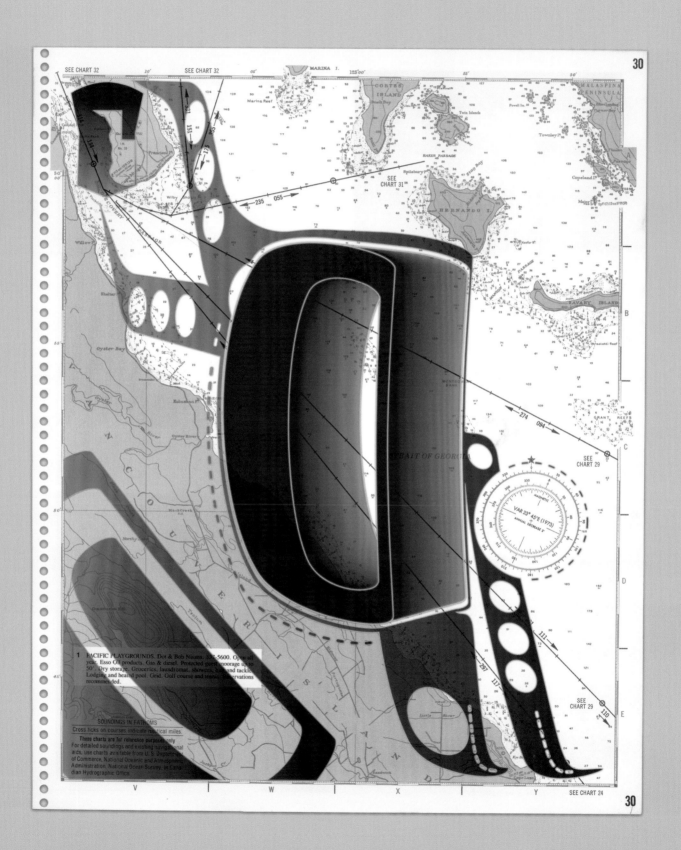

IN ORDER TO SURVIVE WE CREATE

MARIANNE NICOLSON

Long ago, the Ligwiłda'xw were living at Galdzadzolis (Longbeach Village) near Malcolm Island. They were allies of the Kwikwasut'inuxw, Dzawada'enuxw, Gwawa'enuxw, and Haxwa'mis of the Musagamakw Dzawada'enuxw who live in the Broughton Archipelago of Queen Charlotte Strait and the adjacent mainland inlets. Together with their allies, they made war on the 'Namgis living along the Gwa'ni River. It was a war that was ultimately lost. Adding insult to injury, the box of coppers that Wi'kai, the ancient ancestor of the Wiwaka'e of the Ligwiłda'xw, was to receive as a dowry from his marriage to T'sat'salał, the daughter of the chief Wulasawe of the Haxwa'mis, was stolen while it was being transferred from the canoes to his house. After these ancient events, the Ligwiłda'xw began to move south to where they live today, in Campbell River and Cape Mudge.

These are some of the ancient histories that form connections between Sonny Assu and myself: Ǧʷaʔǧʷadəx̌ə (Sonny Assu) being of the descent line of Wi'kai of the Likwiłda'xw and my own descent line through the Dzawada'enuxw, Kwikwasut'inuxw, and Haxwa'mis as 'Tayagila'ogwa (Marianne Nicolson). There are many more. Some of these connections are stored in the living memory of our old people and culturally astute Kwakwaka'wakw who continue to practise their ancient traditions within the ceremonial house. Much of it, however, is stored in vast treasure houses of the anthropologists and ethnographers who travelled our territories collecting our masks and stories. The narrative above comes from the collection efforts of George Hunt and Franz Boas, who spent close to forty years documenting the Kwakwaka'wakw, whom Boas referred to as the Kwakiutl.

The territories of the Kwakwaka'wakw nations encompass the upper eastern portion of Vancouver Island and the deep fjords of the adjacent mainlands as well as all the islands in between. This place, our ancient place, was given to us when "light first came into the world." It was, and remains, a wonder. Salmon, driven by biological agendas beyond our understanding, enact their predestined regimens by the thousands. The islands and mountains are covered in trees and wildlife. Always there is water, whether as a constant marine presence as river or ocean or the steady drip of the rain. Our stories covered every mountain, inlet, and island, and

13

← *The Paradise Syndrome, Voyage #30*, 2016, archival pigment print, 21 x 36 inches SONNY ASSU

our personal names reflected this: 'Nagedzi, "Great Mountain"; Hawalkwame', "Person who is the essence of cedar"; Sewid, "One who is paddled to"; and Kiksisalas, "The one many people walk to see" are a few of them. These names are both of the land and about the land and our relationship to it.

The colonists who came here only a few short years ago within the context of ancient times chose not to see these things, or perhaps they were incapable. Preferring to consider these places void of history in order to claim the land, they closed their eyes and shut their ears to the great names and powerful stories of the Kwakwaka'wakw. The colonists then began a process of destruction. First they took the trees in massive quantities, disrupting streams and valleys, leaving the mountains bare and vulnerable. Then they took the fish, previously so abundant. They were taken in such massive quantities by the greedy canners, who often left much of it to waste and rot, that their numbers began to stumble and fall. Ironically, the colonists placed blame for this failing on the Indigenous nations whose weirs and fishing practices had sustained the fishery for thousands of years. The traditional fishery became monitored and the weirs torn apart, declared illegal.

Our traditional economy ripped apart, today the Kwakwaka'wakw are being asked to become partners in the oil and gas industries, fish farming, and continued logging. The artists and cultural workers are asked to sell their works as valued objects to a society rich off the pillage of their lands. It seems we have few options; in order to survive we sell, but perhaps the fundamental truth of it is that in order to survive we create. Through all this somehow, the ancient names and stories still have life; they burn at a low temperature, and we hold on for a new day where they will burn bright once more within the minds of the Nations and we will assert our jurisdiction over our lands under our own terms and understandings. There are flare-ups as experienced through Idle No More and the current movements to resist pipelines, fish farms, and massive dams. It seems the intensity of our struggles against forces more extreme and oppressive than ever is far from "reconciliatory." The clear message is get on board or be crushed by colonial laws and force.

This is the context of the practice of Sonny Assu. His expressions are an attempt to work on the tenuous attachments to the past and the challenges of the future, which stem from his Ligwiłda'xw ancestry. The Ligwiłda'xw have faced challenges before: the loss of a war and of their great coppers. They recovered, carried on, and continue to exist. The stories exist, the people exist, and the land exists. As an ongoing lifetime performance, each act of creation represents an inquiry, a questioning, and a reconstitution of understanding. The works are, in a way, acts of resistance within a dominant colonial system that gives little and requires careful navigation in order to be heard. His work *Silenced: The Burning* (2011) is particularly poignant in this regard.

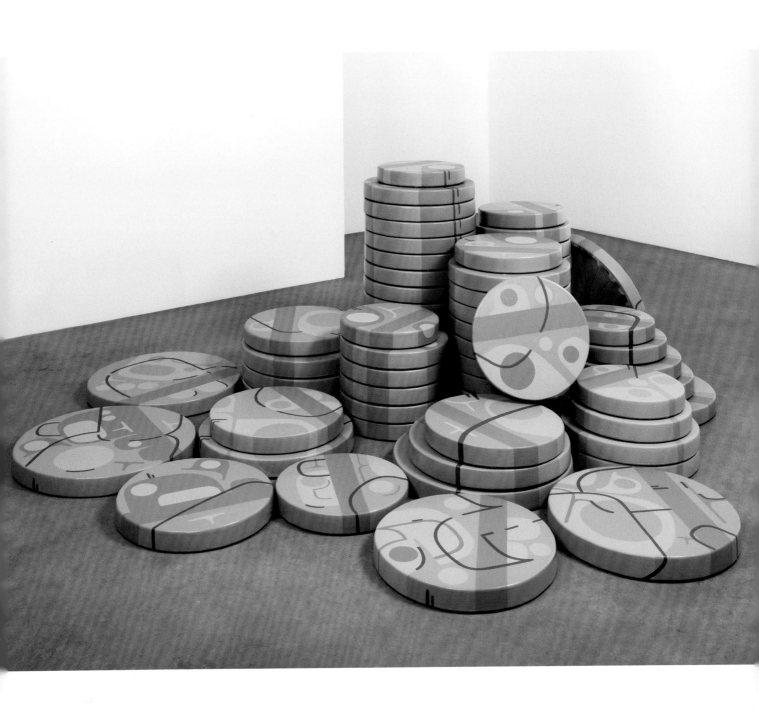

↑ *Silenced: The Burning,* 2011, acrylic on elk-hide drums, 16- to 24-inch
diameter, height variable. Installation of 67. SCOTT MASSEY, SITE PHOTOGRAPHY

↑ Pictographs, Petley Point, Kingcome Inlet.

The stack of sixty-seven drums in *Silenced: The Burning* refers to the sixty-seven years that spanned the official ban that outlawed the traditional ceremonies and political forum referred to as the potlatch for Indigenous Nations from 1884 to 1951. During this time, the Kwakwa̱ka'wakw surreptitiously maintained their practices through creative means. Finally, in 1921, the Indian Agent William Halliday was able to have incarcerated many of the high-ranking potlatch participants on charges levied against them for taking part in a potlatch held at Mimkwa̱m'lis (Village Island). The imprisonment of these valued members at Oakalla struck a severe blow to the Kwakwa̱ka'wakw, and afterwards only the most subversive and isolated nations, such as the Dzawada̱'enux̱w, Ḵwiḵwasut'inux̱w, Gwawa'enux̱w, and Ha̱x̱wamis, continued to risk the punishment of colonial law. As an outright act of resistance, a pictograph was painted at the mouth of the Kingcome River, home of the Dzawada̱'enux̱w, with the same date as the 1921 incarcerations. The pictograph depicted coppers and cows used in a potlatch ceremonial by the Scow brothers, who were chiefs of the Ḵwiḵwasut'inux̱w and Dzawada̱'enux̱w.

For the Ligwiłda'xw, whose homelands were less isolated and more easily monitored by colonial law enforcement at T'sakwa'lutan (Cape Mudge), the ability to resist seemed less possible. As Sonny Assu, direct descendant of Chief Billy Assu of the Wiwaḵa'e of the Ligwiłda'xw, describes it, "*Silenced: The Burning* is about a story I heard of Chief Billy Assu being confronted by an indian agent at the time of a potlatch. The agent gave him an ultimatum: 'surrender' your potlatch regalia and cease your potlatch, or be fined, jailed, and I'll take it all anyway. He brought this to the village and they told him to give it up. So he dragged it down to the beach and burnt it all. He knew this stuff would be sold off, so he figured best give it back to the ancestors."

I remember hearing stories of this when I was young. For us, the thought of burning your regalia and masks seemed sacrilegious, simply horrifying, and the image in my mind stayed with me. When I saw this work of Sonny's in a picture, it brought back that sense of hopelessness and disbelief that I had felt hearing this story even decades after the event had occurred. What seemed hopeful to me, however, were the glowing red lines—embers, the element of light not quite died out and containing the seeds of possibility. The drums reminded me of the efforts of the young Kwakwa̱ka'wakw men and women I had grown up with who were learning the songs and bringing our ceremonies back to life within our contemporary potlatch system. I had been able to witness the weakening voices of the very old elders slowly transition to the strength and power of the young people today. Amongst the Kwakwa̱ka'wakw, the songs were brought back within a single generation, largely thanks to the efforts of Wa̱x̱awidi, Hiłamas (William Wasden Jr.), and my brother A̱l Siwid, Tłalis (Mikeal Willie). It showed how a burning ember could be fanned into a bright flame.

Today, after witnessing the resurgence of our culture in our ceremonial house, it is traditional governance that requires our efforts to bring it back to life. All of our songs and dances

and masks were actually tied into our governance. When the potlatch was banned it was the ceremonial recognition of our ancient ties to each other and the land through our genealogies and stories that was being suppressed. The colonial government followed this up with forced conversion to modern elected chief and council systems. As well as losing their traditional ceremonial rights, the hereditary gigagame' "chiefs" also lost their ancestral right to lead. It was the loss of the structure and the severance of ceremony from politics that was the most troubling because through tradition they had been intrinsically linked. After all, how could one make decisions regarding the lands and waters without referring back to the ancient stories that not only told of how we came to be in the lands and what had occurred there, but also how we were to conduct ourselves for the wellbeing of the land and the people? It was in the ceremonial house that these ties were both witnessed and affirmed according to Kwakwaka'wakw law. The hereditary chiefs were the generational embodiment of the ancient ties to the land. When they were replaced as political decision makers, the application of traditional law became weaker and the connection to colonial laws and administration of "Indian Affairs" strengthened. In the long run, governance always returns to the land. In the case of the Kwakwaka'wakw, who had revitalized their cultural practice in the ceremonial house over two quick decades, it is now time to return to their traditional political structures and the understanding they represent.

It is within this context that Sonny Assu's overlayed chart images titled The Paradise Syndrome (2016) resonate. The maps and charts of the series represent the layering of colonial understanding of the land over top of Indigenous understanding. They remind me of stories the old people documented of their first contact with surveyors and the stakes they would put into the ground. Most of this was experienced with suspicion, and justifiably so. Eventually these charts would be used to push our people onto small plots of land called reserves so that the rest could be exploited by industry or sold off to private landowners. This could only happen by oppressing and subjugating our nations through the imposition of colonial law.

In these images Assu seeks to re-assert an Indigenous understanding through visual gestures akin to tagging, a rebellious anti-establishment writing over the supposed authoritative text. By doing this, he is tapping into the current resistance movements against the development aspiration of land access for oil and gas, fish farms, logging of forests, and damming of rivers. In an odd juxtaposition that exposes how far we still need to go, these works, which are attempts at resistance, are still firmly contained within the very system they critique. They are primarily sold to and collected by those who have economically benefitted from the theft of Indigenous lands. This is not just Assu's dilemma but that of all Kwakwaka'wakw artists who engage in a high art market, including myself. Under these conditions, we could say, however, that the value of the works lies not in their status as art objects valued under

imposed colonial economics but in their meanings, which are attempts to express ideas within whatever spaces are still available after having experienced so much oppression. This brings us back to the burning of Billy Assu's potlatch paraphernalia. For the Kwakwa̱ka'wakw, the value lay not within the objects themselves but in what they symbolized. The colonial government demanded that the cultural objects that symbolized the Kwakwa̱ka'wakw connections to their lands be removed or destroyed, but their meanings survived in the minds and memories of the people. If we consider these works as mnemonic devices, they become subversive iterations of Kwakwa̱ka'wakw testimony and survival under the colonial duress that continues still today.

FROM THE COPPER RECORD TO EMILY CARR: INTERVENTIONS ON THE IMAGINARY

CANDICE HOPKINS

Many of Sonny Assu's works are preoccupied with sound and with silence. Consider *Ellipsis*, a series of 136 copper LPs that are hung on the wall. While the LPs imply sound, they are not intended to be played. The aptly titled Silenced series consists of sixty-seven hand-painted elk-hide drums. Here, silence is politicized: the sixty-seven drums refer to the number of years that the potlatch was banned under Canada's Indian Act (1884 to 1951). Important within the legalese of the document is the understanding that, for Indian Agents, not only was the potlatch concerned with redistribution of wealth, but this gifting was also necessarily accompanied by dance, ceremony, and song. Assu's work deliberately carries these silences through to the present. It was the discovery of recordings of songs sung by his great-great-grandfather Chief Billy Assu that led him to a deeper engagement with the archive, and thus a sampling from the original.

The available recordings of Chief Billy Assu are tethered to the legacy of ethnomusicologist Ida Halpern. A Polish refugee, Halpern fled Nazi Germany for Canada, arriving in 1939. When immigrating she stated her interest in folk music and, through this, her goal to record the songs of Indigenous people. This was reportedly met with bemusement. At the time, not only was Native song not considered worthy of serious study, but it wasn't even considered *music*. Not easily deterred, Halpern persisted for six years until she was entrusted with this task, first recording songs of Chief Assu on a reel-to-reel recorder. She then collaborated with ceremonialists and artists from nearby communities, including Chief Dan Cramner and Mungo Martin, among many others. Halpern, the first woman in Canada to hold a PhD in ethnomusicology, recorded an estimated five hundred songs and sound samples through her work, including Haida, Nuu-chah-nulth, Nuxalk, and Coast Salish. Yet some of Halpern's releases have come under criticism. New scholarship and insight from Indigenous academics makes clear that some of the songs she recorded and distributed are not meant for the uninitiated (a Hamatsa song, for example), and others are not intended to be shared outside of specific families. Silence, then, goes both ways.

← *Spaced Invaders,* 2014, digital intervention on an Emily Carr
painting (*Heina*, 1928), archival pigment print, 22.5 x 31.5 inches

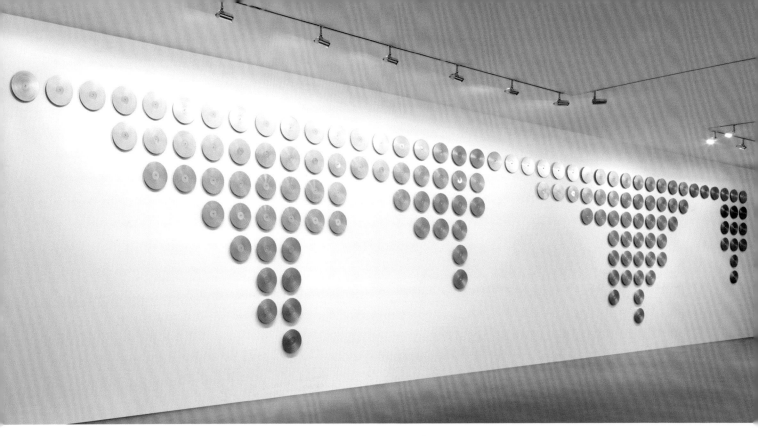

↑ *Ellipsis*, 2012, copper LPs, 11.75 inches diameter each. Installation of 136.
RACHEL TOPHAMN, VANCOUVER ART GALLERY

The copper records in *Ellipsis* hang on the wall in a fashion that conceptualizes the work's title, the things left unsaid. From a distance they look like an inverted equalizer pattern, symbolizing the resistance of the potlatch practice and peoples maintaining their culture during the ban. The copper records once again make reference to the Indian Act, 136 records for the number of years (in 2012) of the Act's existence. For Assu, this work is a call for Indigenous socio-political history to be a part of the public record:

> *I feel that this act, even though not understood or known about, has bred a historical, often bigoted view of Indigenous people. Most recently, we only need to look to states of emergency declared by various First Nations across the country to see the ramifications of this act and the historical hate placed upon the people. The upside down, abstracted equalizer pattern indicates the silence or the omission of the oppressive act from our collective Canadian consciousness.[2]*

Assu considers the work a "conceptual record" of the Indian Act. Each year of race-based legislation—laws that continue to govern not only who is "Indian," but also housing, economic practices,

2. Sonny Assu, sonnyassu.com/pages/ellipsis.

sustenance (including hunting and fishing), education, and healthcare—is replaced with a copper LP, thereby substituting repression with song. These recordings exist despite the bans on ceremonial and customary life outlined in early amendments to the Indian Act. Chief Billy Assu was able to perform and record songs in the name of ethnography, but not in the name of maintaining his own culture.

Assu's link to his great-great-grandfather goes deeper. He has spoken often of an event that shaped his life: the chance finding of the late Chief Billy Assu's ceremonial regalia tucked away in the storage of the collection of the Canadian Museum of Civilization (now the Canadian Museum of History). Assu's grandparents Herbie and Mitzie Assu had sold the regalia to the museum in the early 1980s to protect and preserve its history. When the elder Assu's robe was placed on the artist's shoulders, he felt something of an electric shock, as though in that very moment the past reached out and touched him. Incidentally, the reason why many other robes and ceremonial regalia are in these collections is because of the potlatch ban. When Chief Assu and others were caught by Indian Agents in 1921 taking part in a potlatch ceremony on Village Island, Alert Bay, three hundred were charged under the ban. In place of incarceration they were given the option to hand over their masks, their headdresses, their bentwood boxes, and their regalia. These items were then sold to museums and private collectors, including George Gustav Heye, whose holdings are the basis for the Smithsonian's National Museum of the American Indian.

Since the discovery of his great-great-grandfather's robe, Assu has dug deeper, making ties between his relatives' lives and his own life more explicit in his work. This experience hasn't been entirely positive, as it exposes the constants of racism and oppression.

>>>

Leila's Desk (2013) consists of a refurbished 1930s-era school desk, the kind that has the chair directly attached to the table, with a packaged bar of soap on top.** What is clear about looking at the desk is the level of care taken in its refurbishment. All of the wood has been sanded and refinished, and underneath, the base of the desk and the chair are entirely gilded in copper. *Leila's Desk* has been installed next to a desk from another era—the 1990s. This one, entitled *Inherent* (2014), is freestanding in sea-foam green and lacks a chair. The base of this desk is not gilded in copper, but underneath the lid, normally the site of adolescent graffiti, is a single stylized word on a copper background: "chug."

There is a backstory to both desks. On her first day of high school in grade 9, Assu's grandmother was presented with a bar of soap. To drive the point home, the student who left it for her took it upon himself to call her "a dirty Indian." The story is all too common in Canada. Survivors of the residential school system recall being stripped nude and harshly scrubbed with soap upon their arrival, before having their hair cut short and being placed in a uniform. The insinuation was that their home lives were dirty and they were in need of cleansing. Others, including my

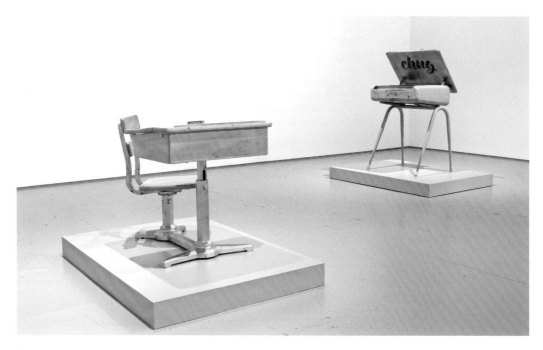

↑ LEFT: *Leila's Desk,* 2013. Vintage 1930s school desk (wood, metal), vintage Lifebuoy soap, copper leaf. 33 x 22 x 26 inches. RIGHT: *Inherent,* 2014. 1970s school desk (wood, metal), copper leaf. 25 x 19 x 30.5 inches. Collection of the Vancouver Art Gallery, purchased with proceeds from the Audain Emerging Artists Acquisition Fund. EQUINOX GALLERY

own grandmother, speak of having their mouths washed out with soap for speaking Indigenous languages or for talking out of turn. Soap has larger connotations. Residential schools were about the management and subjugation of Indigenous bodies. They were also about the creation of difference. Difference must be defined before it can be managed; this requires the active construction of the other—in this case, Indigenous children—as dirty, savage, unintelligent, and the list goes on. The management of difference is necessitated upon the active remaking of Indigenous people as colonial subjects in the first step towards cultural genocide in the name of assimilation. This active production of difference carries through to today.

The desk in *Inherent* is similar to one that Assu used to sit at in high school. During the Mohawk Resistance (commonly known as the Oka Crisis) of 1990, in an incident that exposed the thin veneer of racism across the country, a student labelled Assu a "chug" after the artist stood up to his racist characterizations of "dirty, dumb, drunk Indians." Under the lid of the school desk, the ethnic slur is remade into graffiti—a territorial mark.

The recurring material in each of these works is copper. Copper and iron were the two most traded metals along the Northwest Coast, extending into the Arctic region, in the early

colonial era. However, sophisticated metallurgy, including the creation of tools and ceremonial items, was practised well before the arrival of newcomers, and dates back more than one thousand years. Assu's use of copper calls attention to the high value placed on the metal in Kwakwa̲ka̲'wakw society. T'ła̲kwa, the copper shield, is the most valued object and acts as a symbol of wealth and prosperity. Only people of high rank have the right to own T'ła̲kwa, and only they have the right to gift one to another person.

In the early days, these coppers also operated something like banks. To explain the value of T'ła̲kwa, in a desperate appeal to Western economic interests, a man named Wawip'igesuwe' wrote a letter dated April 16, 1919, on behalf of his community to petition the potlatch ban:

> Each tribe has its own coppers, and each copper has its own value. In the old days there was no money and these coppers were a standard of value but increased in value each time they changed hands. When the white man came and we could earn wages in cash for our labor we invested our savings in coppers and used them the same as a white man would do with a bank and would always expect more back than we put in. We are giving you a list of the coppers belonging to the 'Namgis Tribe and their values, other tribes have their own coppers so that you will see the great financial loss that would entail on us if our custom is suppressed.[3]

What Wawip'igesuwe' is also trying explain is that the coppers do not simply represent money, but rather they represent the level of *economic commitment* invested in the object.

Yet he deliberately leaves out the spiritual dimension of copper. Copper is transformative and holds great power and requires reverence. When a T'ła̲kwa is broken, a piece is bestowed upon another person of similar rank or, in the case of an enemy, to bring great shame to that person and their community. For Assu, copper becomes a way to heal the wounds of the past. The metal elevates objects associated with trauma in an attempt to bring about another kind of transformation—from genocide into survivance, which Gerald Vizenor defines as the "repudiation of dominance, obtrusive themes of tragedy, nihilism, and victimry."[4]

This repudiation of dominance, the resistance to narratives of nihilism, carries forward into Assu's recent series, Interventions on the Imaginary, which began as a playful intrusion of one culture's aesthetic practice into another. Brightly coloured ovoids descend, alien-like, into the picture plane of well-known paintings of the Northwest Coast by Emily Carr, Paul Kane, and others. These paintings are almost entirely devoid of Indigenous people. Scholars such as Marcia Crosby have pointed out that what stands in for the absence of people, particularly in the work of Emily Carr, are signs of

3. U'Mista Cultural Society, archive.umista.ca/collections/collection.php?item=133&all=&pg=5
4. Gerald Vizenor, "Aesthetics of Survivance," in *Survivance Narratives of Native Presence*, edited by Gerald Vizenor. (University of Nebraska Press, 2008), 11.

↑ *What a Great Spot for a Walmart!,* 2014, digital intervention on an Emily Carr painting (*Graveyard Entrance, Campbell River,* 1912), archival pigment print, 22.5 x 33.25 inches SONNY ASSU

26

their demise: gravestones, memorial poles, and abandoned houses. The tongue-in-cheek titles for works in the Interventions series, including *Spaced Invaders* (2014) and *What a Great Spot for a Walmart!* (2014), potentially obscure the deeper implications of what is initially proposed by these images—namely, making the Northwest Coast formlines appear strange and the paintings, done by the newcomers to the land, appear natural.

Growing up in the 1980s, Assu has a stated interest in remix culture. This is found in the bold colour choices of his paintings that are more akin to the urban vernacular of the street than to the more muted palette of his ancestors. This isn't a new tactic. The American media scholar Henry Jenkins argues that "the story of American arts in the 19th century might be told in terms of the mixing, matching, and merging of folk traditions taken from various indigenous and immigrant populations."[5] This is also apparent in the paintings that Assu chooses as his source material. For Emily Carr, it wasn't enough to represent the landscapes and villages of Kwakwaka'wakw, Nuu-chah-nulth, Tsimshian, and Haida peoples; in her own form of cultural cannibalism, she quite literally became the other. For a time, she took on an Indigenous name, Klee Wyck. She also created works that took on the aesthetics broadly associated with Northwest Coast art, including ceramic bowls decorated with ravens, serpents, and turtles in a rather unsophisticated formline.

This being said, Interventions on the Imaginary challenges what is "natural" and what is a construct. While much of the early paintings of the Northwest Coast, including those by Carr, are described as land-

5. Henry Jenkins, *Convergence Culture: Where Old and New Media Collide* (New York and London: New York University Press, 2006), 135.

scapes, Marcia Crosby notes that "[Carr's] association of the material culture of the Northwest Coast native people with the 'primitive greatness of the West' was naturally facilitated by the already entrenched construction of the Indian *as nature*."[6] Thus, the picture planes that Assu's ovoids descend upon and hover over, like spaceships from another planet, are anything but natural. They are images inscribed with power and the entanglement of colonial relations. In some, like the rather elaborately titled *Yeah . . . shit's about to go sideways. I'll take you to Amerind. You'll like it, looks like home* (2016), an ovoid hovers over a group of people seated in a circle in front of a big house, as though their own cultural forms have come back from the future to rescue them from Western painterly oblivion.

Convergence culture is described by Henry Jenkins as "where old and new media collide, where grassroots and corporate media intersect, where the power of the media producer and the power of the media consumer interact in unpredictable ways."[7] Interventions on the Imaginary first premiered on Instagram, a virtual space where the consumption of images is a collective process. It was here that the works first struck a chord with the audience, true to the collective meaning making offered by the digital platform. Similar to how Carr paintings circulate, Assu's images have the potential to jump from the confines of art into popular culture, where they can continue to erode mainstream notions of the imaginary, by supplanting one notion of the imaginary with another—this time one that is deliberately de-colonial.

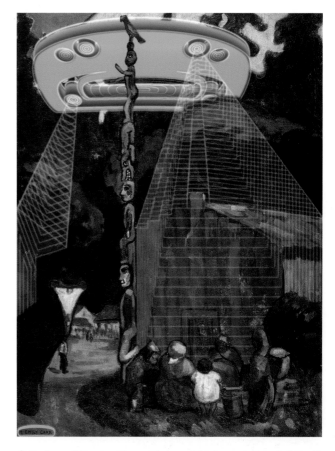

↑ *Yeah . . . shit's about to go sideways. I'll take you to Amerind. You'll like it, looks like home.,* 2016, digital intervention on an Emily Carr painting (*Cape Mudge: An Indian Family with Totem Pole,* 1912), archival pigment print, 22 x 29.5 inches SONNY ASSU

27

6. Marcia Crosby, "Construction of the Imaginary Indian," in *Vancouver Anthology,* edited by Stan Douglas (Vancouver: TalonBooks/ Or Gallery, Vancouver, 2011) (reprinted edition), 286. Italics mine.

7. Jenkins, *Convergence Culture,* 2.

↑ *iDrum (Red)iscovery #2,* 2009, acrylic on cow hide, 20 inches diameter CHRIS MEIER

(RE)SOUNDING BEYOND: SPECULATIVE FUTURES IN THE DRUM WORKS OF SONNY ASSU

ELLYN WALKER

Every night, we each go to bed under the same moon.

Many cultures follow the moon as a calendar, epistemology, or other kind of relation, such as within Latin, Mediterranean, African, and Indigenous societies across Turtle Island and around the world. Despite cultural differences, colonial borders, and vast geographic distances, from a certain vantage point, we are each able to access and share a common "vision" in the moon. From an early age, we teach our children that the moon exists in the sky for all to see, and this remains true regardless of whose land we find ourselves on. Every time we look for the moon in the sky, my niece, who is part Taiwanese, reminds me that in the Chinese worldview, the moon's fullness represents the family coming together.

The moon has endured aggressive exploration and, more recently, attempted "claiming" through what is called "extraterrestrial real estate." This, combined with the undeniable effects of climate change, makes the moon vulnerable as a contested site and unstable entity as it orbits around the earth. As the fifth-largest natural satellite in our solar system, the moon represents a powerful and precious being. The Anishinaabe, one of the oldest inhabitants of the area I write from today, uphold the belief that the moon is our grandmother, alongside the earth, who is our mother. Uniquely, this perspective renders the relationship between the viewer and moon tender —a relationship that both deserves and demands care just as our human grandmothers would.

I miss my deceased grandmother each night when I look at the moon, and I know that Sonny Assu misses his, who passed recently. As such, I'd like to dedicate this text to these two women, and to all of the grandmothers who live in the sky and in our hearts.

>>>

Like the moon, the drum spans both cultures and time, and it can be found throughout Sonny's artistic practice as a recurrent symbol and form. The drum tells stories in ways that cannot always

be spoken and, as such, it reflects a new plane of vocality. Art historian Camille Usher explains, "When a drum is struck, its sound vibrates through the air, filling space and extending invaluable connections that bring together generations and diverse collections of knowledge, history and life, all created within a circulation of sound."[8] In this way, the drum takes on a life of its own—creating rhythmic intersections between affect, feeling, and knowing that transcend the present. Usher elaborates on the particular significance of drumming to Indigenous peoples, stating, "What the drum announces is this continuous, thriving presence, declaring that we are still here, decolonizing, taking up space and making noise."[9] This noise will continue to reverberate, as sound is something that moves, unfolds, ebbs, and flows. It is alive and, as such, is one of our relations.

Today, Sonny lives in Campbell River, British Columbia—his ancestral homeland and unceded Ligwiłda'xw territory—with his family. Here, Sonny learned of his Wiwaḵa'e and Weiwaikum ancestry from spending time with his grandmother. In Kwakwaḵa'wakw communities, music is a ceremonial art form based on percussive instrumentation that includes log, box, and hide drums beaten and sung by a large group of people. While there are indeed important distinctions across Indigenous communities in terms of their nuanced cultural drumming practices, the drum is widely considered a symbol of creative expression, resistance, and resilience that has endured across cultures and throughout time. Enslaved peoples in Africa, and later in North America, used drumming as a mode of communication to evade their enslavers during the eighteenth and nineteenth centuries; and more recently, the sound of drumming became synonymous with the Idle No More movement, in which round dance demonstrations took place around pow wow drums in public places.

Sonny's introduction to the drum in his visual artistic practice dates back to 1999, when he was taught how to make a drum by Brenda Crabtree at Emily Carr University. Since 2005, the drum can be found intermittently throughout his practice, most notably in the iDrum series. The work appropriates hand-held hide drums as the physical objects on which Sonny directly paints, each one discretely titled and decorated with a combination of formline shapes, animal figures, and Apple products. This amalgamation of cross-cultural imagery presents its own connotative possibilities for viewers. For example, by using a recognizably Indigenous object (the hide drum) and West Coast iconography (formline) with consumer icons like Apple, Sonny is connecting ancestries of cultural practice to contemporary technologies of capitalism in a place that has been inhabited since the last ice age. This connection is not benign, as Indigenous worldviews uphold the belief that technology is akin to a shape shifter.[10] Sonny's continued reference to technological modalities such as videogames, computing products, and, more recently, spaceships, evidence Indigenous engage-

8 Usher, Camille, "The Life of a Drum," *Inuit Art Quarterly* 29, no. 2 (Summer 2016): 26.

9. Ibid.

10. Alicia Inez Guzmán, "Indigenous Futurisms," *InVisible Culture: An Electronic Journal for Visual Culture*, March 15, 2015. ivc.lib.rochester.edu/indigenous-futurisms.

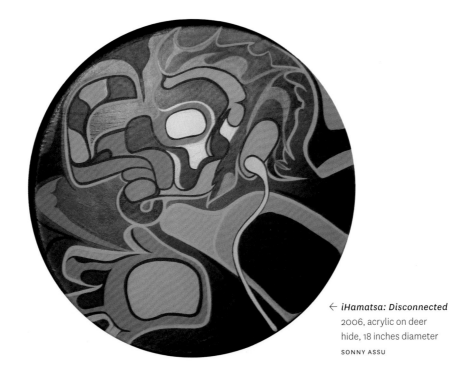

← *iHamatsa: Disconnected*
2006, acrylic on deer
hide, 18 inches diameter
SONNY ASSU

ment with what has been traditionally considered Western media. This is significant because "the understanding that technology is essential to contemporary Indigenous constructions of selfhood contrasts notions of Native peoples as artifacts of a bygone past."[11]

The aesthetic combination of Indigenous-Western tropes marks much of Sonny's practice, allowing him the opportunity to nuance the ways in which he represents and responds to notions of Indigeneity. He describes this as the impetus behind his work, explaining that he seeks to "bring to light the dark, hidden history of Canada's actions and inactions against Indigenous peoples."[12] Neither Sonny nor I, roughly of the same generation, learned about Indigenous histories in school, let alone politically accurate ones. Sadly, this means that historical intervention is still a hugely important act, and, as such, remains an integral strategy within Sonny's practice.

>>>

One history Sonny often returns to, which directly affected his ancestors in the place where he now lives, is that of the potlatch. Banned from 1884 to 1951 by the Canadian government,

11. Ibid.
12. Sonny Assu, sonnyassu.com/pages/general-artist-statement.

the potlatch represents a cultural, ceremonial, and economic practice of Pacific Northwest Coast Indigenous peoples that includes gift giving, breaking copper, and rhythmic dancing. During its ban, the potlatch continued to be practised underground. In scholar David M. Higgins's essay "Survivance in Indigenous Science Fictions," he emphasizes the fact that "despite centuries of genocidal violence and extraordinary hardship within enduring settler-colonial regimes, indigenous narratives deconstruct victimization and eschew imperial masochism in favor of what Gerald Vizenor refers to as survivance paradigms."[13] These posit "an active repudiation of dominance, tragedy, and victimization,"[14] or what scholar Grace Dillon calls "*biskaabiiyang*," the Anishinaabemowin expression for a process of "returning to ourselves."[15] Thus, the recurrent use of the drum in Sonny's works also evokes the impression of "re-sounding," of making Indigenous histories heard regardless of who is listening. Indeed, Indigenous peoples are hardly silent.

Sonny's work increasingly lends itself to interpretation within the burgeoning field of "Indigenous futurisms"[16] of which Higgins writes and that spans the visual arts, music, literature, theatre, and orality, among other disciplines. This discourse focuses on kinds of alternative futuring that involve re-imagining, reclaiming, and reframing colonial constructions of Indigeneity through visionary projects for better living. This is true of Sonny's works, many of which "speak to the realities of being an Indigenous person in the colonial state of Canada" in the past, present, and future sense of what that means. Other Indigenous artists whose works also leverage strategies of (re)appropriation and sites of futurity are Wendy Red Star, Bear Witness, and Skawennati, among others working in settler-colonial contexts like Canada, the United States, and Australia. Scholar Alicia Inez Guzmán explains that within Indigenous futurisms, "time is no longer simply forward-moving. The present is understood through the prism of the past and future,"[17] which offers radical possibility for a kind of future that can look vastly different from our past. In some ways, one could perhaps even argue that this kind of futurity is already unfolding, as the iTunes charts recently revealed the immovability of three Indigenous DJs from Canada who remained in the top spot for weeks. Notably, A Tribe Called Red's 2016 summer hit featured well-known American MC and activist Yasiin Bey (formerly known as Mos Def) on the track, another indication that Indigenous peoples' voices are rightly amplifying across cultures, movements, and borders.

In another of Sonny's drum series, Billy and the Chiefs (2012–13), he presents a number of individual works as stand-alone installations that recreate record-playing stations often

13. David M. Higgins, "Survivance in Indigenous Science Fictions: Vizenor, Silko, Glancy, and the Rejection of Imperial Victimry," *Extrapolation* 57, no. 1–2 (2016): 51. https://doi.org/10.3828/extr.2016.5.

14. Gerald Vizenor, *Fugitive Poses: Native American Indian Scenes of Absence and Presence* (Lincoln, NE: University of Nebraska, 1998), 15.

15. Grace Dillon, *Walking the Clouds: An Anthology of Indigenous Science Fiction* (Tuscon, AZ: University of Arizona Press, 2012), 10.

16. See the works of Robert Sullivan, John Rieder, Grace Dillon, Leslie Marmon Silko, and Diane Glancy.

17. Guzmán, "Indigenous Futurisms," ivc.lib.rochester.edu/indigenous-futurisms.

↑ *Billy and the Chiefs: The Complete Banned Collection,* 2012–13, acrylic on elk-hide drums, 10 and 12 inches diameter. Installation of 67. RACHEL TOPHAMN, VANCOUVER ART GALLERY

found in music stores. Each of Sonny's painted hide drums sits atop a real turntable as its record, suggestive of the distinctively "Indigenous" sounds contained within it. One of these works, *Live from the 'Latch* (2012), presents a "record" abstractly painted with formline shapes, recording grooves, and an LP centre hole. Again, this mixture of cultural emblems works to nuance representations of Indigeneity as something not necessarily separate from pop culture and Western influences. The "record" is thoughtfully painted copper to reference its breaking during potlatch ceremonies, where, even amid outlaw, Indigenous peoples found a way to make noise. By naming the piece in reference to the potlatch, emphasis is placed on the fact that society needs to listen to Indigenous peoples, who, even in the face of criminalization and other colonial tactics, continued their cultural practices. These are indeed the people who deserve "records."

>>>

I started this text thinking about the moon and grandmothers. I have tried to gesture towards some of the ways in which these living relations are akin to the sound of a drum—reverberating outwards into the world with unwavering persistence. There is a lineage between us and them, of time, feeling, distance, gifts, and histories, which continue unto our children and our children's children. These are the kinds of relations that I care about, ones that began before me and that will continue after me, like the sound of a drum.

If I close my eyes, the drum and the moon appear as if the same shape to me. They are forever suspended, a circle to which we all have relation.

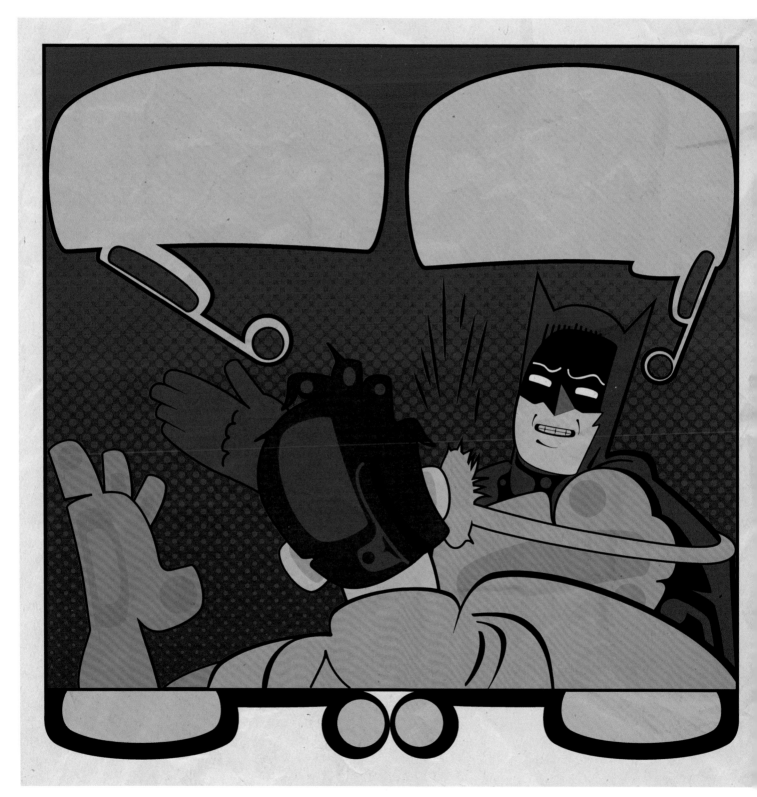

SONNY ASSU IS PURE PSIONICS AND I TRAVELLED BACK IN TIME TO TELL YOU THIS

RICHARD VAN CAMP

The first Sonny Assu piece that I ever saw was, oh, probably ten years ago at my friend Erin's place. East Vancouver. Off Commercial. A supper. Friends. Fear freezing me as I looked up and witnessed a million crows flying over us flocking to Burnaby. "It's all right, Richard." Erin looked at me and smiled. "They do this every night and the sun still rises every day."

She had saved her money for Sonny's *Enjoy Coast Salish Territory* print. You know the one: the one with the Coke brand with the swoosh—except it had been Assu'd.

I could not believe an Indigenous artist would dare to take the Coca-Cola brand and rebrand it. Claim it.

I was both in awe of Sonny Assu at that very moment, and afraid for him. What if Coca-Cola representatives showed up at his house with a cease and desist order? It was happening with Haida Bucks, the coffee shop in Haida Gwaii. Starbucks was going after them.

Then I saw his cereal brands and his Pez thing. Who was this guy? He was a modern-day Contrary poking fun at the biggies. But, better than that, he was taking his traditional and contemporary teachings and living large with them.

Have a look at Sonny's radionic[18] graffiti. His ovoid Wolverine and Hulk, his button blanket Spiderman, his Batman slapping Robin, his Rez Pez, his Tapwe warnings on his cigarette packs. I love how he sweetens the traditional with contemporary pop culture and vice versa. He's a modern-day Watchman and I adore him and his work.

35

18. I don't even know what this word means, but it feels so right, ya know?

← *It's 2016!*, 2016, adhesive dry-erase wall vinyl, 48 x48 SONNY ASSU

Oh, by the way: it's 1984 for me. I keep going back. I've found wolverine medicine. Time is nothing for us. I sometimes return a year from now, tonight, yesterday. '84 is my fave. Why? I was a mess and loved it. Big hair; bad attitude. My brother had a rat tail.

I figured that the crossroads were calling me and it all went back to what I didn't realize at the time was one of the greatest nights of my life. We were playing Dungeons and Dragons at my buddy James's house. Jon Liv is there; so is Chris; so is my brudder; so are a few friends who were already starting to drift but we were holding—Lord knows. Jon Liv is asking if we can have Psionics. Our DM keeps saying no. We all want Psionics: the ability to turn any part of your body into a weapon. It's better than ninjas and I never thought I'd catch myself saying this.

I keep coming back—not for the game but for the night. Sandy Schuman will call us and he'll tell us that the last can of Fort Smith's first ever delivery of Cherry Pepsi is at Kelly's Gas Station. The Cherry Pepsi is dented and is way in the back of the fridge, but it's there with a bubble on its side, but she's good to go, he'll tell us. We'll all fire up our Ski-Doos and race down to get it. We were Mad Max before he was even born. A rooster tail of sparks will prevail around and through us. I was The Gimp before there was a Gimp. We'll get the last can and she will be dented almost in half. There'll be a huge bubble spooning out of the top and there'll be tiny hissing coming from the can. Oh, well. We'll get hoagies and race back to James's. We gotta be careful cuz his dad works graveyard for the Power Corp. His bed just happens to be directly above the basement where we play. It smells like hot scalp in this room we get so worked up. We'll play for hours, days at a time. As long as the wood box is full and our chores are done, our folks know we're not hunched over an oven hot knifing an 8 ball of hash. Well, most of us. It's almost too late for me.

But we take turns playing rock-paper-scissors and I'm second. My bro wins above all of us. I've gone back to this game so many times and changed my signals. He always wins. I'm always second. Fate braids us. What this means is he gets the first sip out of our crew of ice cold Cherry Pepsi. The first sip. The forever sip. This is like kissing Cindy Crawford directly on the mouth. I worry each time I reappear to do this I'll start tonguing the can hole it's so delicious when I get going, but restraint is my middle name.

The point of this night is my brother eats his hoagies and makes us wait before he has the first sip out of the can. So we all eat our hoagies. Timed perfectly at 2:30 in the micro. It's delicious. Our jobbles[19] probably glow in the dark to this day for all the hoagies and nachos we ate, but we lived like of High Council of Subotais,[20] I guess. Anyway, when it's time, my brother

19. "Balls," in Raven Talk.
20. Get it? From *Conan the Barbarian*, the movie. Subotai was the helper of Conan. His true party bud. An incredible archer. A lone wolf who finally found a master to learn from. Mah!

→ *When Raven Became Spider, Embrace,* 2004, Melton wool, cotton, Akoya shell buttons, 66 x 85 inches TONI HAFKENSCHEID

36

opens the can and takes a sniff of the aroma. We can all smell the perfume of cherries. Yum. I think we were all rocking half chubs it was so good. Then he took the biggest sip. "Hey, take it easy." "Come on, Roge." "Eff sakes, Bro!" "Hey, you guys. Don't wake my dad!" I take my time watching everyone emote. It doesn't matter how the dice flows before or who shows up first or how I try to influence the bivouac, it always comes to him having a sip and coming back stoned and grinning, going, "Holy fuck, boys. It's so good."

I'm next. Even though I know what's coming, I still love it. Roge backwashes and I get a mouthful of bun, mayo, pretend lettuce, rubber meat with a little mayo bathed in Cherry Pepsi. I gag and sputter and the whole room erupts in shock and awe. Then laughter. I give my brother the meanest look and he smiles back. It's too late: it's done. We're sealed in a treaty of saliva and cherry fizz. I wipe my mouth and swallow. I have to. I want to. Because after that we all take turns going round and round sipping Cindy Crawford kisses with a tiny mouthful of Kelly's gas station going down rugged and lumpy. We were like Vikings for a night. Knights. Brothers.

I figure that was the last perfect evening of all of us. Soon after, some of us would discover drugs, drinking, women, parties, lifestyle decisions, rock gods like AC/DC, Iron Maiden (I prefer Platinum Blonde and can totally air drum that solo in "Standing in the Dark"), choking ourselves out with our hockey socks, sports, school, life paths.

I go back time and time again to feel perfect confusion of my life and the glory of that room in James's basement. I feel me.

In today's time, I write to Sonny and asked him if he was worried about a cease and desist order from Disney. His response: "I never have, not from Disney (when Marvel and Disney were separate). And I guess not from Apple or Coke. In my mind, I always thought about this work as re-appropriations. Especially from Disney, taking from them, changing, just like how they did from us and other Indigenous folk. Which is why a lot of the Mickey Mouse imagery is titled 'The Great Appropriator.'

"In my artist head, all this mass media/advertising we are served up with on a daily basis belongs to us, as much as it belongs to their brand. It becomes part of us. We are bombarded by it; everywhere we look, there it is. So how can we not use it to use as part of our personal narratives? I think that is where that fearlessness comes from: this is part of me. Sitting down as a kid on a Saturday morning, watching thirty-minute cartoons that were really adverts for toys, mixed with adverts for other products, while eating bowls of sugary breakfast cereal. I have just as much a right to it as they do."

What was Sonny doing in 1984 while I was slurping sloppy seconds from my brudder?

>>> Let's see, I was nine. And living in East Van. I had just moved in with my mom the year and a half previous . . . Up until then, I was raised by my grandparents. I thought my mom was my sister. Long story.

'84 would have been my second go at grade three. I joke that I loved it so much that I wanted to do it again. Reality is, I was probably sucking at school because of the move and the upheaval of my life at the time. I remember busting out my old Phonics workbook from the previous year and having a classmate try and bust me for cheating. I proudly said it's mine; how can I cheat if it's mine? I now have the class photo in my head, where I am a full head taller than everyone else.

My teacher thought there was something wrong with me. I wouldn't answer to my name. So she called my mom in. "You know, I'll occasionally call on Ronald and he doesn't answer. Is everything okay at home?"

"Ronald?" my mom says. "He goes by Sonny."

I'd stop at the corner store on the way to school to get some candy, and hockey stickers. You remember those hockey sticker books? Bigger than hockey cards at that time. I'd spend recess/lunch trading those stickers and playing ball hockey. I was usually the goalie, using my smart bomber jacket as both pads and a means to block the ball.

I also remember eating packs of ramen, dry. The Vietnamese kids at school did this, and it became a bit of a craze for my class. So I'd occasionally pick up packs of ramen. Crushing the packs up and then sprinkling the seasoning all over and tossing them back like chips.

When I didn't have any money, or didn't feel like spending what my pops gave me, I'd stop at the small grocery store by our house for an éclair (cream filled Long John! *Woot!*). I'd tell the owner to put it on our tab. Which they did. I remember having to sell them hard on it at first, that it was fine: "My mom said." After that it was smooth sailing. I'm not sure how long that went on for, but I do remember being yelled at for a fairly large doughnut bill.

I went to a school called Laura Secord, on Broadway, between Victoria Drive and Nanaimo Street. I remember wanting to walk to school in late fall and winter with wet hair, just so my hair would freeze on the way.

I think construction of the SkyTrain in Vancouver was just starting around then. We lived near the Commercial Drive station. There was an open construction pit on our street. My friends and I would raid the cardboard dumpster behind the Shoppers [Drug Mart] and slide down the sand and gravel piles.

I'd get into scraps with the kid who lived downstairs. We'd get over ourselves and play "guns" in the yard and around the block. I had a couple of friends who lived down the alley . . . in a house, of course, brothers. We'd play Atari or with our Transformers or GI Joes.

I'd be summoned in for dinner. My mom yelling my name until I ran into the house. We lived on the top floor of an old duplex. So I'd run up the back steps to our deck and into the kitchen.

My room was the loft, about ten to twelve feet above the living room. I had to climb a ladder to get to my room. My friends and I would have jumping contests off the ladder, seeing who could jump from the highest place. We all made it to the top, and never broke anything. I fell off that ladder a lot. My stepdad, a carver, was napping on the couch below one day. I fell off the ladder, landed right on his stomach. He awoke with an exhaled 'WHAT THE FUCK!' as I rolled ass over head onto the floor. Another time, I bounced off the couch and onto the coffee table, which was a section of a tree, and broke it.

My first records (vinyl!) were Van Halen's *1984*, Huey Lewis and the News' *Sports*, and Paul Revere & the Raiders (I'm not sure which album).

Summers were spent on my pop's commercial fishing boat. A small purse seiner. I'd sleep on a foam pad in the wheel house and be moved by him into his bunk when the work day was starting. He had a stash of chocolate bars "hidden" in a small cupboard by his bed. I'd spend time reading Archies and chowing on Oh Henrys, Coffee Crisps, and Crunch bars. I'd go to the top of the cabin to watch the crew work. There I'd also curl up in the pile of webbing (net) by the warmth of the smoke stack and read comics. When anchored, I'd play with the radio, annoying all the channels with time calls. Just asking for the time.

This was probably the time when I discovered Spiderman. There was an old greasy spoon diner here in Campbell River called The Bee Hive. We've go there for breakfast when in port. There was a diner counter in the front, with a long magazine rack behind it. Filled with every magazine and comic book you can imagine. This is where my collection started.

Other than that, I was into WWF (wrestling, not the animal org) and had a goal to become a professional wrestler.

I believe it was that fall when my pops was living in a hotel in North Delta. I'd spend weekends with him there. Although I was mostly in the room alone, watching wrestling and other junk on TV.

I had a tough street dog, named Skipper. He was a small poodle. Not those tiny little ones, a medium-sized one. He was black/fading black/grey. We gave him Mohawks with the pom-pom ankles. He wore a green t-shirt.

I was a latch-key kid who kept losing his key.

I had a killer red and orange BMX with orange tires.

My gran bought me some new clothes; I unknowingly wore the pajamas to school. She was waiting for me after school one day, and asked me why I was wearing my PJ shirt.

Have you watched *Stranger Things*? I was so tripping balls over how much that was my childhood. The free-roaming aspect. Our block was our 'hood.

Summers were spent on the Rez, as well: berry picking with my great-gran. Roaming around by myself. Roaming around with my cousins.

Oh, yeah, shit, I forgot about this. There was a group of kids I hung out with in East Van. My mom's friend's kids. A group of brothers. Their dad was a carver as well, so my stepdad would go there to carve all the time. There was a time that I wore nothing but camo. They called me "Sarge."

Speaking of the stepdad. My mom went out of town for a week once. And we'd conveniently show up at friends' places around suppertime. :P <<<

>>>

GOLD, Cousins!

I have come to realize that some people are born with Psionics and Sonny Assu is one of them. He's a weaponized spirit stomp and I adore his fearlessness. He's a Contrary with a message: you can make it but I'll reclaim it. There isn't a cease and desist order that's gonna stop "Sarge" from conducting his business! He was born to do it and we're a better planet for it.

Keep shining, Sonny.

You inspire everyone who has the privilege of knowing you and seeing your artwork. Your work is Boss!

Mahsi cho and with respect,

—*Richard Van Camp,* Tlicho Dene from Treaty 8 living in Treaty 6 Territory

A SELECTIVE HISTORY

SONNY ASSU

When I was a kid, I would lay on the bow of the *W.#7*, my grandfather's seine boat, as we travelled up and down the BC coast. I had many "spots" on the boat, but the bow was one of my favourites, mainly on our trips back to Campbell River. As I reflect on this, I envision Leo and Kate from *Titanic*. No idea why, as I was a lone chubby kid with an affection for sweatpants. Yet, in that place and at that time, I did feel like the king of the world.

The bow was a place of solace. It was where I could take a break from monkeying around, reading comics, or drawing in the galley. Rough life, I know. Here, I'd watch the boat part the water around it, like two ribbons of cedar being planed off a board. I would listen to the cacophony of the sea battling the rhythmic hum of the diesel engine and the frantic flapping of the wind-tattered flags.

As I lay in the warm sun, the cool breeze of our homebound travel brought the smell of the sea to me. I'd be hit with the reddy smell of rust from the anchor and its chain—a smell you can place a colour to, like how grape juice tastes purple. It smelled like red. The aroma of the mud, brought up from last night's slumber, was folded in. It was earthy and pungent. The mud was infused with kelp, rocks, and bits of shellfish, all drying in the sun and wind. I remember kicking the massive chain next to me and watching the dried mud crumble into the sea. No expected plop. Just mud, absorbed into the wake and placed back from where it came.

>>>

My grandfather is steering from "up-top" with Ivan, one of his skiff-men. Everyone calls him Tarzan, and even to this day, I'm unsure why. Tarz squints towards the distance, keeping a watchful eye for jumping salmon as we travel homeward.

My grandfather catches my eye and nods his head up with a smile. His face is sun-worn, brown and stubbly, with the character of a man who has worked hard all his life. His

← *Longing #16,* 2011, found cedar and brass, 16.3 x 12.5 x 6.5 inches,
 photo: 15 x 19.25 inches SCOTT MASSEY, SITE PHOTOGRAPHY

"fisherman's tan" covers his face, neck, and hands only. Even on the hottest days, he wears a long-sleeved shirt to hide an embarrassing tattoo on his forearm.

I smile and wave and turn back to see if his nod is not merely a show of affection but an indication for me to see what I've been waiting for. And then I see what I always come to this spot for: the porpoise. Porpoises are small whales that look like dolphins but with a stubbier snout. What is special about witnessing these creatures isn't just the fact that they are here, but how they dance in and out of the water, up and down, mere metres from the bow. It amazes me how fast they can swim. Here I lie on the bow, thinking they have come just to see me and dance for me. Arms widespread, the breeze drying the salty spray on my face, I am in wonder of these creatures.

>>>

It is hard to say what drew me to this memory as I sat down to write the introduction to my work. Perhaps it was pure escapism—a response to an unconscious need to revisit a time when I wasn't plagued with stressful tasks such as writing about my own career. A simpler, carefree time, when my only worries were having enough quarters in my pockets for an afternoon at the Family Fun Centre, running to the Bee Hive Cafe to grab a handful of comics, or begging my grandfather to let me explore the pebble shore of a remote beach.

Or perhaps the memory was triggered by conversation that happened the other day. I was gassing up my car, and there was Christine, Tarz's daughter, working the till at the Clam Shell (what my granny called the Shell gas station on the Rez). We never really hung out at all as kids, but we knew each other. So we made small talk; she asked how things were and how I liked living in Campbell River. (We'd moved here last year from the Lower Mainland by way of Montreal.)

"I love it," I said. "I thought it would be challenging for my work, but I'm feeling pretty focused here. There is something about waking and working where our ancestors are."

"Cool," she said approvingly. "Who would have thought: Sonny Assu, *not* a captain of a fishing boat?"

"Right?!" I said as we shared a laugh. She did have a point. I had been so close with my grandfather that I called him Dad. I'd been his shadow, and for a while everyone, including him, thought I would carry the family line and become a seine boat captain.

But as I grew older on that boat, I became less and less interested in actually working on it. It never was in me, I think, to be a fisherman. And that became pretty clear to my grandfather one day as I tried to get a salmon out of the webbing.

My grandfather had stopped the drum to allow the deck crew to do what they do. I can't recall exactly how old I was, maybe fourteen or fifteen. I was standing with him on the stern, and I was having zero luck getting the sockeye freed from the net. I was cussing up a storm,

which is probably the only practical skill that I ever gleaned from working on a boat. (Ask me to tie a fancy knot? Next question. Mend a net? Nope. Find a multitude of ways to express myself via expletives? I'm your guy.) I was getting progressively agitated until I had enough and started to Hulk out and whip that salmon around until its head popped off and the body slid right into the hold.

"That's it," my grandfather said to me. "You're going to law school."

He wasn't disappointed; he just knew this wasn't the life for me, and he figured I might as well do something important with myself.

Now, art has always been a big part of my life. I used to show my pops all my drawings of crazy super heroes, and he got a kick out of my imagination. But to him, doing something important with your life was tied to what Indigenous people of his generation thought would benefit all others.

"Why law school?" I asked as I kicked the salmon head off the stern and into the drink.

"We need people to fight the system from the inside," he said to me. But I think we both knew I didn't have what it took to be a lawyer.

A couple years later, my grandfather passed away unexpectedly. A fisherman all his life, and he never learned how to swim. This is more common than you would think.

>>>

Sonny Assu: A Selective History is the culmination of mining through and selecting works that reflect different stages of my practice—and all the associated successes, failures, and struggles that came with them. It has been a daunting and humbling experience. Doing this while completing an MFA, moving back to the West Coast, battling depression, and creating new work for a multitude of upcoming exhibitions and projects made the process all the more challenging; however, the opportunity to reflect on the past has enriched my current practice more than I could have imagined at the outset of this project.

Covering the period of roughly 2002 to 2017, this book presents a wide selection of works from nearly all of my major series. More recent works (2010 onward) are given greater representation here than are earlier works, partly because there were more to choose from in that period and partly because they reflect a more confident expression of the "voice" I was still developing in the early years.

Beginning with *Coke-Salish* (2006), an early pop-culture-infused piece that garnered a lot of attention (and, thankfully, not a cease-and-desist letter, as Richard Van Camp speculated it might have), the more than 150 works on the coming pages do not follow a strict chronological order so much as a fluid order that loosely follows the trajectory of my career in a way that

draws attention to the visual or thematic connections between series of works whose commonalities may not be obvious at first glance.

There are many, many drum works included in this book. Drums have been both a central theme and a grounding medium in my work, as Ellyn Walker has so eloquently written about in her essay. Each series—from iDrums, with their playful expressions of consumer culture, to Silenced, a sombre commentary on the potlatch ban, to Billy and the Chiefs, a tribute to my great-great-grandfather—uses this simple, ancient form to tell a story. My fascination with drums took hold when I was a student at Emily Carr University. I think it's safe to say that without that education—and particularly the knowledge of Brenda Crabtree, who taught me how to make drums—my practice would not have taken shape in the way that it has.

Chief Billy Assu is a constant presence in my work, and over the years I have discovered different ways of honouring his story while critiquing the political system that shackled our cultural practices. Billy and the Chiefs and *Ellipsis* both reference the recording that Dr. Ida Halpern created as a means of recording our traditional songs for academic purposes. At the same time as these recordings were made, colonial law prohibited Chief Assu and others from performing these songs in the ceremonial and cultural contexts for which they were intended. *Ellipsis* is one example of my exploration of and fascination with copper—a material that holds great meaning in Kwakwa̠ka'wakw culture.

Objects made of copper have inherent and conceptual wealth and traditionally could be elevated to higher status through the actions of high-ranking members of society. A Copper could represent the wealth of centuries' worth of sacred potlatch ceremonies: multiple canoes, sacred objects of cedar, maple, and alder, cedar clothing, baskets of mountain goat wool, stacks upon stacks of trade blankets, and other utilitarian objects would all be conceptually represented through that one object. The wealth of a chief (the host of a Potlatch) was based upon how much he gave away. This system of commerce, as displayed through potlatch ceremonies, was considered unacceptable by the colonial government.

Copper, as a material, has played a central role in several of my works relating to the potlatch ban, most notably the installation *1884–1951* (2009). In this piece, the systematic, discarded piling of the sixty-seven copper "to-go" cups references how the Canadian government has treated the First People as disposable, as well as our Western and globalized momentum towards becoming a disposable society. *1884–1951* is a commentary on Canadian history and consumer-sociology: in juxtaposing two dramatically different societies, it creates a conversation on how wealth is disseminated and how history is hidden.

Between 2012 and 2013, I became interested in the concept of propaganda posters of the early twentieth century, used to instill fear, hatred, and conformity in the hearts of citizens during times of political turmoil. I created several series of posters, experimenting with com-

bining typographical elements against a background of Northwest Coast ovoids, u-shapes, and s-shapes. The text excerpted on these posters references racist policies imposed by Canadian colonial rule. The posters speculate how visual propaganda could have been used to influence Canadians about the so-called "Indian Problem." Collectively referred to as the Propaganda Series, these works fall under the titles of *The Happiest Future* (2012) and *Selective History* (2012). *Strict Law* (2013) provides and alternative to this colonial agenda, by quoting Chief O'waxalagalis of the Kwagu'ł, in conversation with Frans Boas in 1888. This is followed by *There Is Hope, If We Rise* (2013), inspired by Shepard Fairey's "Hope" poster depicting Barack Obama during his first presidential campaign, but reimagined to motivate both Indigenous and non-Indigenous communities to stand up during the #idlenomore movement, and *Product (Res)* (2013), a satirical critique on the strange blending of consumerism and social activism. While the relation to the aesthetics of iconic propaganda imagery fell short on this series, the display of Canada's historical bigoted words against Indigenous people still remain relevant today. Even in this era of "reconciliation," Canada's treatment of the Indigenous people has improved very little over the last 150 years.

The Longing (2011) and Artifacts of Authenticity (2011) series explore the importance of cedar to the Kwakwaka'wakw and question the definition and value of art based on where and how an object is displayed. *The Value of What Goes on Top/The Value of What Goes Within* (2015), while revisiting the value and significance of copper, expands on this theme somewhat, speculating how my ancestors would view Western art and how they would place value on the objects that are used to elevate or display the art itself.

Leila's Desk (2014) and *Inherent* (2014), both discussed earlier in this book by Candice Hopkins, are deeply personal pieces that address the lifelong impact that instances of racism had on both me and my grandmother when we were in high school. Up until the early 1940s, under mandate of the Indian Act, Indigenous people could only attend a residential or Indian day school, and only up to the grade eight. However, the Canadian government amended the Indian Act to allow Indigenous people to attend high school without enfranchising. My grandmother was one of the first Indigenous people to be allowed to attend a high school. On her first day, nervous and excited about her newly granted rights, she was confronted with an instance of racism that haunted her for the rest of her life. A boy, whose name she always recalled, placed a bar of Lifebuoy soap on her desk and had a good laugh with his fellow classmates. Her pride turned to shame, faced with being seen as nothing more than a dirty Indian.

Although I never suffered through the indignities of the residential or the Indian day school system, our common experience of being targeted by racist bullies fifty years apart reflects the deeply ingrained attitudes towards Indigenous peoples that live on through the

generations. My experience is represented in *Inherent* and speaks of the Oka Crisis of 1990 and how I stood up to a classmate spewing hate about Indigenous people.

My most recent works, and the last three series presented in this book, combine Northwest Coast formline with pop-culture themes using digital technology, painting, and collage to blend, distort, and abstract Western imagery and display the vibrancy of contemporary Indigenous culture.

Interventions on the Imaginary (2014), explored in depth earlier in this book by Candice Hopkins, situates itself within the realm of remix culture as digital interventions, or tags, on works by Emily Carr, Edwin Holgate, Paul Kane, and others. The series playfully challenges the settler/Western artist's depiction of seemingly empty landscapes that have always been occupied by Indigenous peoples.

The Paradise Syndrome (2016), discussed by Marianne Nicolson, takes its name from a 1968 episode of the original *Star Trek* TV series in which the crew of the USS *Enterprise* lands on a planet inhabited by Native Americans who were removed from Earth and transplanted halfway across the galaxy, where they have been free to flourish without the effects of colonization. Like Interventions on the Imaginary, this series superimposes formline aesethetics and copper shield imagery over colonial depictions of the Pacific Northwest Coast, in this case marine charts that show the vastness of Indigenous territories, while highlighting what the colonial governments left for us—demarcations on the charts as "IR" for indian reserve—after forcibly taking our land or removing us from it.

The abstract visuals that range from 2D to 3D are meant to reclaim these spaces, while making note of the importance of the land and water to the Indigenous people of the Northwest Coast. The fascination with the Copper comes back into play in this series, where the Copper form is presented as a symbol of wealth for the land. But the scaled up reserve shapes are broken out of that Copper, becoming an act of shaming the colonial government and its pillaging of Indigenous lands.

Finally, the Speculator Boom series (2017) sees my practice going back to the whimsy found in the works of the Challenging Tradition series, a body of work from 2002 to 2005, which I see as the launching point of my early career. In Speculator Boom, comic books are a material to be explored and a notion of wealth to be challenged. But when I was a kid, comics were a form of entertainment and escape, fuelling my imagination and spurring on my early creative pursuits. As I grew older, the importance of collecting started to take hold. No longer could I roll these things up and whack my cousins over the head or eat sloppily near the pulp pages. Once read, they were "bag-and-boarded" and placed in a comic saver long-box.

I did most of my collecting during what has become known in the comic book industry as the "speculator boom" (1985–93). It was a time when every other issue seemed to be important.

Publishers like Marvel, DC, and Image would release a variant or gimmicky issues to tease with the importance of collecting comics for their future monetary value. In one instance, I ended up collecting twenty-one of the same [expletive deleted] issue. I was led to believe that my $42 investment would pay out in the future. Turns out, like most of the comics from the speculator boom era, these comics, gimmicky or not, are now fairly worthless.

Through painting and collage, this series forms a deeper connection of the importance of comic books in my life and sees my practice seemingly coming full circle. Even after fifteen years, Speculator Boom feels like a natural progression of the Challenging Tradition series and the continuation of adding diversity to my practice and the continued exploration of materiality.

>>>

Reflecting on these past fifteen years of my career, I know my grandfather would be proud of what I've accomplished. Sure, I'm no lawyer fighting the system from within, but as an artist I'm attacking it from the outside. My work started out as an investigation into who I was: a product of pop culture, far removed from my heritage, growing up in Vancouver and its suburbs. That early work froze a specific time in my life when I was just discovering my Indigenous heritage. It reflected a 1980s consumer and pop culture aesthetic with the exploration of Kwakwaka'wakw culture and artistic form. I wasn't interested in creating work that pandered to the exploitative stereotype; I was interested in telling my story. To this day, most of my work is autobiographical in nature to some degree. But as my practice grew, that autobiography expanded from the self to my family and to the ancestors. Looking back at all the works assembled here, I've observed how the personal and the political flow in and out of each other like the ebb and flow of a tide. As I look to a number of my contemporaries for support and inspiration, it's obvious we feel that making art while Indigenous is a political act. Our art making speaks to our survivance, to borrow Gerald Vizenor's term, and our ability to move forward while looking back.

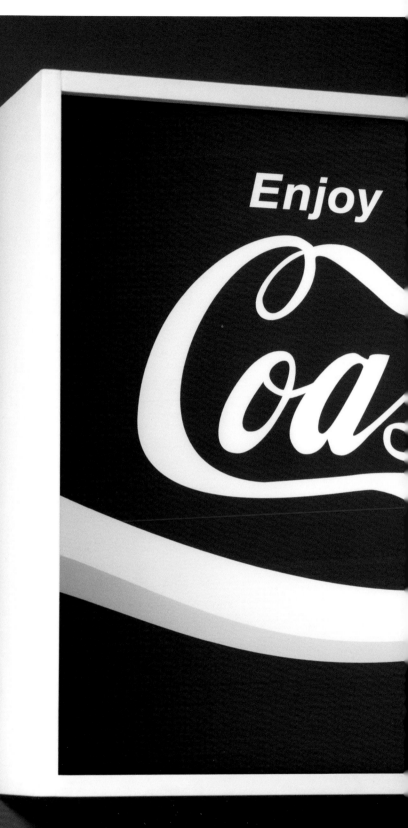

50

→ *Coke-Salish,* 2006, duratrans and
lightbox, 24 x 35 inches CHRIS MEIER

t'Salish

Territory

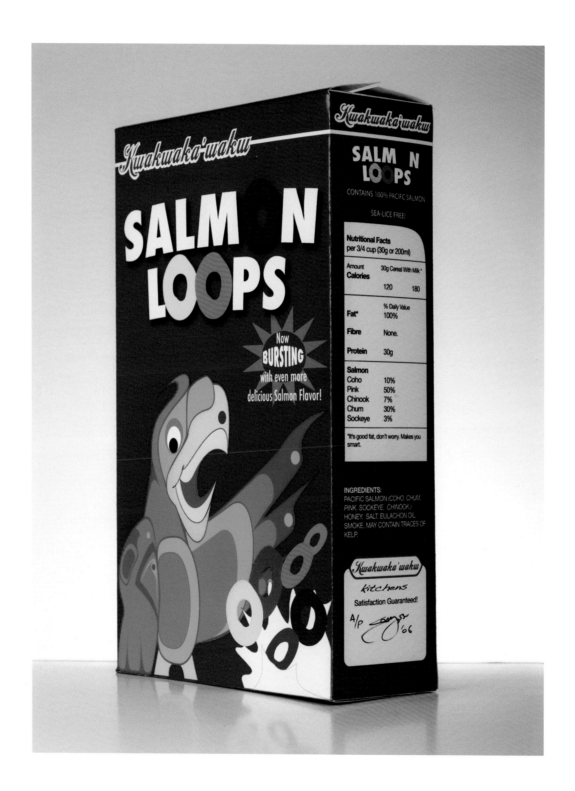

↑ ABOVE *Salmon Loops*; OPPOSITE, CLOCKWISE FROM TOP LEFT *Bannock Pops, Treaty Flakes,*
Salmon Crisp, Lucky Beads, 2006, digital print, foam core, 12 x 7 x 3 inches each CHRIS MEIER

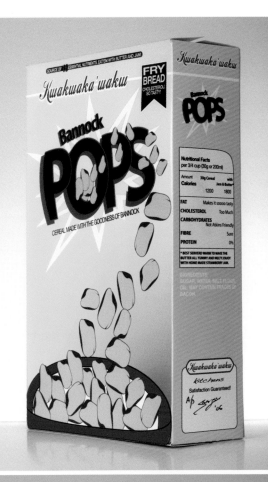

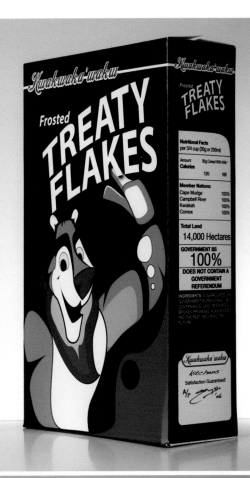

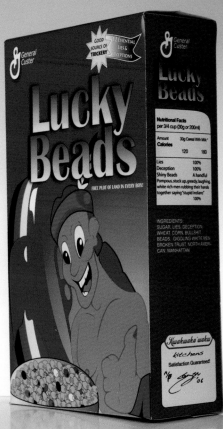

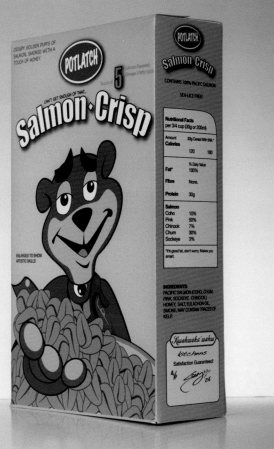

"The items we use and covet from pop, consumer, and technology culture have become our new forms of totemic representation."

—**SONNY ASSU,** 2008

→ OPPOSITE *iPotlatch: 10,000 Ancestors in your Pocket,* 2008, acrylic on panel, 36 x 72 inches CHRIS MEIER

iPotlatch: 5,000 Ancestors in your Pocket, 2006,
acrylic on panel, 48 x 24 inches CHRIS MEIER

→ *iHamatsa,* 2007
acrylic on panel, 24 x 48 inches
CHRIS MEIER

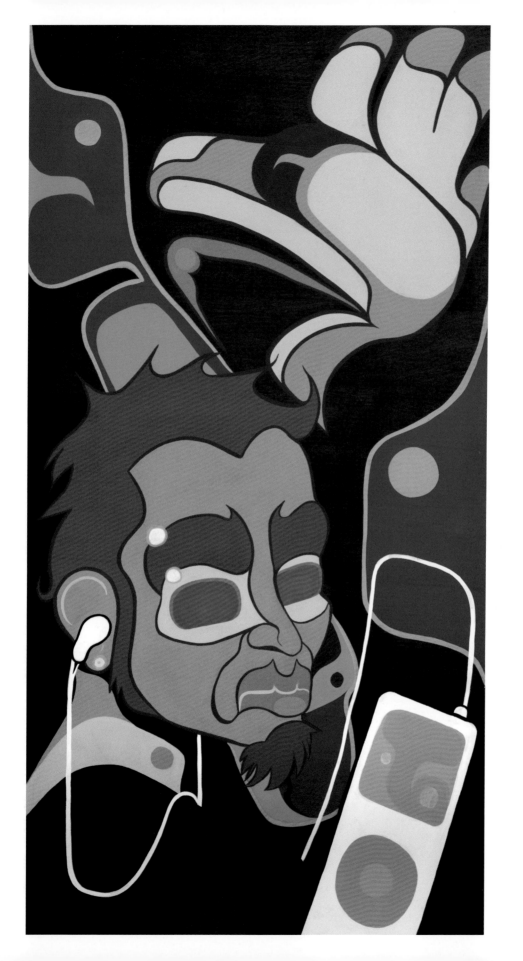

← *iPotlatch Ego,* 2007,
acrylic on panel,
24 x 48 inches CHRIS MEIER

→ *iDrum, Silenced, and Disconnected series.* Installation at the Equinox Gallery, 2010 CHRIS MEIER

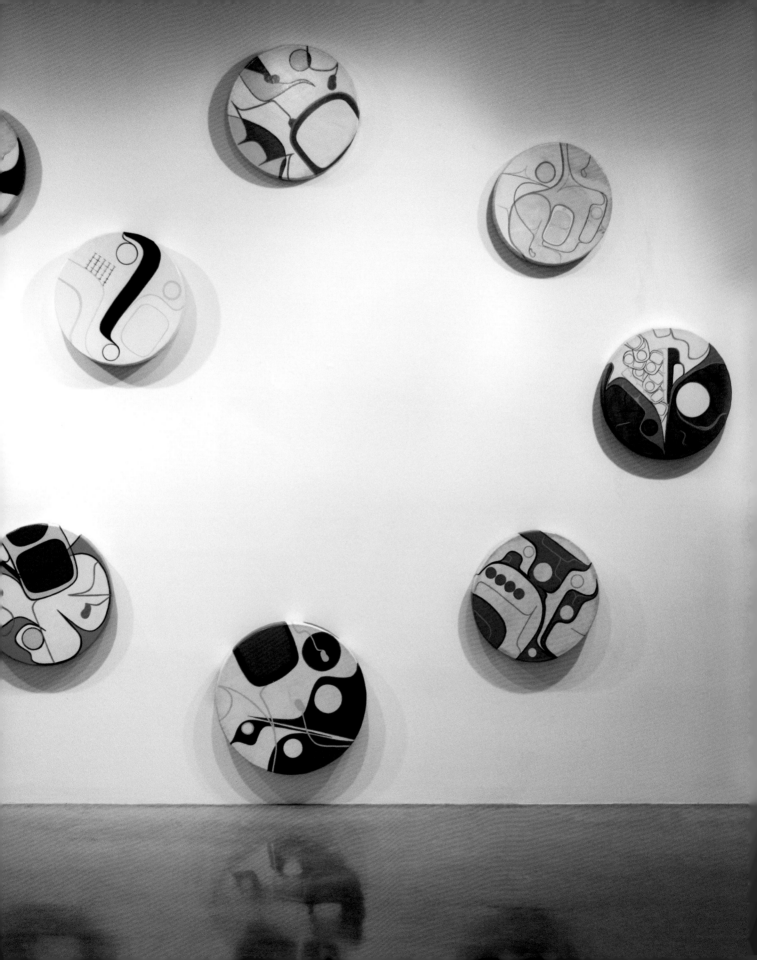

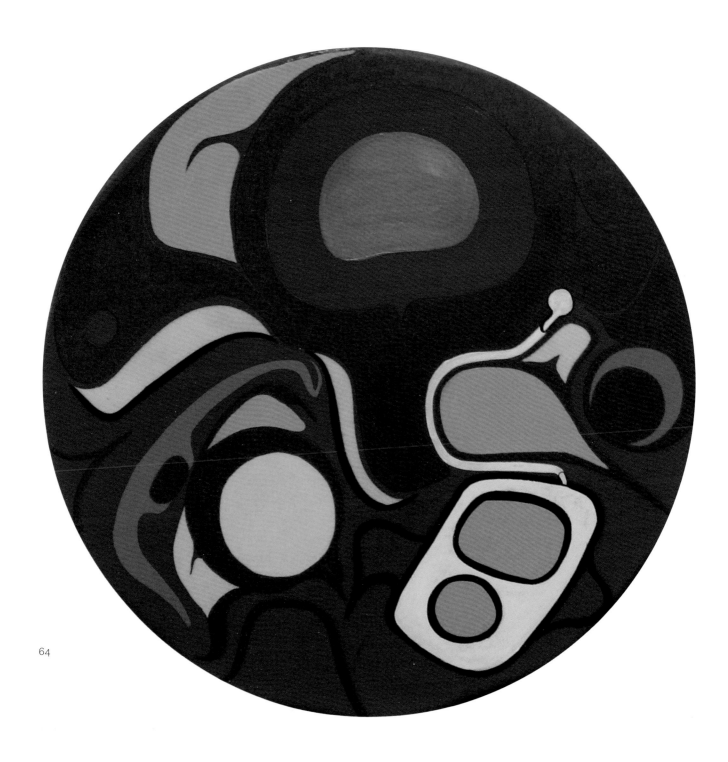

↑ *iDrum,* 2006, acrylic on deer hide, 16 inches diameter SONNY ASSU

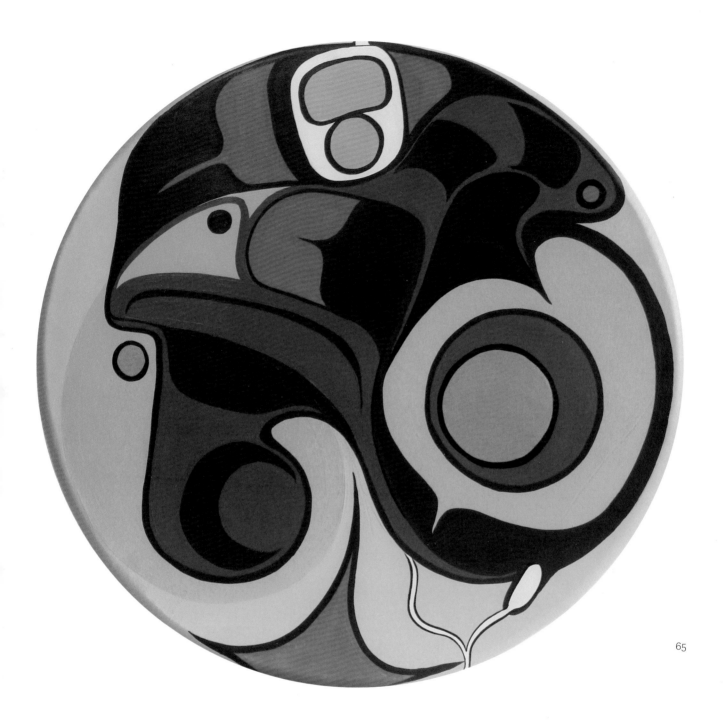

↑ *iHamatsa Nano,* 2007, acrylic on deer hide, 15 inches diameter SONNY ASSU

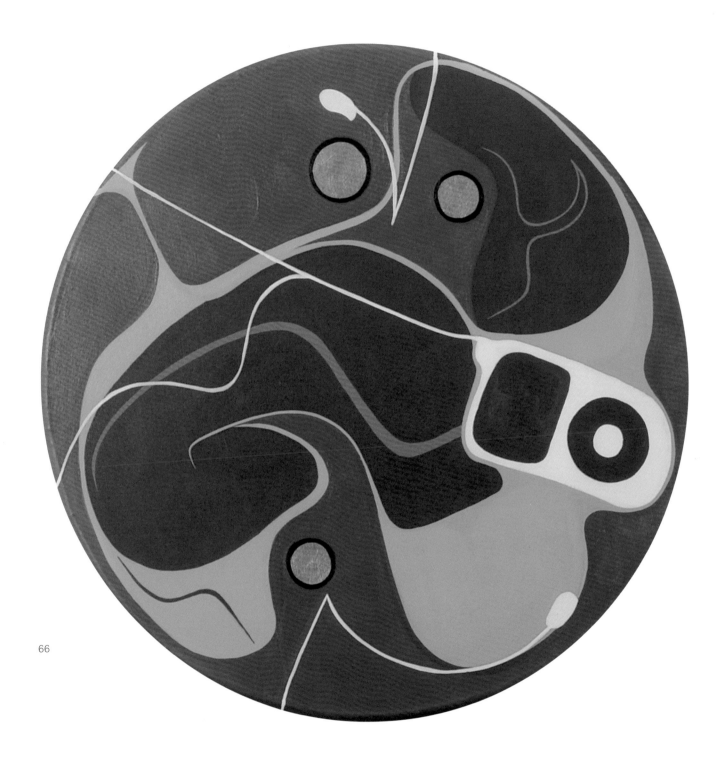

↑ *iDrum Personal Totem #1,* 2008, acrylic on deer hide, 20 inches diameter CHRIS MEIER

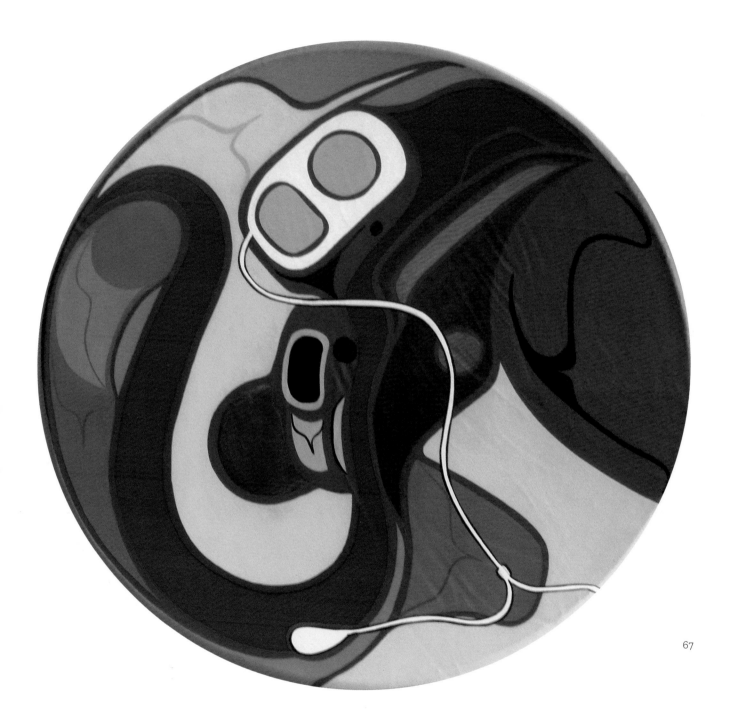

↑ *iDrum: Hotel California,* 2007, acrylic on deer hide, 18 inches diameter SONNY ASSU

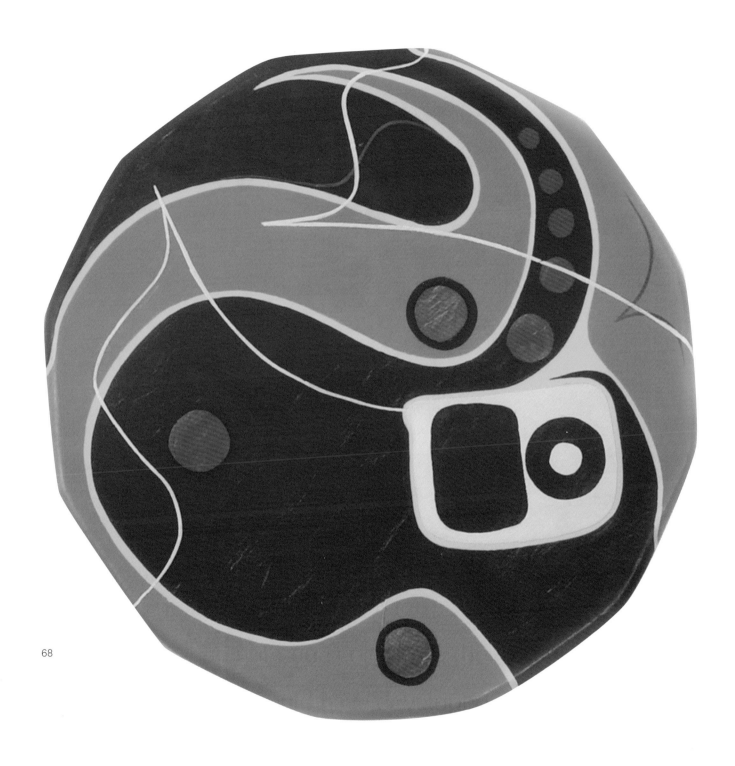

↑ *iDrum Personal Totem #2,* 2008, acrylic on deer hide, 20 inches diameter CHRIS MEIER

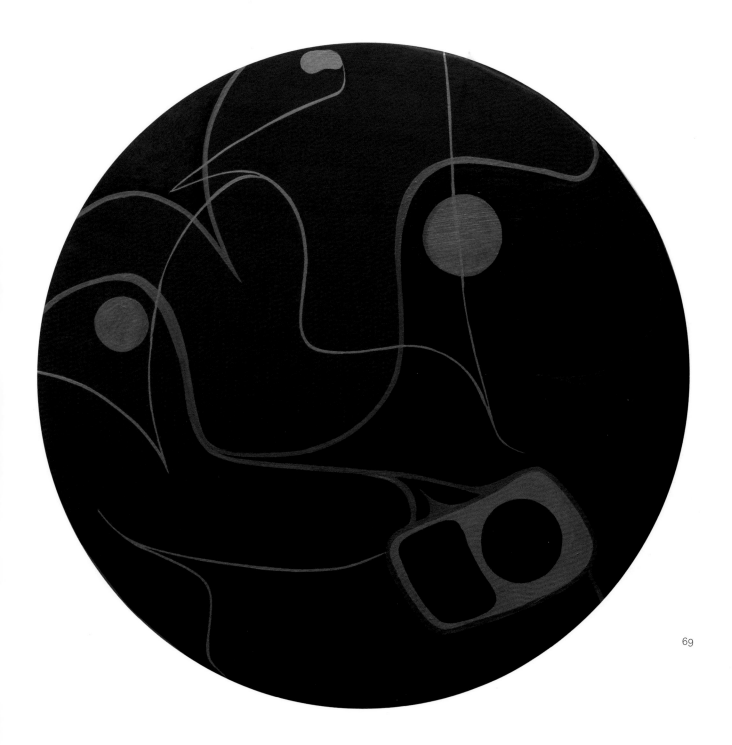

↑ *iDrum for the Chief,* 2009, acrylic on cow hide, 22 inches diameter CHRIS MEIER

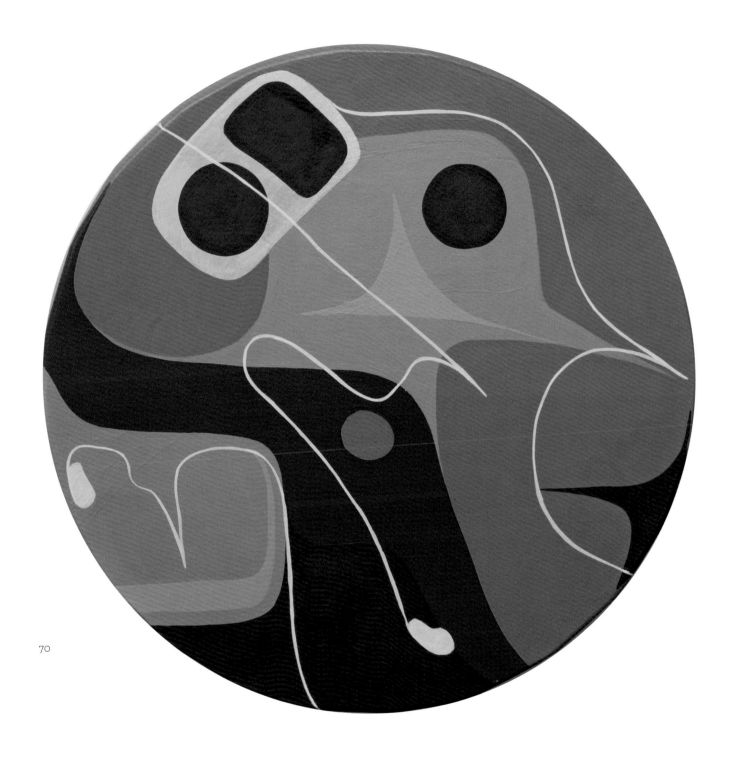

↑ *iDrum for the Hummingbird,* 2008, acrylic on cow hide, 20 inches diameter CHRIS MEIER

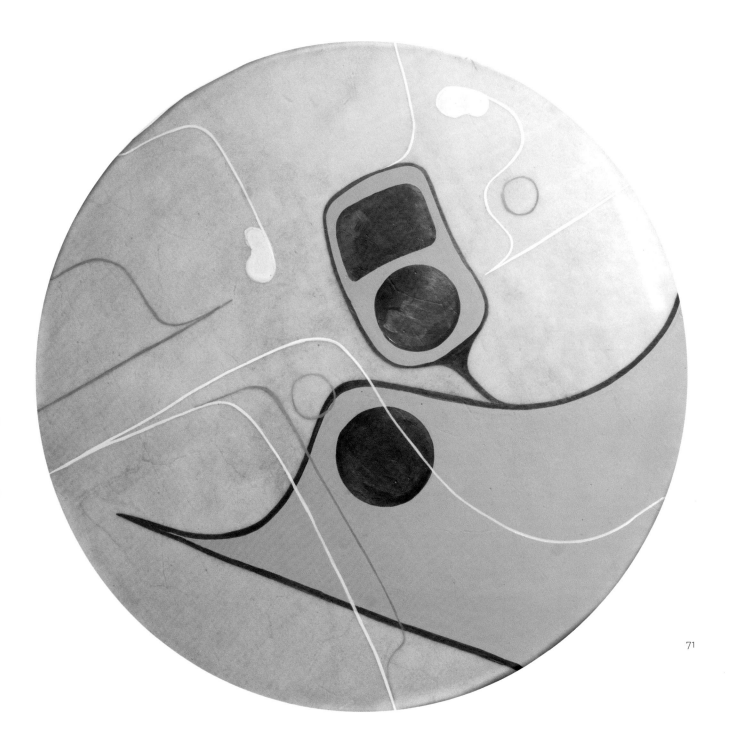

↑ *iDrum Nude,* 2009, acrylic on cow hide, 20 inches diameter CHRIS MEIER

↑ *iDrum Sea Festival,* 2009, acrylic on cow hide, 20 inches diameter CHRIS MEIER

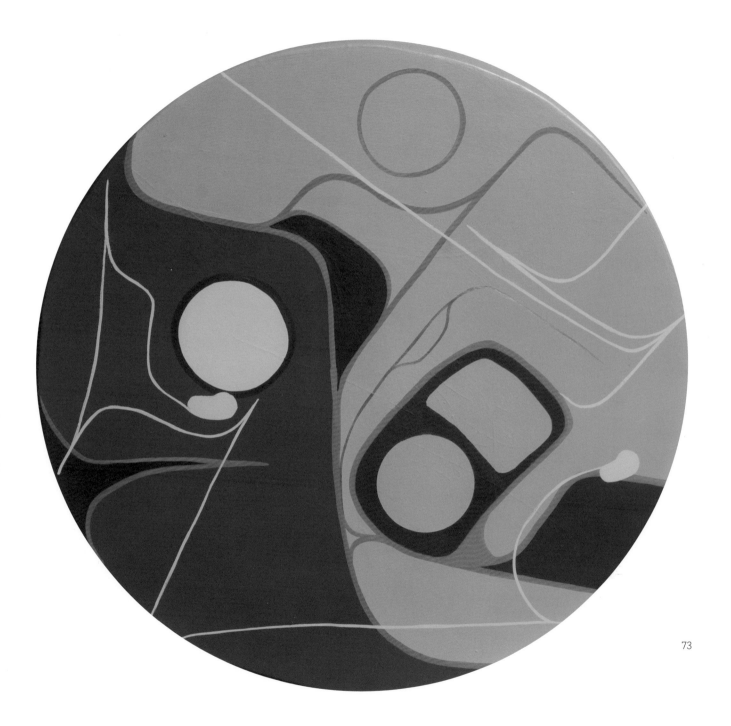

↑ *iDrum Tides of Change,* 2009, acrylic on cow hide, 20 inches diameter CHRIS MEIER

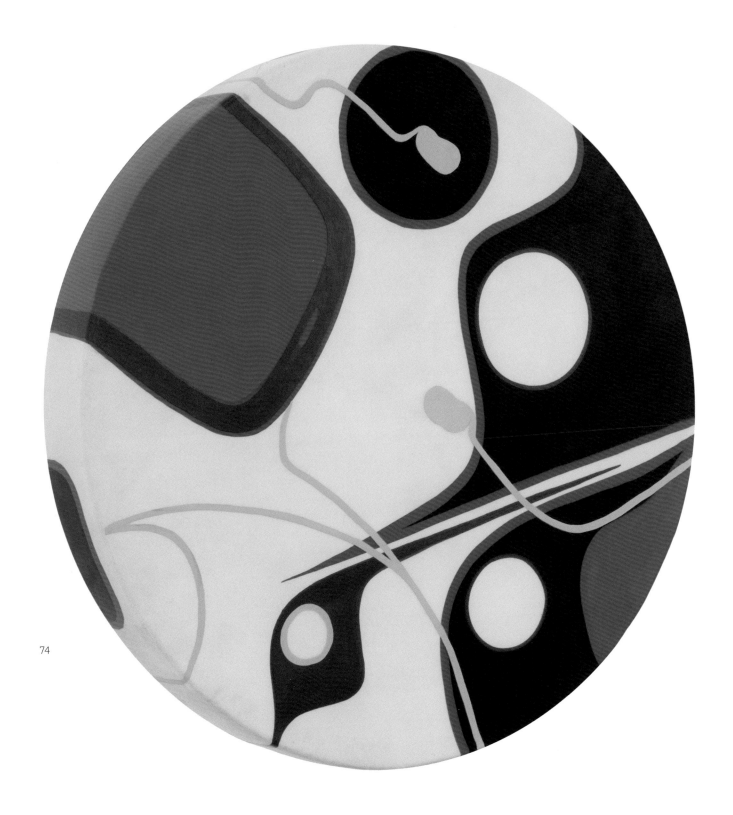

↑ *Hamatsa Calling,* 2010, acrylic on elk hide, 22 inches diameter CHRIS MEIER

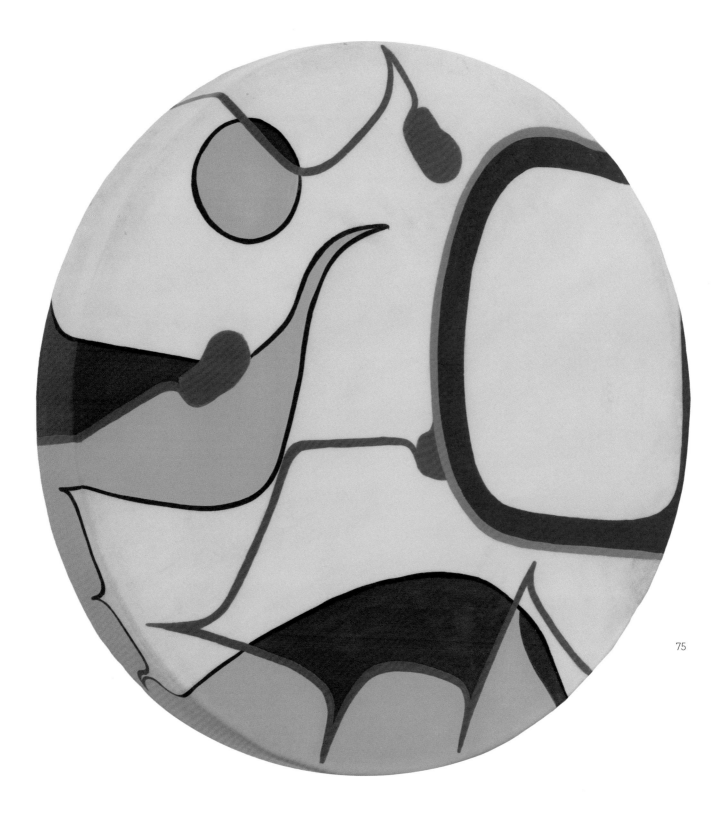

↑ *iDrum #3,* 2010, acrylic on elk hide, 22 inches diameter CHRIS MEIER

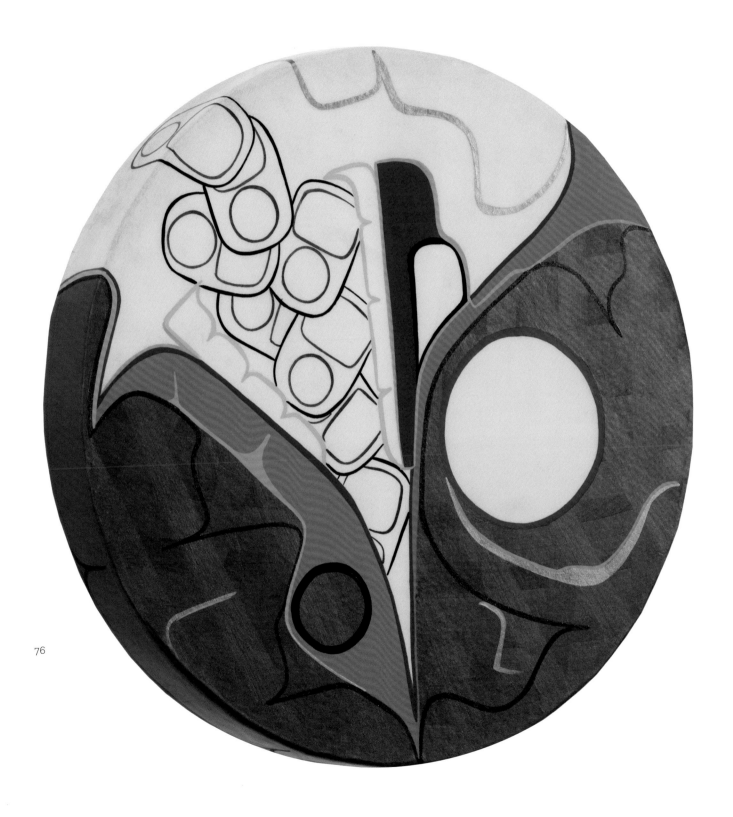

↑ *iDrum: Consumption,* 2010, acrylic on elk hide, 22 inches diameter CHRIS MEIER

↑ *iDrum Nude #2,* 2010, acrylic on cow hide, 22 inches diameter CHRIS MEIER

↑ *Disconnected #2,* 2010, acrylic on elk hide, 20 inches diameter CHRIS MEIER

↑ *Disconnected #3,* 2010, acrylic on elk hide, 24 inches diameter CHRIS MEIER

↑ *Disconnected #4,* 2010, acrylic on elk hide, 18 inches diameter CHRIS MEIER

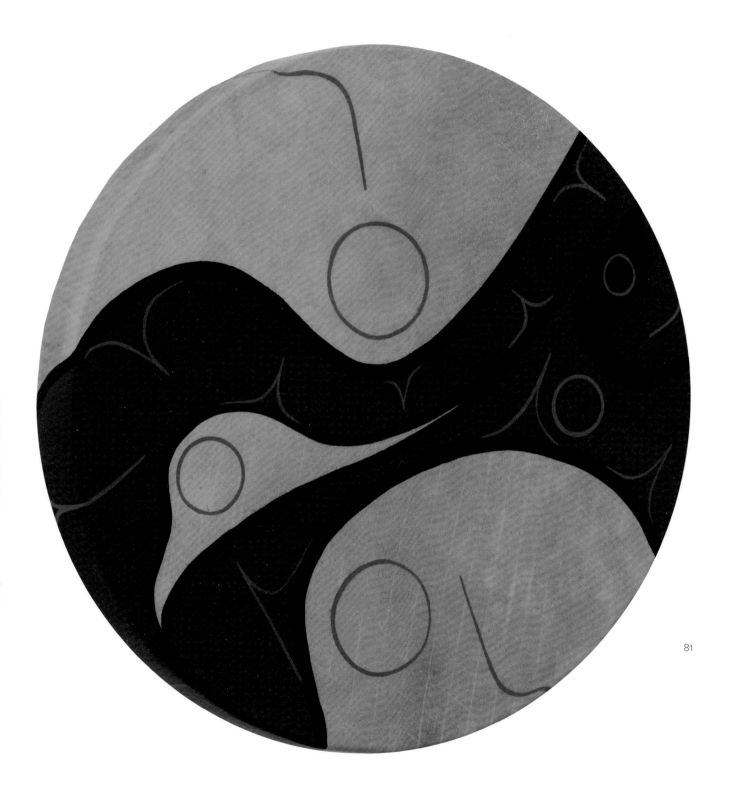

↑ *Disconnected #6,* 2010, acrylic on elk hide, 20 inches diameter CHRIS MEIER

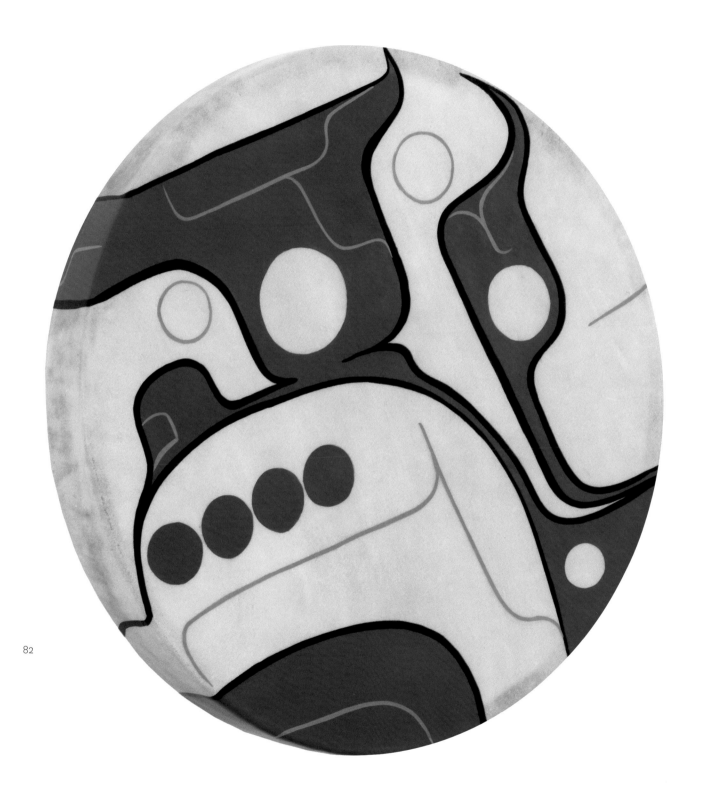

82

↑ *Disconnected #7,* 2010, acrylic on elk hide, 18 inches diameter CHRIS MEIER

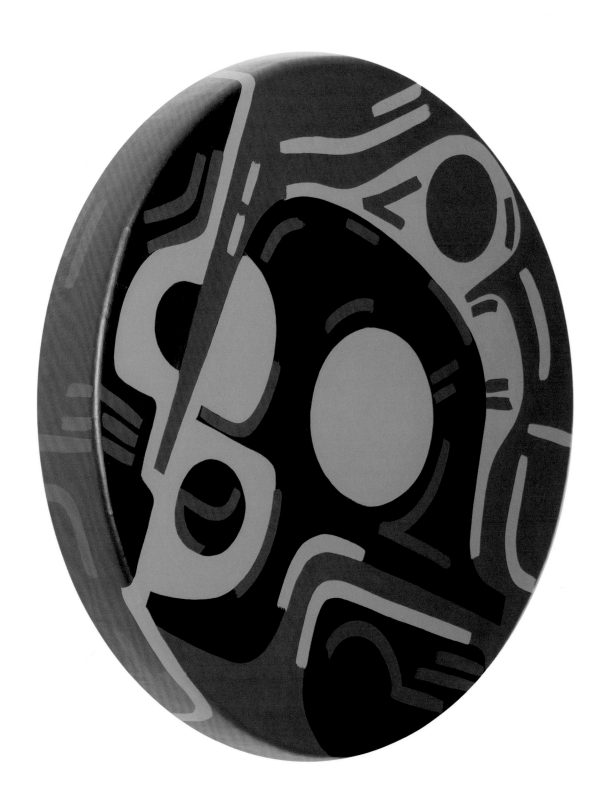

↑ **#PutABirdOnIt,** 2013, acrylic on elk hide, 20 inches diameter DAYNA DANGER

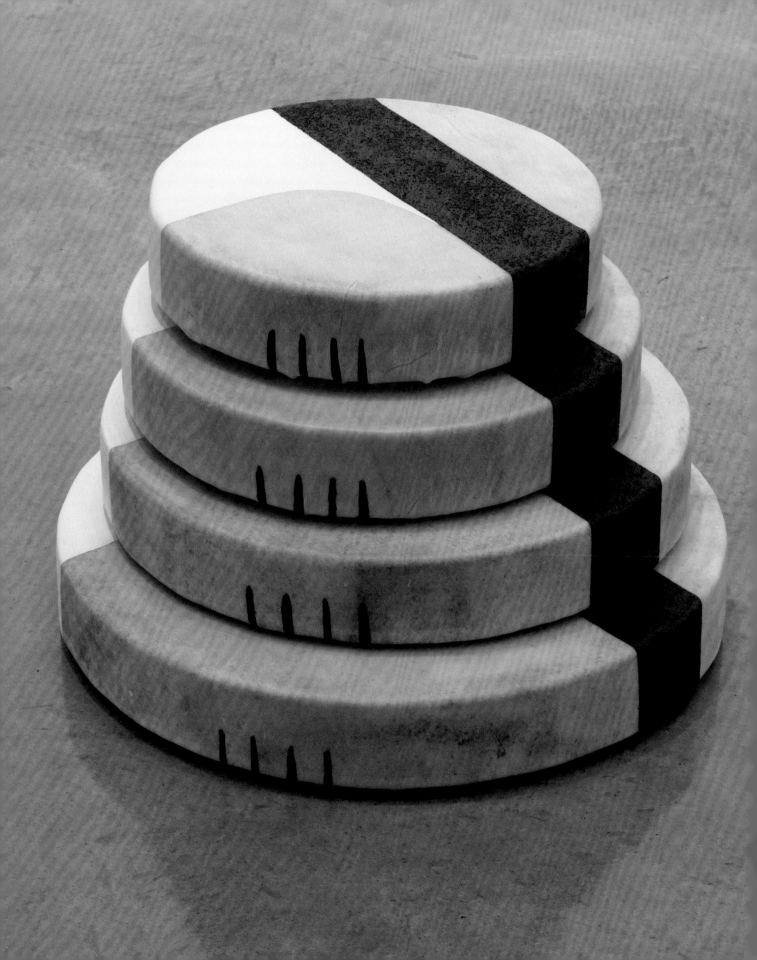

"The Silenced series uses the painted drum as a politically silenced ceremonial object. The drums either lay stacked on the floor or are hung on a wall, allowing the viewer to witness the historical implication of Canada's colonial past."

—**SONNY ASSU,** 2010

← *Silenced #1,* 2010, acrylic on stacked elk-hide drums, 14-, 16-, 18-, and 20-inch diameter drums. Overall dimensions: 11 inches tall x 20 inches diameter CHRIS MEIER

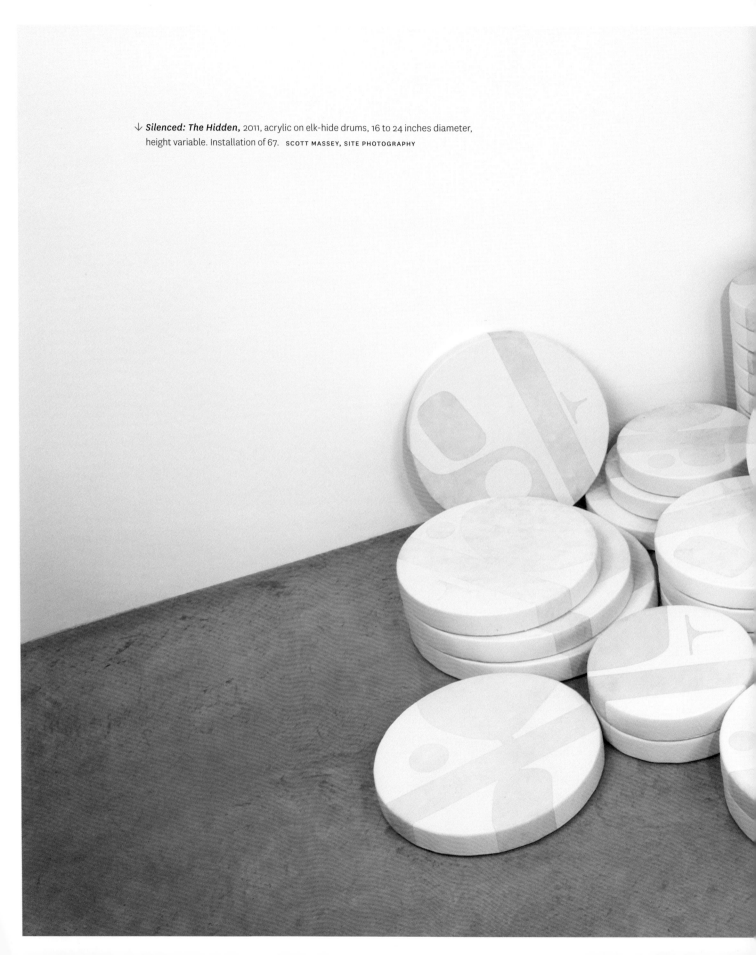

↓ *Silenced: **The Hidden**,* 2011, acrylic on elk-hide drums, 16 to 24 inches diameter, height variable. Installation of 67. SCOTT MASSEY, SITE PHOTOGRAPHY

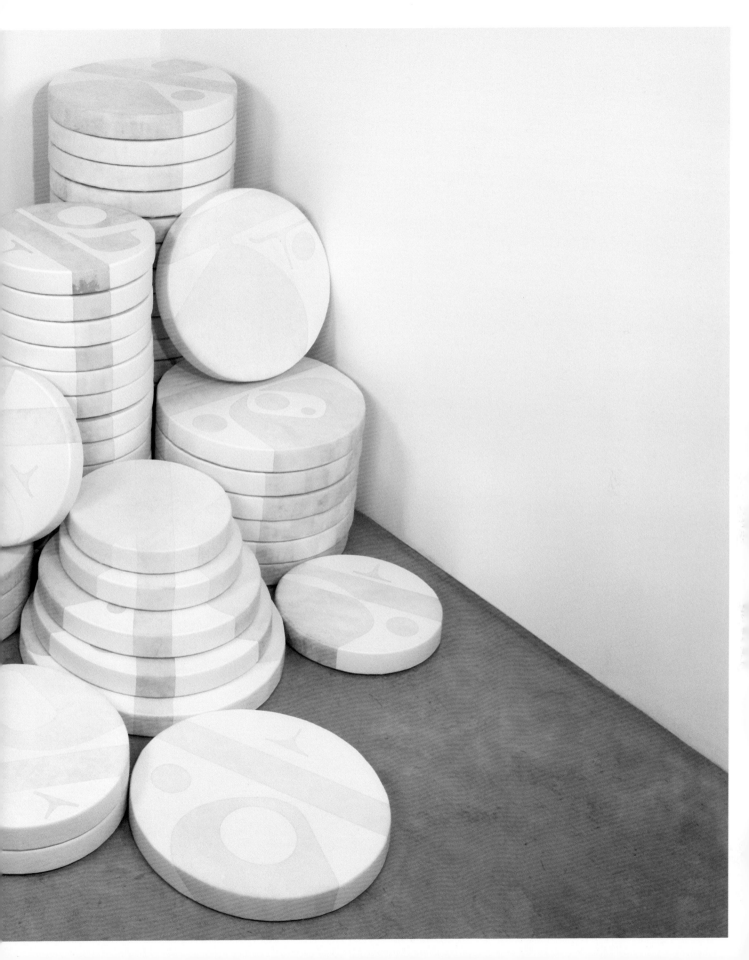

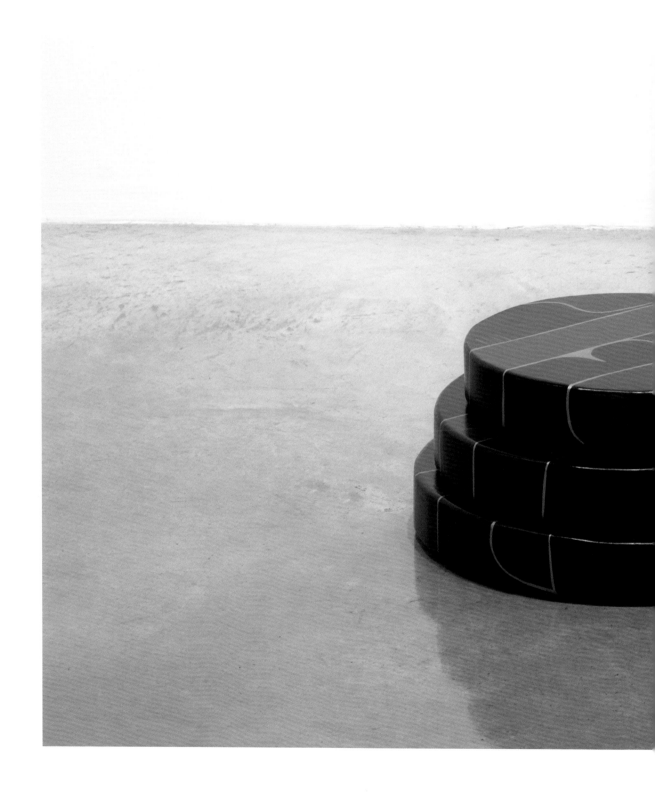

↑ *Silenced #2 & #3* (installation shot), 2010, acrylic on stacked elk-hide drums. Overall dimensions: 11 inches high x 18 inches diameter and 8 inches high x 18 inches diameter CHRIS MEIER

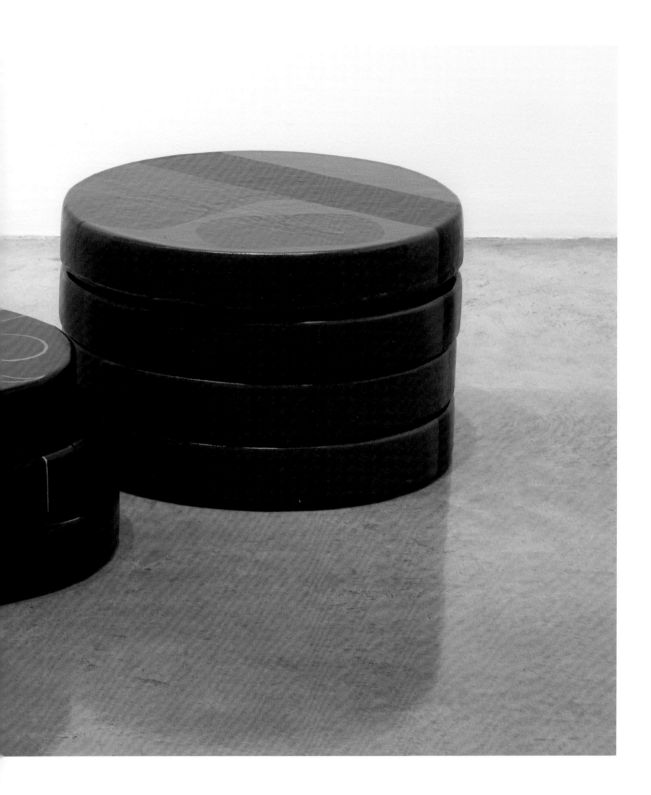

90

↑ *Silenced #4,* 2010, acrylic on elk hide, 22 inches diameter CHRIS MEIER

↑ *Silenced #5,* 2010, acrylic on elk hide, 22 inches diameter CHRIS MEIER

↑ *Longhouse #1,* 2009, acrylic on panel, 30 x 96 inches CHRIS MEIER

"I can read a totem pole or ceremonial
formline and design is a form of written
had not been colonized, the form-
u-shapes—would have developed into a
to Asian character writing or

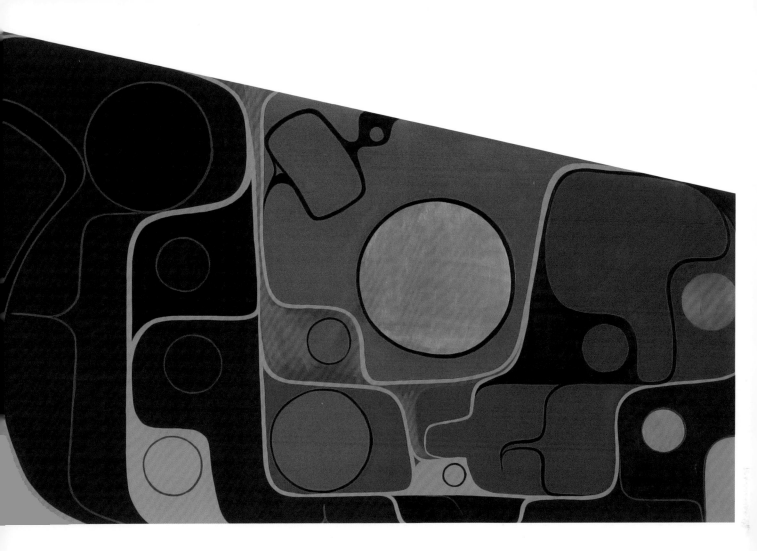

object; thus, Northwest Coast art/
communication. I speculate that if we

line elements—ovoids, s-shapes and

form of written communication akin

Egyptian hieroglyphics." —SONNY ASSU, 2009

↑ ABOVE *Ovoid as Language,* 2009, acrylic on panel,
30 x 96 inches CHRIS MEIER

→ RIGHT *Dialect,* 2010, acrylic on panel,
30 x 96 inches CHRIS MEIER

↑ ABOVE *Consumption,* 2010, acrylic on panel,
 30 x 96 inches CHRIS MEIER

→ RIGHT *Phonology,* 2010, acrylic on panel,
 30 x 96 inches CHRIS MEIER

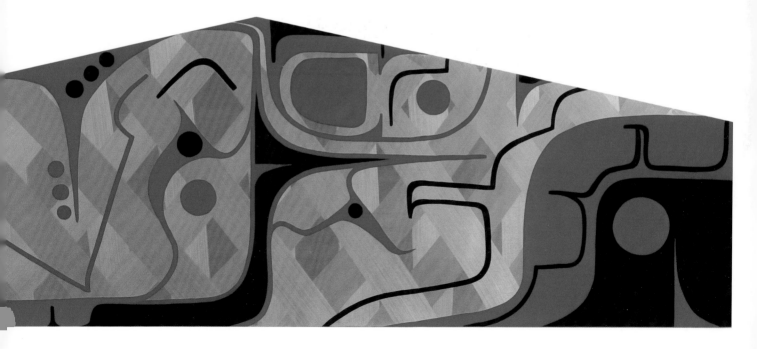

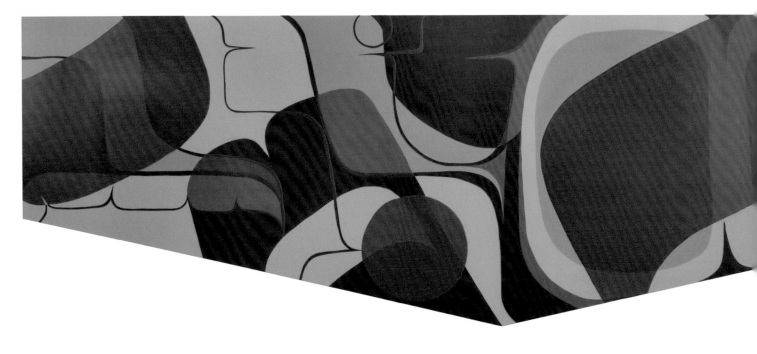

↑ ABOVE *Authentic Aboriginal,* 2010, acrylic on panel,
30 x 96 inches CHRIS MEIER

→ RIGHT *Legacy,* 2015, acrylic on panel,
36 x 96 inches DAYNA DANGER

↑ *Likwala* (diptych), 2013, acrylic on panel,
7.5 x 24 inches and 11.5 x 36 inches DAYNA DANGER

↑ *Feast,* 2015, acrylic on panel,
36 x 96 inches DAYNA DANGER

→ *Boastance,* 2015, acrylic on panel,
36 x 96 inches DAYNA DANGER

↑ *Emanating Dialogue,* 2015, acrylic on panel,
36 x 96 inches DAYNA DANGER

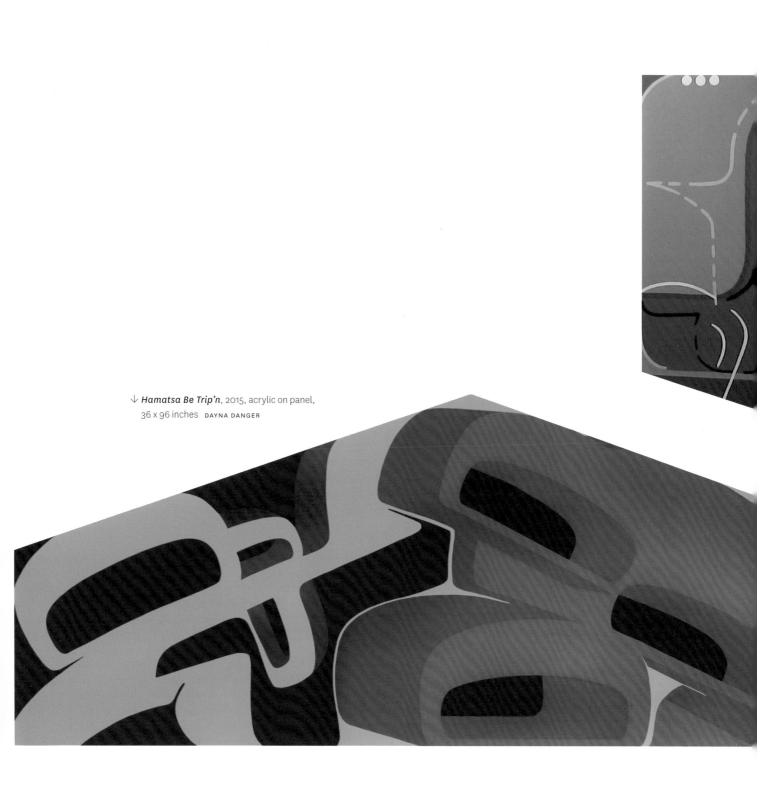

↓ *Hamatsa Be Trip'n*, 2015, acrylic on panel,
36 x 96 inches DAYNA DANGER

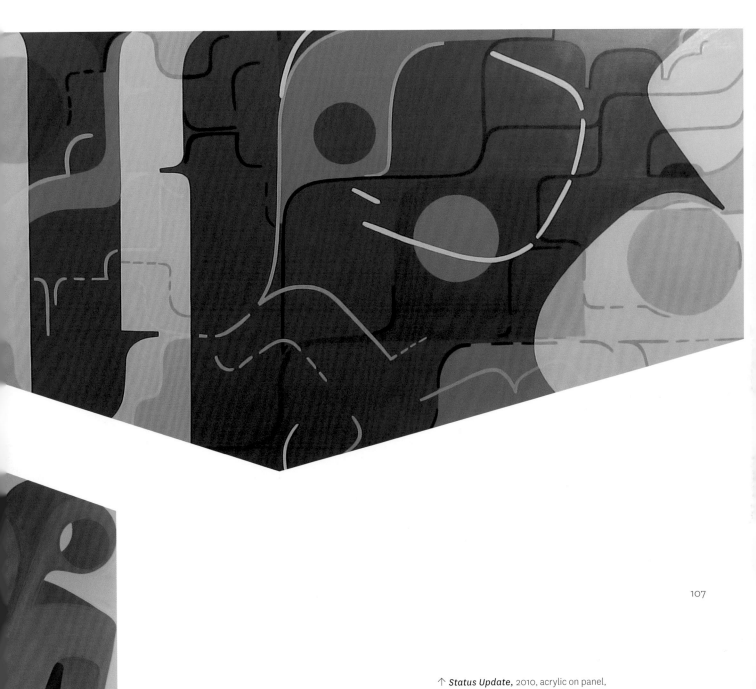

↑ *Status Update,* 2010, acrylic on panel,
40 x 84 inches NATIONAL GALLERY OF CANADA

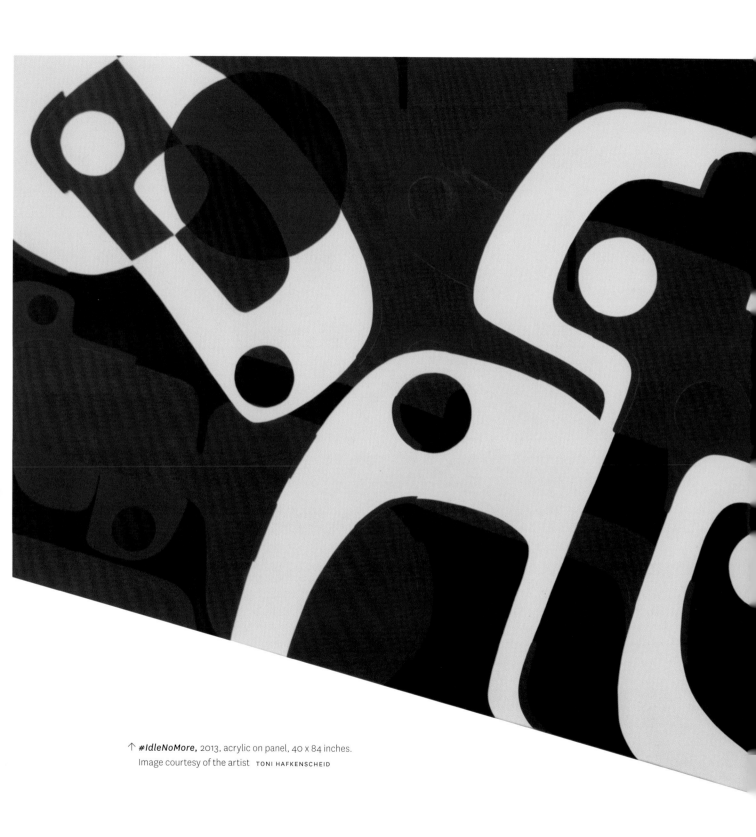

↑ *#IdleNoMore,* 2013, acrylic on panel, 40 x 84 inches.
Image courtesy of the artist TONI HAFKENSCHEID

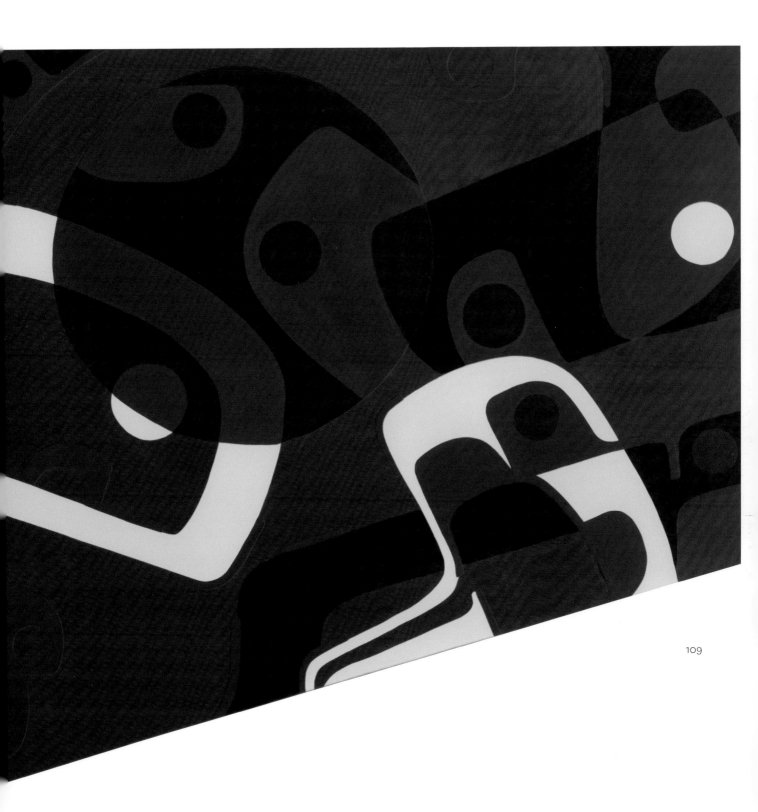

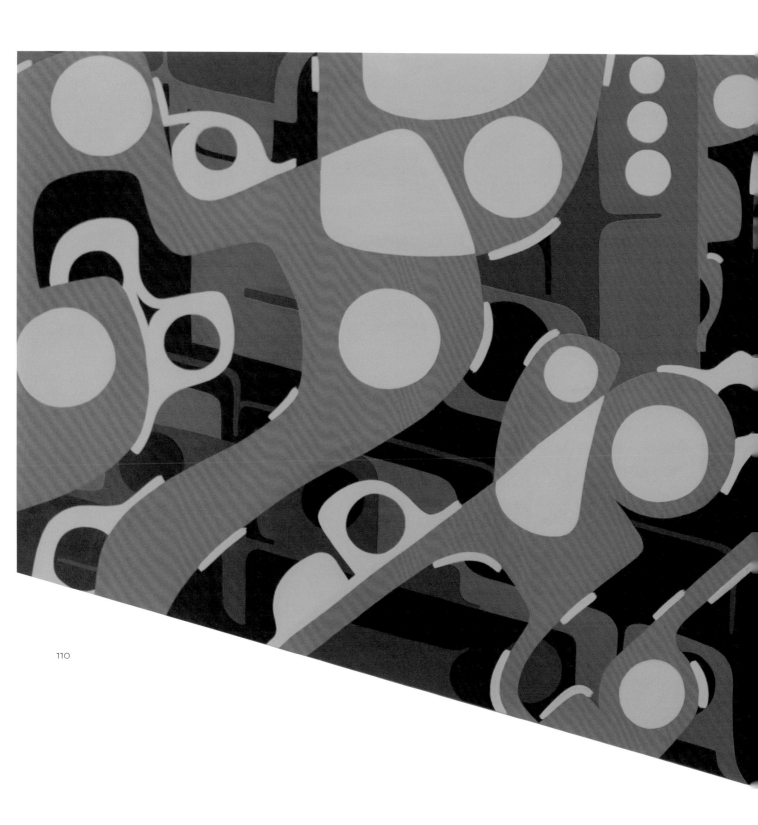

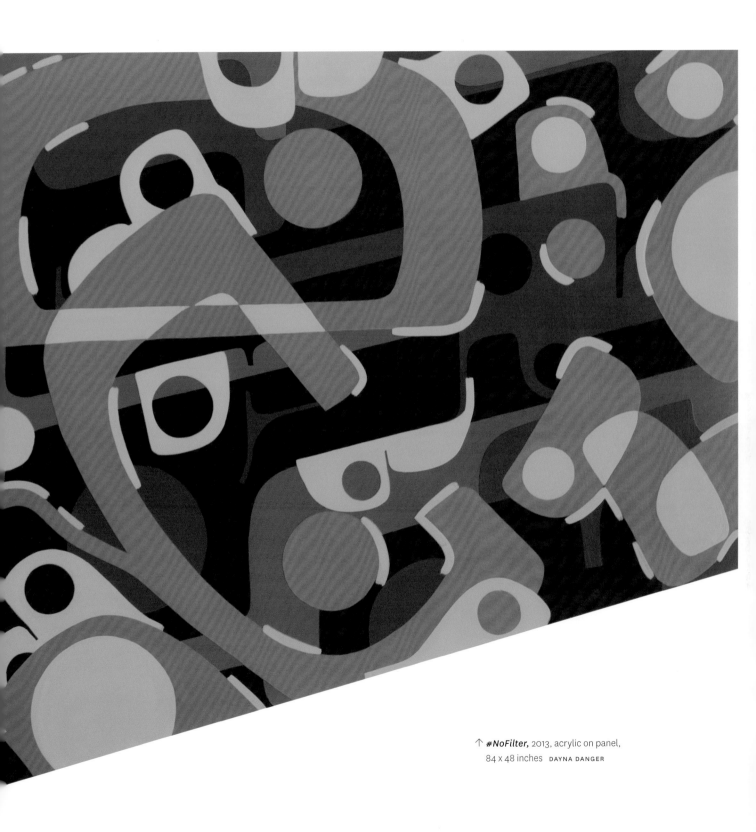

↑ *#NoFilter,* 2013, acrylic on panel,
84 x 48 inches DAYNA DANGER

↑ ABOVE *#PotlatchShadeOfGrey,* 2013, acrylic
on panel, 84 x 48 inches DAYNA DANGER

→ RIGHT *#museumselfie,* 2015, acrylic on panel,
40 x 84 inches DAYNA DANGER

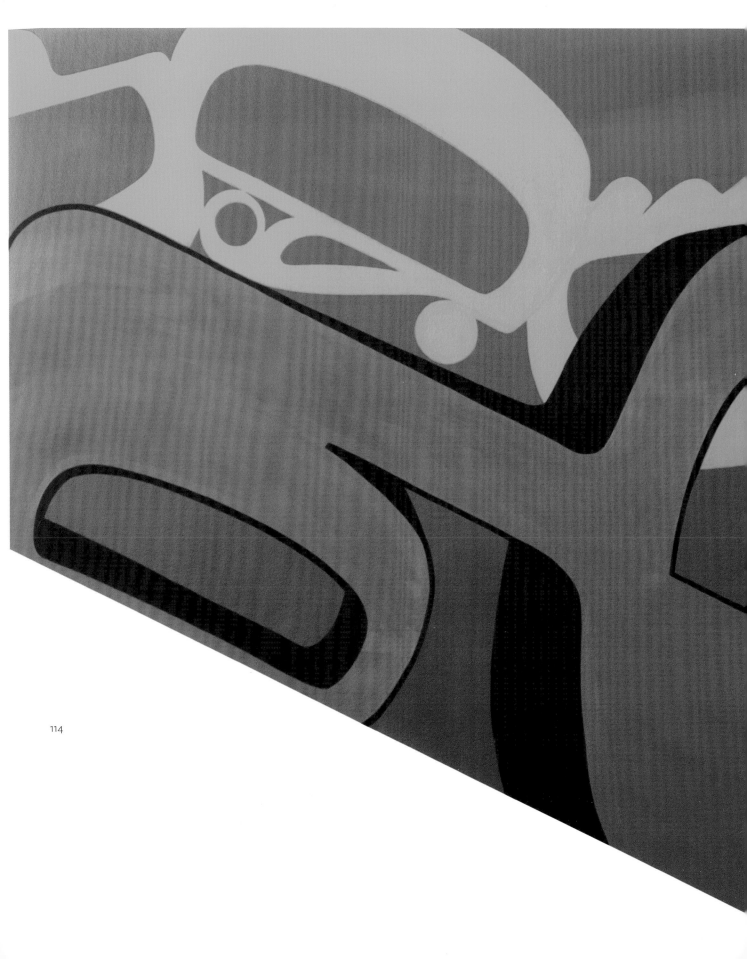

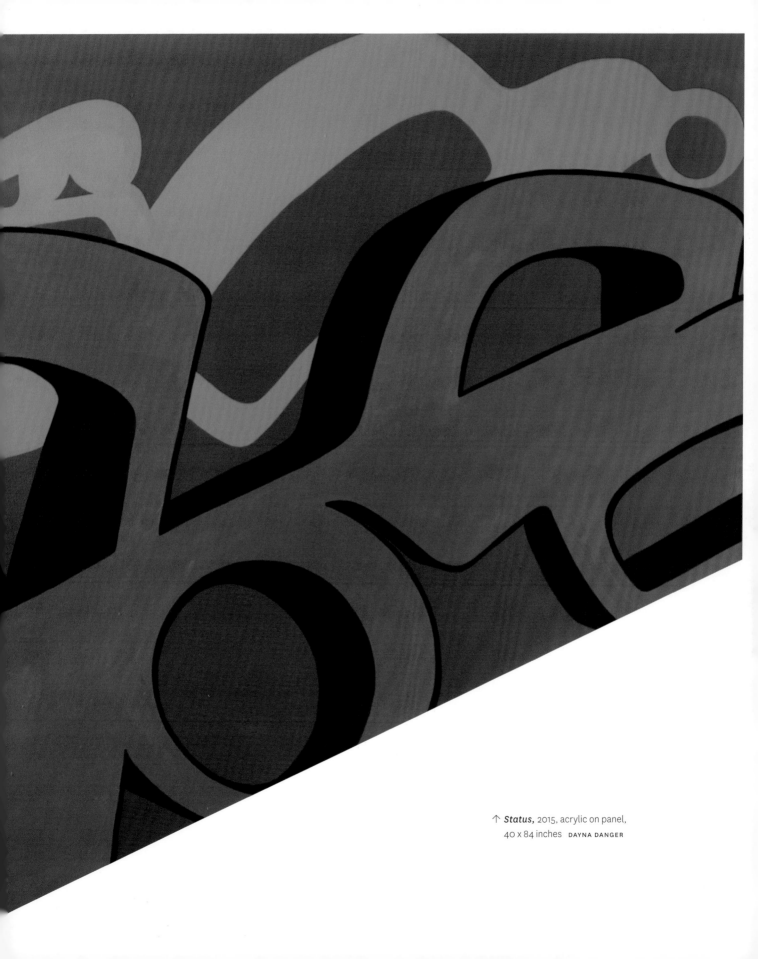

↑ *Status,* 2015, acrylic on panel,
40 x 84 inches DAYNA DANGER

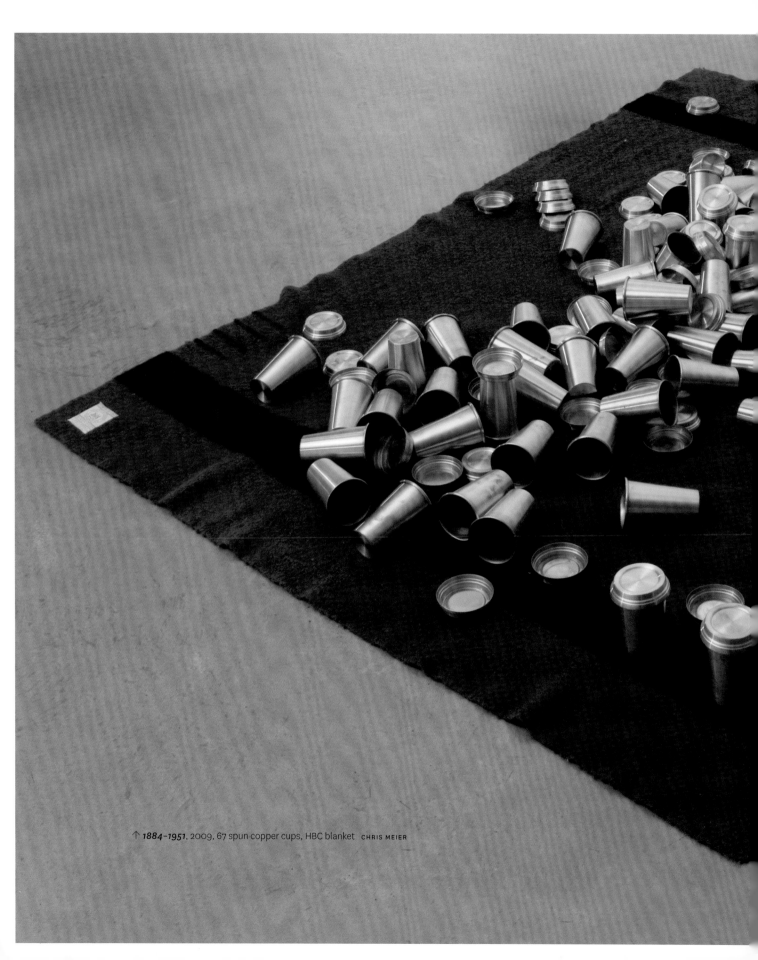

↑ *1884–1951*, 2009, 67 spun copper cups, HBC blanket CHRIS MEIER

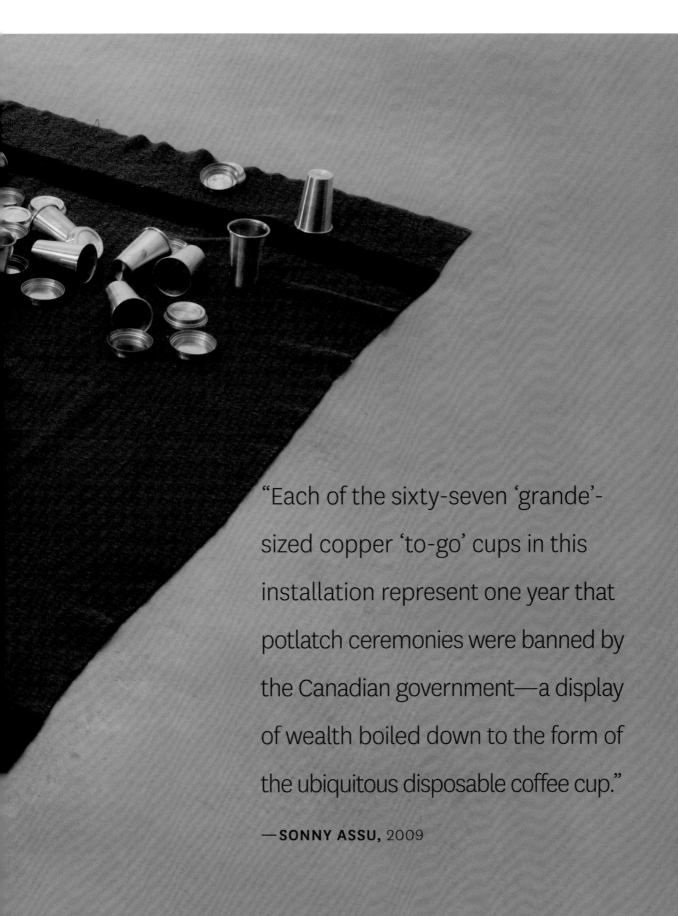

"Each of the sixty-seven 'grande'-sized copper 'to-go' cups in this installation represent one year that potlatch ceremonies were banned by the Canadian government—a display of wealth boiled down to the form of the ubiquitous disposable coffee cup."

—SONNY ASSU, 2009

"The dot-dot-dot of an ellipsis

leaves us hanging, wanting for more.

If we think about an ellipsis in

relation to Canada's actions/inactions against

the First People, what information should

we know that we in fact don't know?

Are there conversations left to

be continued? Has our apathy left us trailing

because of an oppressive bill of law

that is as old as the nation itself?"

—**SONNY ASSU,** 2012

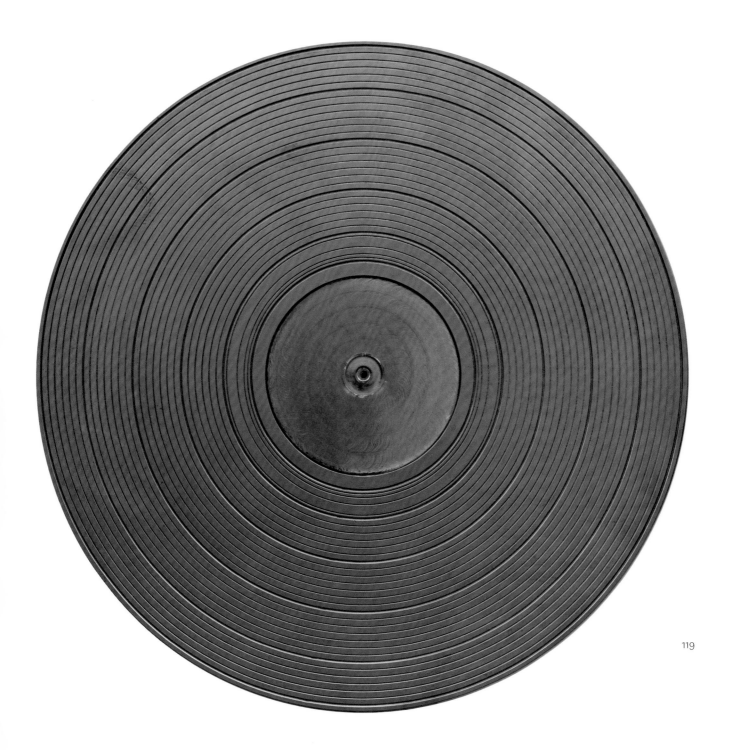

↑ *Ellipsis (detail)*, 2012, copper LPs, 11.75 inches diameter RACHEL TOPHAMN, VANCOUVER ART GALLERY

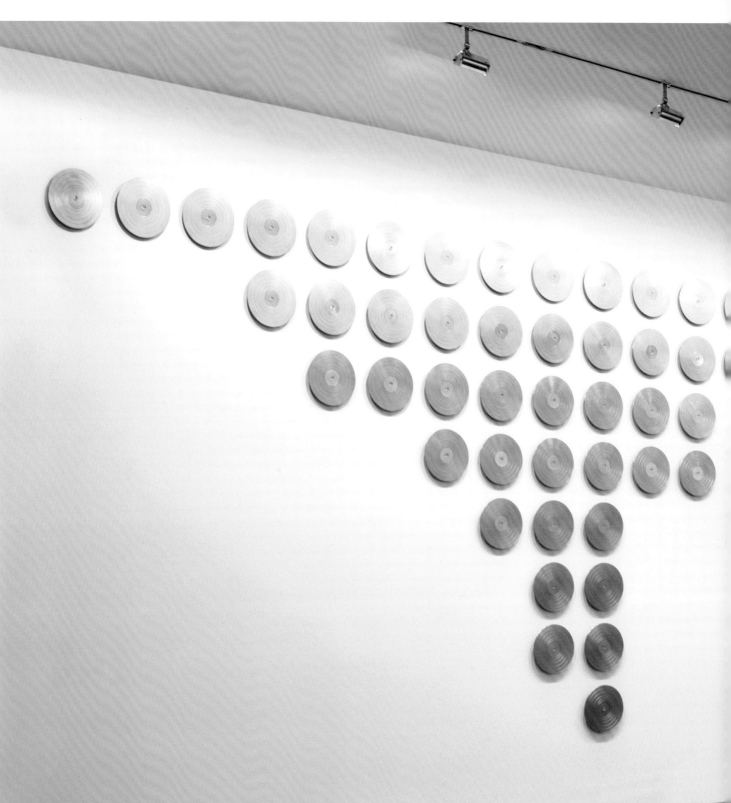

↑ *Ellipsis*, 2012, copper LPs, 11.75 inches diameter each.
Installation of 136. RACHEL TOPHAMN, VANCOUVER ART GALLERY

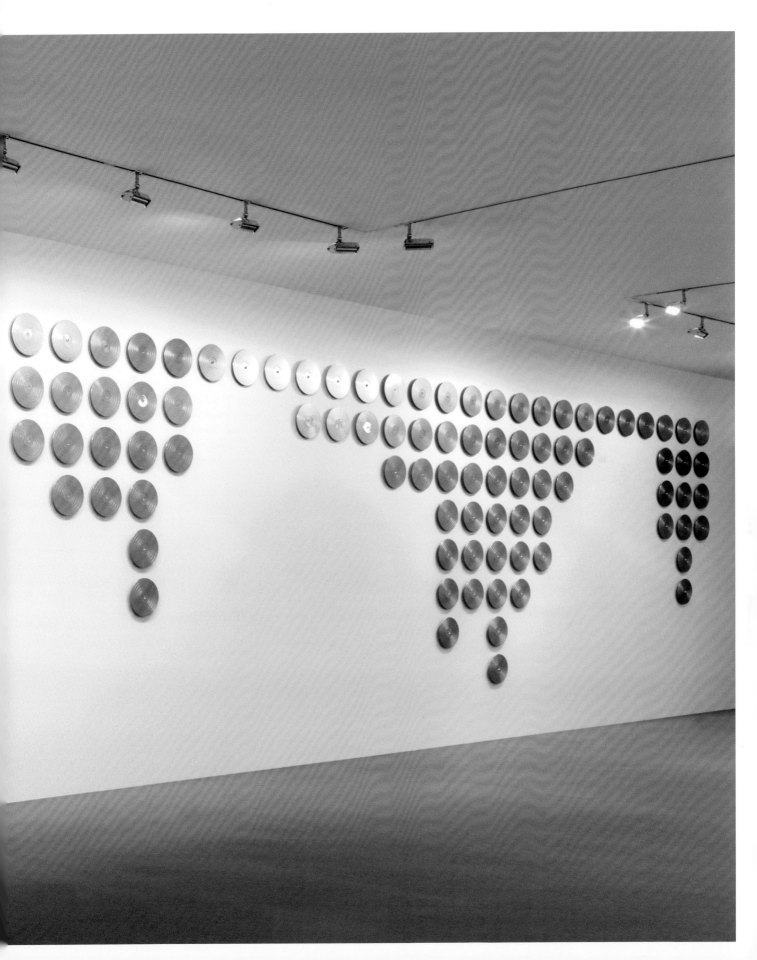

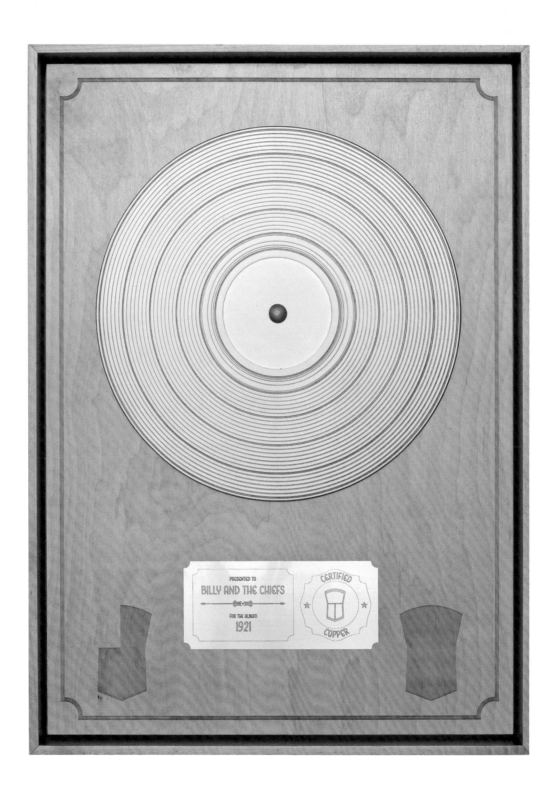

↑ *Gone Copper! (1921),* 2015, copper and maple, 22 x 31 inches EQUINOX GALLERY

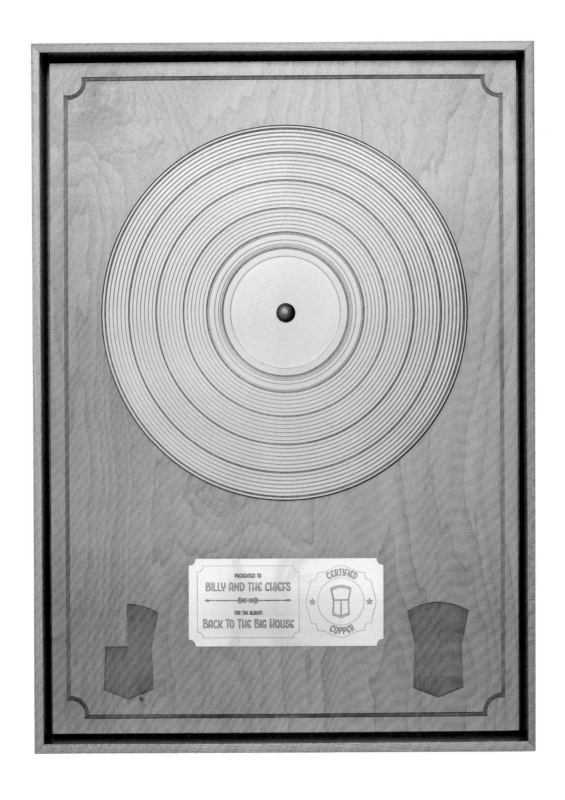

↑ *Gone Copper! (Back to the Big House),* 2015, copper and maple, 22 x 31 inches EQUINOX GALLERY

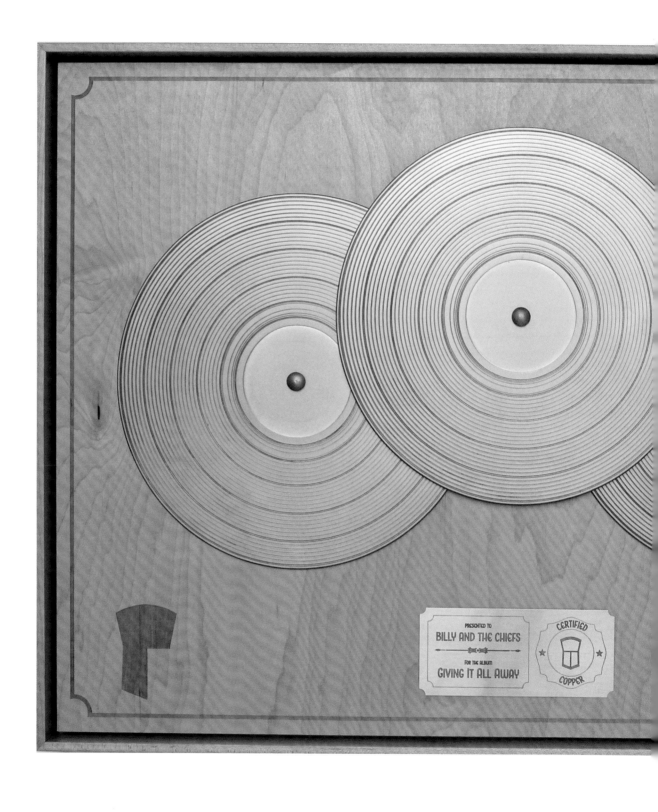

PRESENTED TO
BILLY AND THE CHIEFS
⊱•⊰
FOR THE ALBUM
GIVING IT ALL AWAY

CERTIFIED
★ ★
COPPER

← *Gone Copper! (Giving It All Away),* 2015, copper and maple, 22 x 31 inches EQUINOX GALLERY

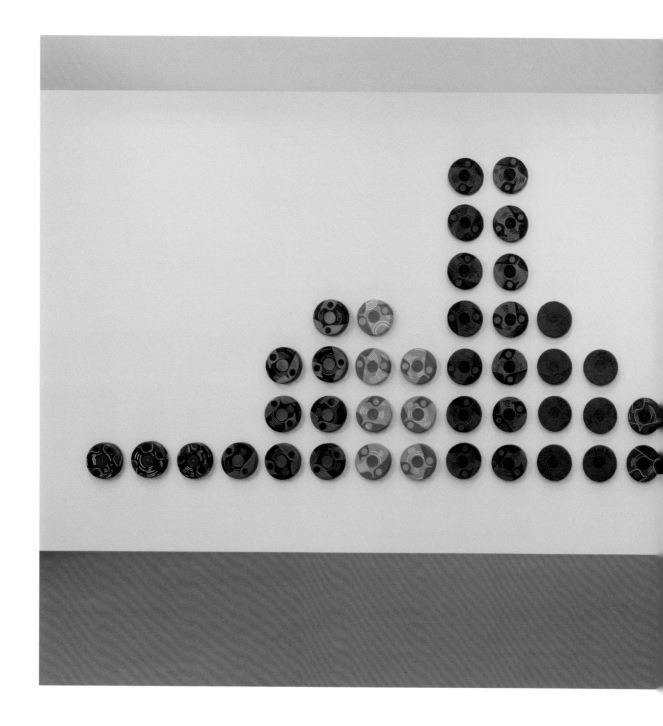

↑ *Billy and the Chiefs: The Compete Banned Collection,* 2012, acrylic on elk-hide drums, 10 and 12 inch diameter. Installation of 67. RACHEL TOPHAMN, VANCOUVER ART GALLERY

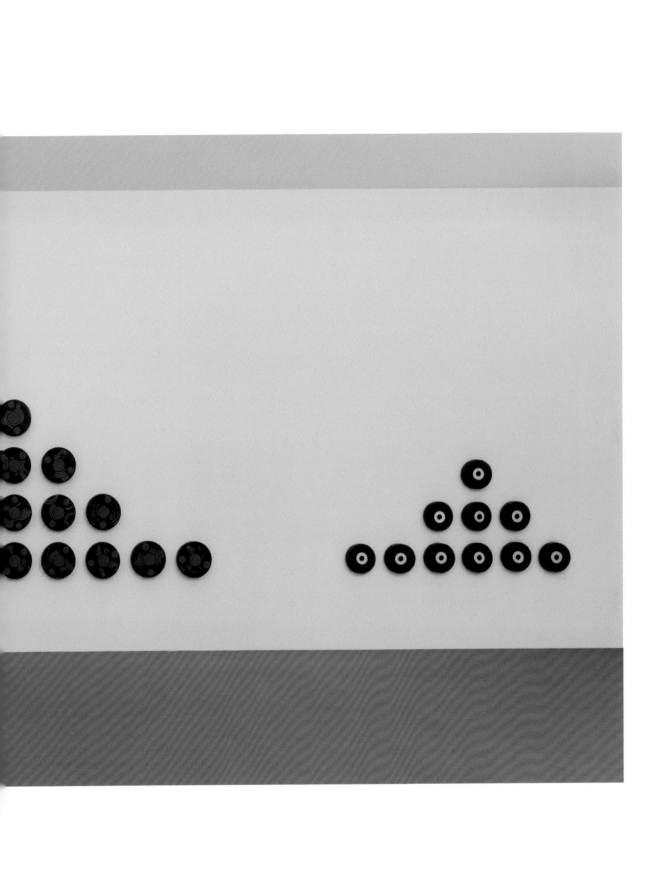

↑ ABOVE *Billy and the Chiefs: Potlatch House #1,* 2013, acrylic on elk hide, wood, 12 inches diameter DAYNA DANGER

→ OPPOSITE TOP *Billy and the Chiefs: Potlatch House #2,* 2013, acrylic on elk hide, wood, 12 inches diameter DAYNA DANGER

OPPOSITE BOTTOM *Billy and the Chiefs: Potlatch House #3,* 2013, acrylic on elk hide, wood, 12 inches diameter DAYNA DANGER

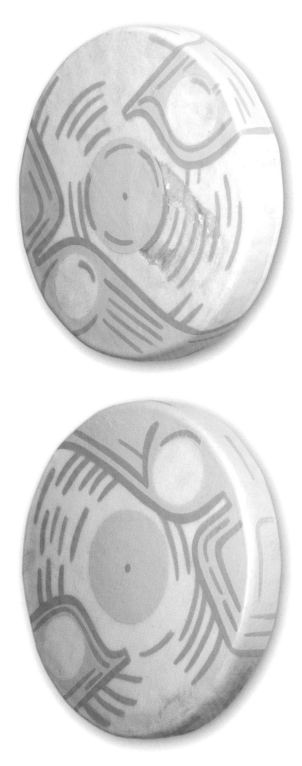

130

↑ TOP *Billy and the Chiefs: Hidden Tracks #1,* 2013, acrylic on elk hide, wood, 12 inches diameter DAYNA DANGER

BOTTOM *Billy and the Chiefs: Hidden Tracks #2,* 2013, acrylic on elk hide, wood, 12 inches diameter DAYNA DANGER

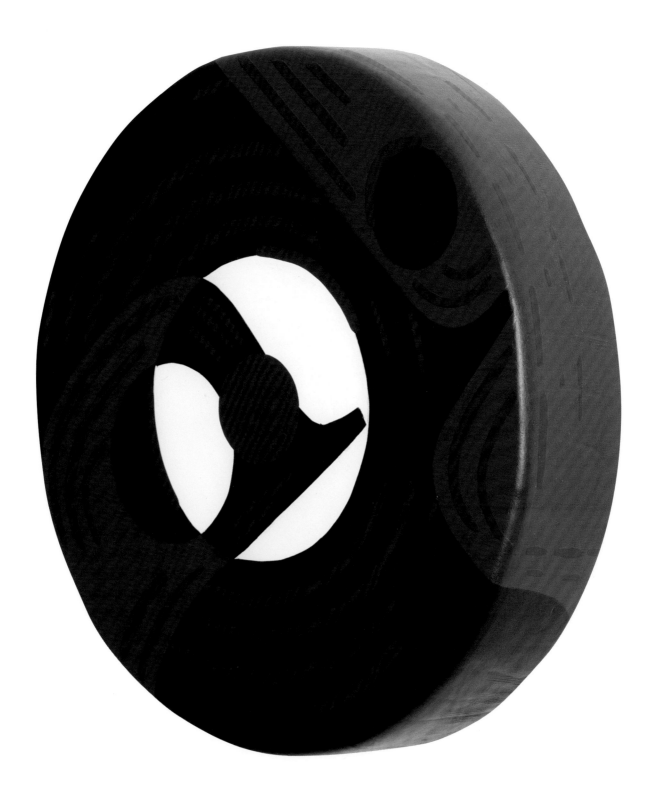

↑ *Billy and the Chiefs: Everybody Do the Round Dance,* 2013, acrylic on elk hide, wood, 12 inches diameter DAYNA DANGER

I want to get rid of the

INDIAN

Problem

*I do not think as a matter of fact, that the country ought to
continuously protect a class of people who are able to stand alone...
Our objective is to continue until there is not a single Indian in Canada
that has not been absorbed into the body politic*

AND **THERE IS NO**

INDIAN

Question

AND **NO**

INDIAN

Department

That is the whole object of this Bill.

Duncan Campbell Scott, Head of the
DEPARTMENT OF INDIAN AFFAIRS
1913 1932

"Some of the most iconic representations of propaganda from the World War eras were the posters used to communicate often hateful and bigoted messages against the enemy or to perpetuate images of unity and conformity for those on the front lines and at home. The speculative nature of this series proposes an avenue for Canadians to support colonialism and the Indian Act, an oppressive bill of subjugation that is still law in Canada today."

—**SONNY ASSU,** 2012

← *Selective History,* 2012, archival pigment print, 30.5 x 40.5 inches SONNY ASSU

THE HAPPIEST FUTURE
FOR THE INDIAN RACE IS
ABSORPTION
INTO THE GENERAL POPULATION
THIS IS THE POLICY OF OUR GOVERNMENT
DUNCAN CAMPBELL SCOTT

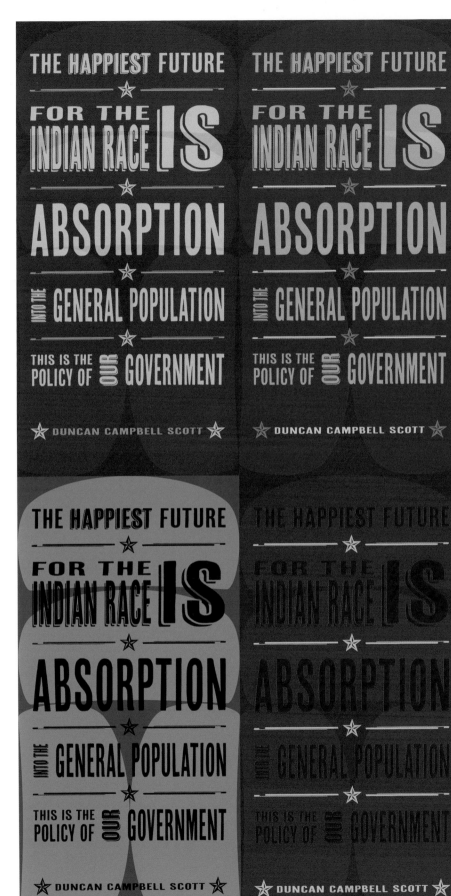

THE HAPPIEST FUTURE
★
FOR THE INDIAN RACE IS
★
ABSORPTION
★
INTO THE GENERAL POPULATION
★
THIS IS THE POLICY OF OUR GOVERNMENT

★ DUNCAN CAMPBELL SCOTT ★

THE HAPPIEST FUTURE
★
FOR THE INDIAN RACE IS
★
ABSORPTION
★
INTO THE GENERAL POPULATION
★
THIS IS THE POLICY OF OUR GOVERNMENT

★ DUNCAN CAMPBELL SCOTT ★

THE HAPPIEST FUTURE
★
FOR THE INDIAN RACE IS
★
ABSORPTION
★
INTO THE GENERAL POPULATION
★
THIS IS THE POLICY OF OUR GOVERNMENT

★ DUNCAN CAMPBELL SCOTT ★

THE HAPPIEST FUTURE
★
FOR THE INDIAN RACE IS
★
ABSORPTION
★
INTO THE GENERAL POPULATION
★
THIS IS THE POLICY OF OUR GOVERNMENT

★ DUNCAN CAMPBELL SCOTT ★

← OPPOSITE, CLOCKWISE FROM TOP LEFT
The Happiest Future #1, The Happiest Future #2, The Happiest Future #3, The Happiest Future #4, The Happiest Future #5, The Happiest Future #6, 2012, archival pigment prints, 18.5 × 36.5 inches SONNY ASSU

← LEFT, CLOCKWISE FROM TOP LEFT
The Happiest Future #8, The Happiest Future #7, The Happiest Future #9, The Happiest Future #10, 2012, archival pigment prints, 18.5 × 36.5 inches SONNY ASSU

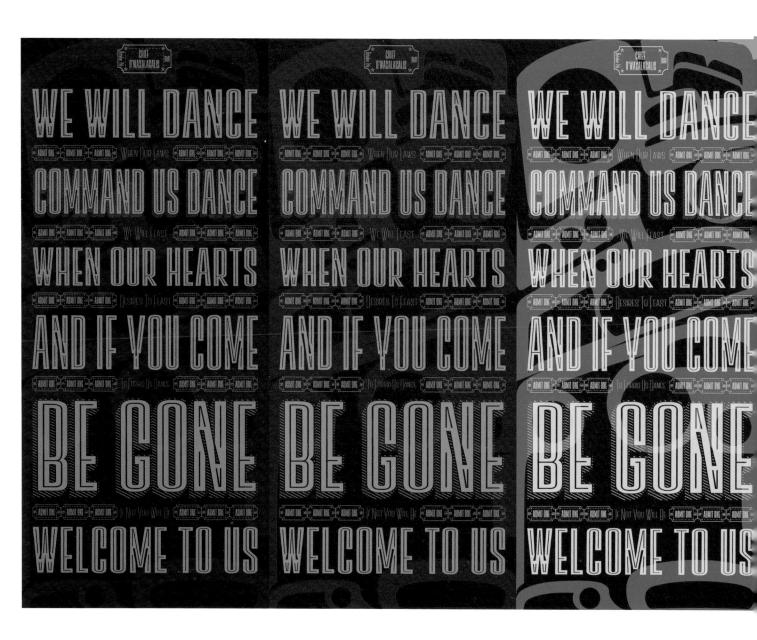

↑ PAGES 136–137, FROM LEFT TO RIGHT *Strict Law V1 #1, Strict Law V1 #2, Strict Law V1 #3, Strict Law V1 #4, Strict Law V1 #5,* 2014, archival pigment prints, 19 x 41 inches SONNY ASSU

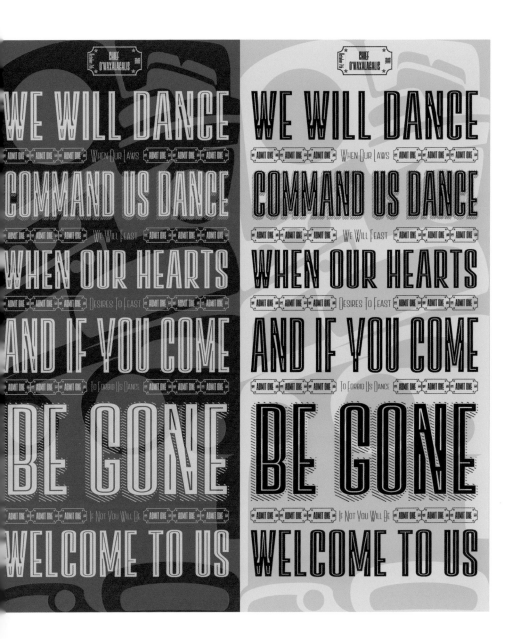

CHIEF O'WAXALAGALIS

WE WILL DANCE
ADMIT ONE ADMIT ONE ADMIT ONE When Our Laws ADMIT ONE ADMIT ONE ADMIT ONE
COMMAND US DANCE
ADMIT ONE ADMIT ONE ADMIT ONE We Will Feast ADMIT ONE ADMIT ONE ADMIT ONE
WHEN OUR HEARTS
ADMIT ONE ADMIT ONE ADMIT ONE Desires To Feast ADMIT ONE ADMIT ONE ADMIT ONE
AND IF YOU COME
ADMIT ONE ADMIT ONE ADMIT ONE To Forbid Us Dance ADMIT ONE ADMIT ONE ADMIT ONE
BE GONE
ADMIT ONE ADMIT ONE ADMIT ONE If Not You Will Be ADMIT ONE ADMIT ONE ADMIT ONE
WELCOME TO US

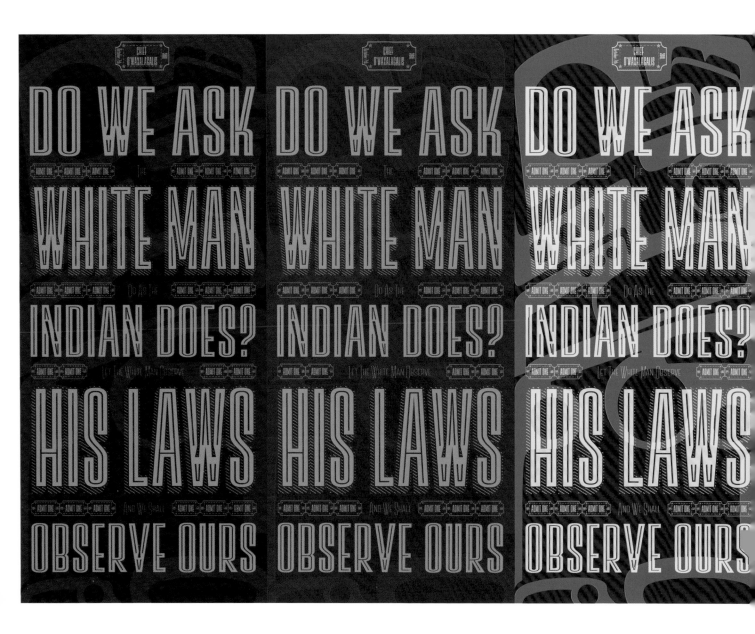

↑ PAGES 138–139, FROM LEFT TO RIGHT *Strict Law V2 #2*, *Strict Law V2 #3*, *Strict Law V2 #4*, *Strict Law V2 #5*, 2014, archival pigment prints, 19 x 41 inches SONNY ASSU

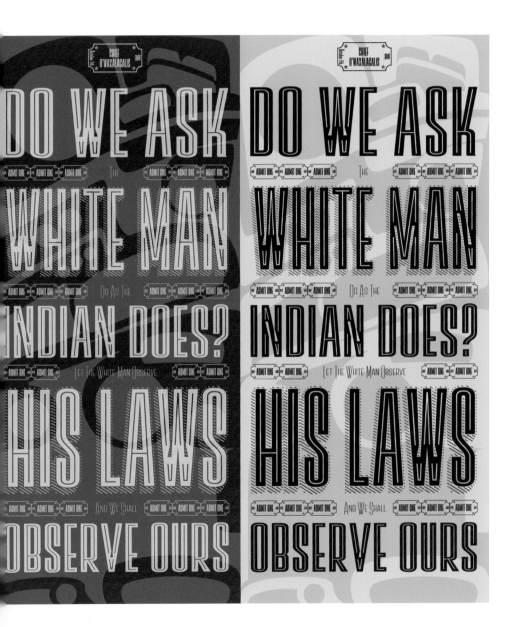

CHIEF O'WAXALAGALIS

DO WE ASK The WHITE MAN Do As The INDIAN DOES? Let The White Man Observe HIS LAWS And We Shall OBSERVE OURS

ADMIT ONE ADMIT ONE ADMIT ONE ADMIT ONE ADMIT ONE ADMIT ONE

ADMIT ONE ADMIT ONE ADMIT ONE ADMIT ONE ADMIT ONE ADMIT ONE

ADMIT ONE ADMIT ONE ADMIT ONE ADMIT ONE

ADMIT ONE ADMIT ONE ADMIT ONE ADMIT ONE ADMIT ONE ADMIT ONE

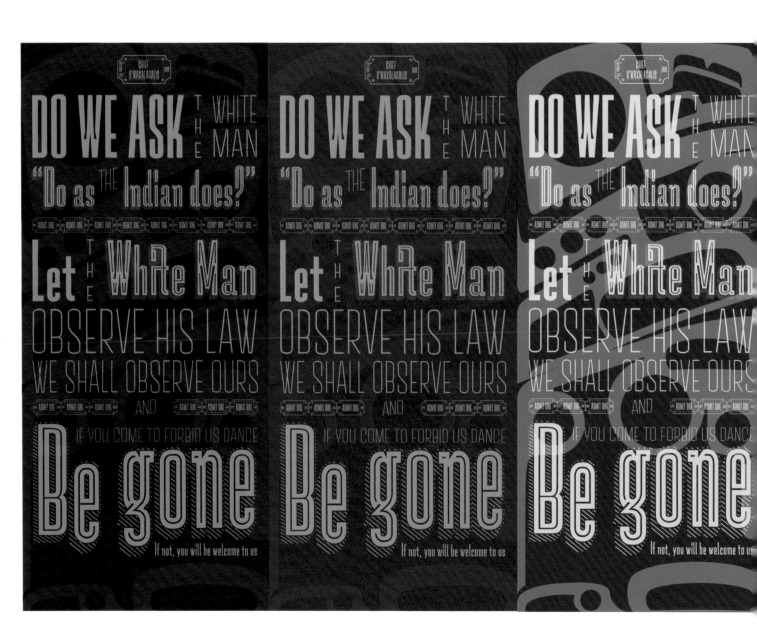

↑ PAGES 140–141, FROM LEFT TO RIGHT *Strict Law V3 #1, Strict Law V3 #2, Strict Law V3 #3,*
Strict Law V3 #5, Strict Law V3 #4, 2014, archival pigment prints, 19 x 41 inches SONNY ASSU

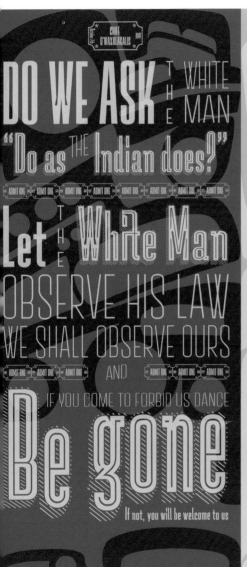
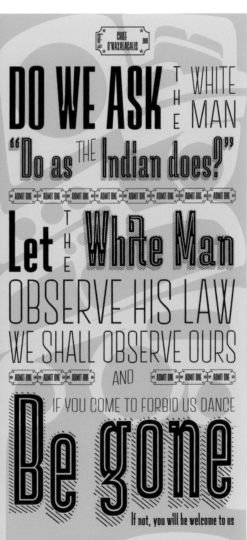

141

"*There Is Hope, If We Rise* was inspired by Shepard Fairey's iconic 'Hope' poster that used the discourse and aesthetics of propaganda imagery to convey a sense of hope to the American people during President Obama's first presidential campaign. My work challenges all Canadians to take a stand to preserve the fabric of this country, while forging a new relationship with the Indigenous peoples."

—**SONNY ASSU,** 2013

→ *There Is Hope, If We Rise #1,* 2013, archival ink on rag paper, 7 x 11 inches SONNY ASSU

ROUND
DANCE

NEVER IDLE

IDLE
NO MORE

IDLE
KNOW MORE

LEARN

TEACH

CHALLENGE
STEREOTYPES

LEAD

CONFRONT

RESIST

DECOLONIZE

← CLOCKWISE FROM TOP LEFT
*There Is Hope, If We Rise
#2, There Is Hope, If We
Rise #3, There Is Hope,
If We Rise #4, There Is
Hope, If We Rise #8 ,
There Is Hope, If We Rise
#9, There Is Hope, If We
Rise #10, There Is Hope,
If We Rise #12, There Is
Hope, If We Rise #11,
There Is Hope, If We Rise
#7, There Is Hope, If We
Rise #6, There Is Hope, If
We Rise #5,* 2013, archival
ink on rag paper, 7 x 11 inches
each SONNY ASSU

(RES)IDENTIAL SCHOOLS

(RES)ERVATION

↑ TOP *Product (Res)#1,* 2013, digital print, 24 x 48 inches

BOTTOM *Product (Res)#2,* 2013, digital print, 24 x 48 inches

↑ TOP *Product (Res)#3,* 2013, digital print, 24 x 48 inches SONNY ASSU

BOTTOM *Product (Res)#4,* 2013, digital print, 24 x 48 inches SONNY ASSU

"These 'masks' have an
inherent beauty: the poetics of a
chainsaw paired with centuries-old growth
rings reveal the wisdom of these once majestic
cedar trees. Each one has a face and story
within—and therefore also an inherent wealth.
The felling of the rainforest enables us to
display wealth in the form of luxury vacation
homes, but we often give little thought to the
waste produced by such affluence."

—**SONNY ASSU,** 2011

→ *Longing #1,* 2011, found cedar and brass, 15.3 x 12 x 8 inches. Photo: 15 x 19.25 inches SCOTT MASSEY, SITE PHOTOGRAPHY

↓ PAGE 150, CLOCKWISE FROM TOP LEFT *Longing #2,* 2011, found cedar and brass, 12 x 14 x 6 inches; *Longing #5,* 2011, found cedar and brass, 12 x 13 x 9.3 inches; *Longing #9,* 2011, found cedar and brass, 13.5 x 12.3 x 8.5 inches; *Longing #7,* 2011, found cedar and brass, 12 x 9.5 x 7.8 inches. Photo: 15 x 19.25 inches SCOTT MASSEY, SITE PHOTOGRAPHY

↓ PAGE 151, CLOCKWISE FROM TOP LEFT *Longing #10,* 2011, found cedar and brass, 12.3 x 13 x 9 inches; *Longing #13,* 2011, found cedar and brass, 17.5 x 13 x 9 inches; *Longing #16, 2011,* found cedar and brass, 16.3 x 12.5 x 6.5 inches; *Longing #14,* 2011, found cedar and brass, 16 x 14 x 7.5 inches. Photo: 15 x 19.25 inches SCOTT MASSEY, SITE PHOTOGRAPHY

"Photographing discarded cedar objects in-situ, the Artifacts of Authenticity series challenges the three eyes of authority placed upon Indigenous arts and culture: the anthropology institution, the commercial art gallery, and the stereotypi-cal tourist trap. Through these images, I use the camera as a conceptual record of authority to capture the cedar objects in circumstances staged solely for the camera."

—**SONNY ASSU,** 2011

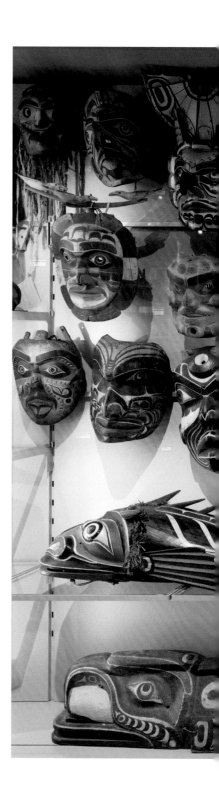

↑ *Museum of Anthropology*, 2011, archival pigment print, 28 x 42 inches ERIC DEIS

↑ PAGES 154–155 *Roberts Gallery and Gifts,*
2011, archival pigment print, 28 x 42 inches
ERIC DEIS

← LEFT *Equinox Gallery,* 2011, archival pigment
print, 42 x 28 inches ERIC DEIS

"The Kwakwa̱ka'wakw peoples place conceptual wealth on objects made of copper and maple, elevating these to a higher status through the actions of high-ranking members of their society. Simply referred to in English as 'a Copper,' such an object gains its conceptual wealth through trade, war, or union."

—SONNY ASSU, 2015

→ OPPOSITE *The Value Of What Goes On Top/The Value of What Goes Within,* 2015, maple plywood, copper leaf, varnish; 6 h x 12 w x 12 d inches; 18 h x 12 w x 12 d inches; 24 h x 12 w x 12 d inches; and 32 h x 12 w x 12 d inches SONNY ASSU

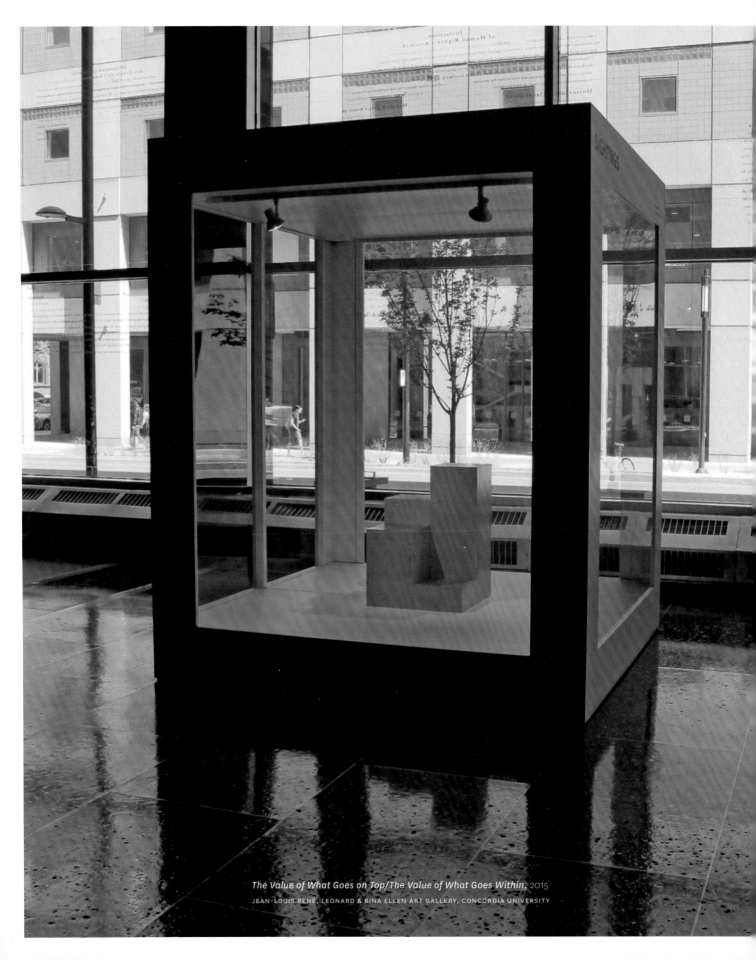

The Value of What Goes on Top/The Value of What Goes Within, 2015
JEAN-LOUIS RENÉ, LEONARD & BINA ELLEN ART GALLERY, CONCORDIA UNIVERSITY

"*The Value of What Goes On Top/ The Value of What Goes Within* was inspired by conversations with community members who have a deep understanding of Kwakw̱aka'wakw art and society prior to European contact. This installation conceptualizes a pre-contact understanding as a pre-colonial gaze, proposing that a pre-colonial observer would question the elevation of ceremonial masks, regalia, and utilitarian objects placed upon a plinth or within other Western modes of ethnographic display. Would this observer assume that the plinth holds the conceptual wealth over the object itself?"

—**SONNY ASSU,** 2015

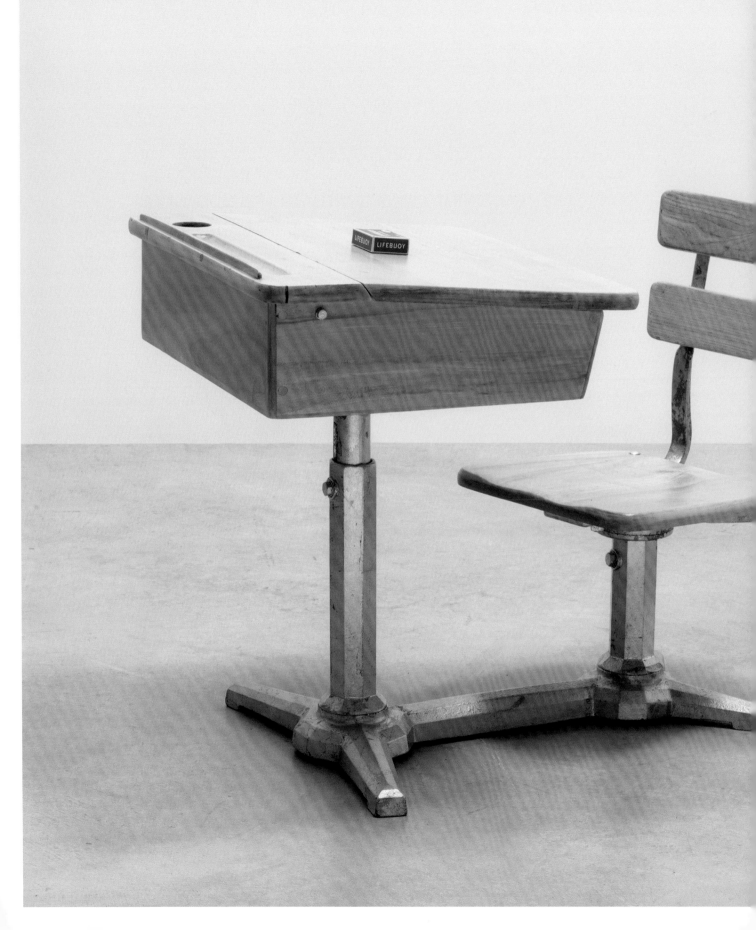

"On her first day of high school, my grandmother was confronted with an instance of racism that haunted her all her life. A boy, whose name she still recalled years later, placed a bar of soap on her desk and had a good laugh with his fellow classmates. Her pride turned to shame, faced with being seen as nothing more than a dirty Indian."

—**SONNY ASSU,** 2013

163

← *Leila's Desk,* 2013, vintage 1930s school desk (wood, metal), vintage Lifebuoy soap, copper leaf, 33 x 22 x 26 inches RACHEL TOPHAM, VANCOUVER ART GALLERY, COLLECTION OF THE VANCOUVER ART GALLERY, PURCHASED WITH PROCEEDS FROM THE AUDAIN EMERGING ARTISTS ACQUISITION FUND

"When I was reflecting upon my grandmother's narrative for *Leila's Desk*, a memory emerged of something I experienced in high school in the early '90s. It was at the precipice of the Oka crisis, national daily news at the time. A boy in my class was running his mouth about 'Indians': the freeloader, the drunk, the dumb. When I spoke up and asserted why I was offended by what he was saying, he perked up with bigoted delight: 'You're a chug!?'"

—SONNY ASSU, 2014

→ *Inherent,* 2014, vintage 1970s school desk (metal, wood), copper leaf, 25 x 19 x 30.5 inches
RACHEL TOPHAM, VANCOUVER ART GALLERY, COLLECTION OF THE VANCOUVER ART GALLERY, PURCHASED
WITH PROCEEDS FROM THE AUDAIN EMERGING ARTISTS ACQUISITION FUND

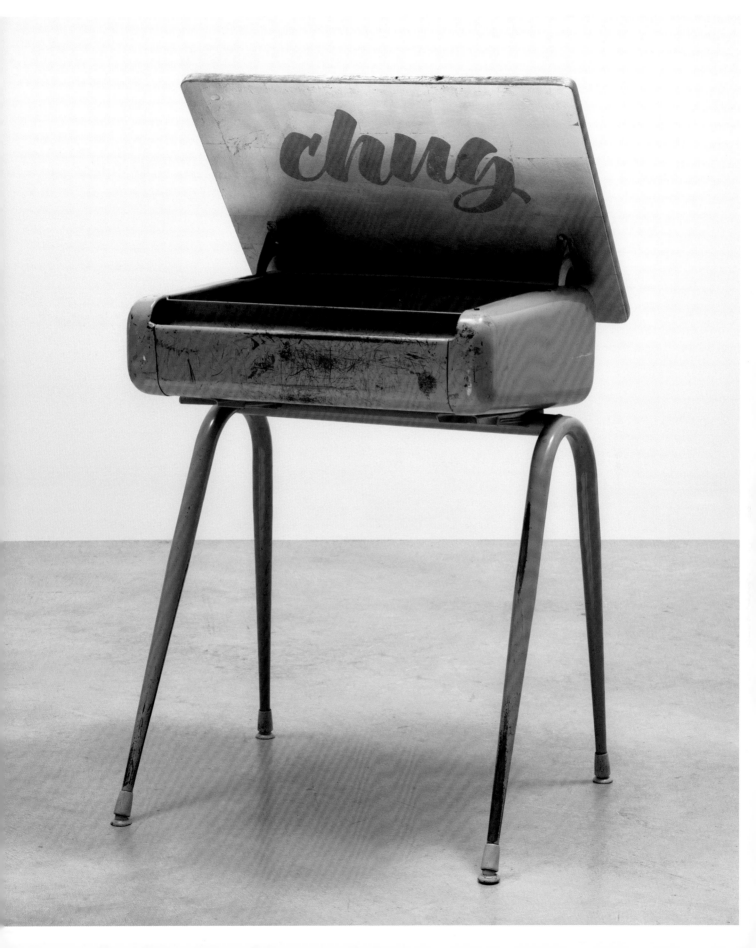

"The Interventions on the Imaginary series challenges the colonial fantasy of terra nullius and confronts the dominant colonial culture's continued portrayal of Indigenous peoples as a vanishing race. With the insertion of ovoids, s-shapes, and u-shapes into the images, both the landscape paintings and the Northwest Coast design elements are changed. The landscapes become marked by the spectre of Indigenous presence, and the Northwest Coast design elements—traditionally two-dimensional in appearance—acquire the illusion of depth through association with Western principles of perspective. I see these bold interruptions of the landscapes as acts of resistance towards the colonial subjugation of the First People."

—SONNY ASSU, 2014

→ *What a Great Spot for a Walmart!,* 2014, digital intervention on an Emily Carr painting (*Graveyard Entrance, Campbell River*, 1912), archival pigment print, 22.5 x 33.25 inches SONNY ASSU

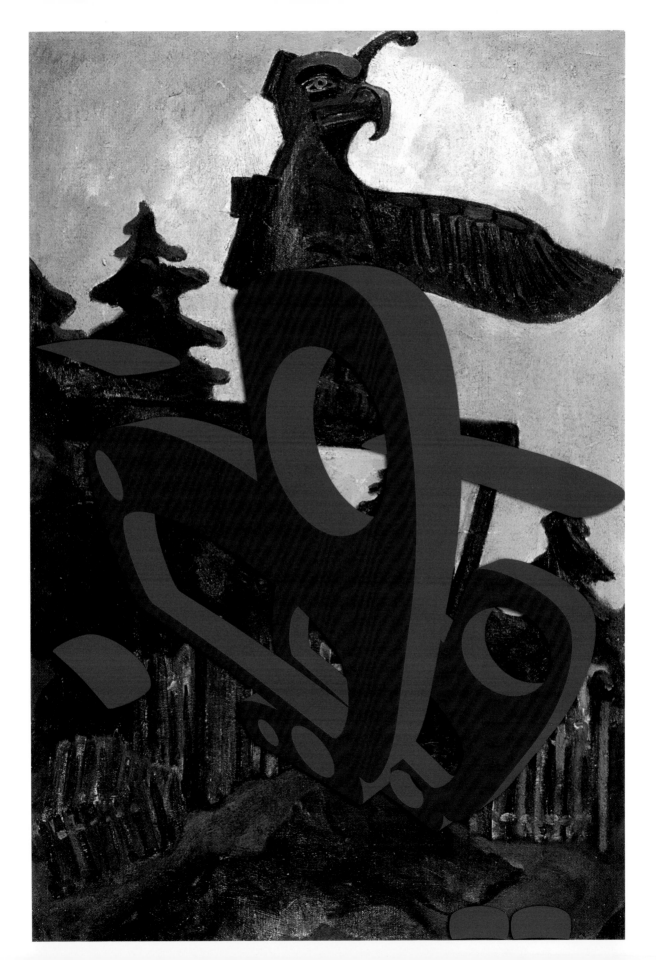

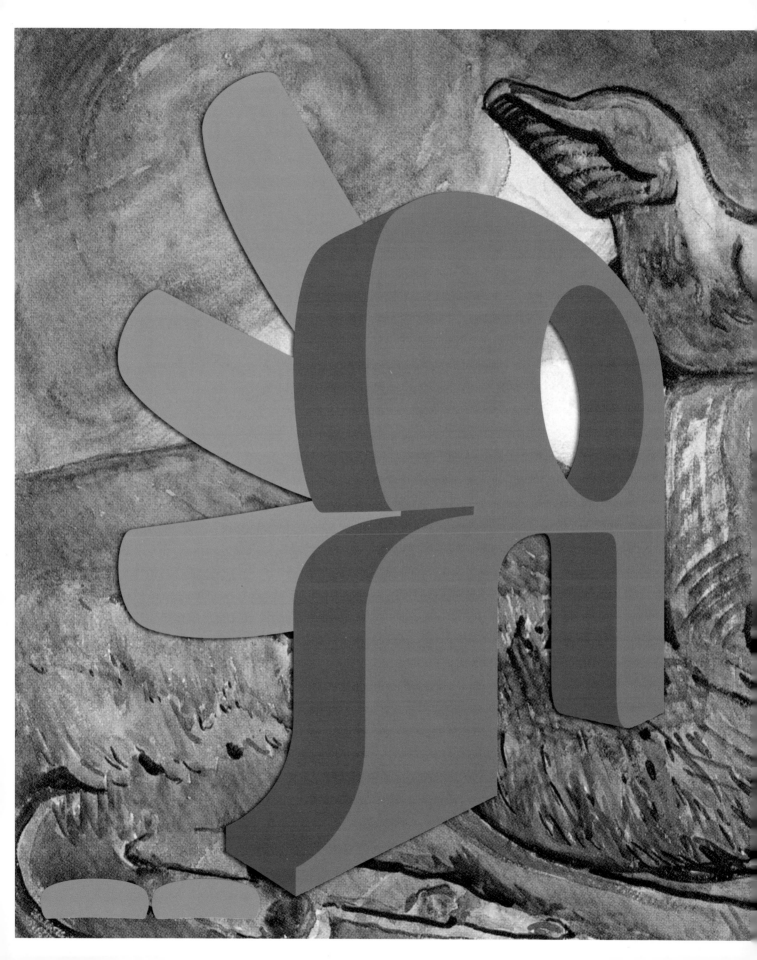

← *It was, like, a super long time ago that ppl were here, right?,* 2014, digital intervention on an Emily Carr painting (*Cumshewa*, 1912), archival pigment print 32.5 x 22.5 inches
SONNY ASSU

"*Choke on an Ovoid* is a tribute to Lawrence Paul Yuxweluptun's deep and ever-expanding body of work that combats the colonial white-washing of Canadian history. But it also acts as a nod to Carr, who had a genuine interest in recording the daily lives and places of a diverse group of people she greatly admired."

—**SONNY ASSU,** 2014

→ OPPOSITE *Choke on an Ovoid,* 2014, digital intervention on an Emily Carr painting (*Strangled by Growth*, 1931), archival pigment print, 22.5 x 29.25 inches SONNY ASSU

↓ PAGE 172 *We Come to Witness,* 2014, digital intervention on an Emily Carr painting (*Silhouette No. 2*, 1930), archival pigment print, 22.5 x 34 inches SONNY ASSU

PAGE 173 *"The only thing more pathetic than Indians on TV is Indians watching Indians on TV."—Thomas Builds-the-Fire,* 2015, digital intervention on an Emily Carr painting (*Street, Alert Bay*, 1912), archival pigment print, 22 x 30 inches SONNY ASSU

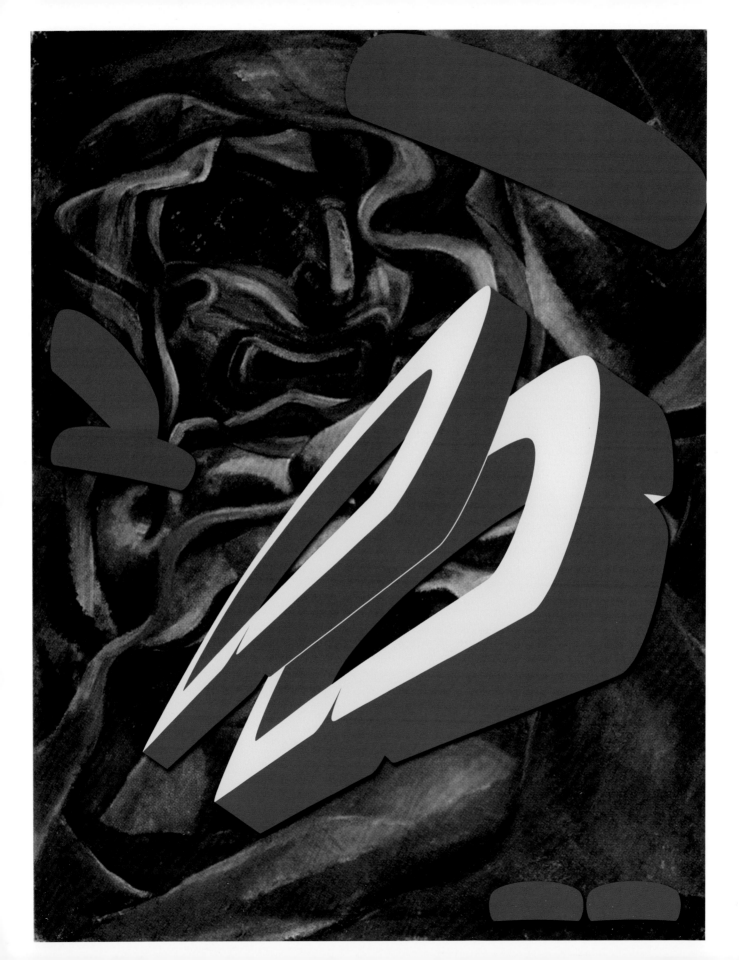

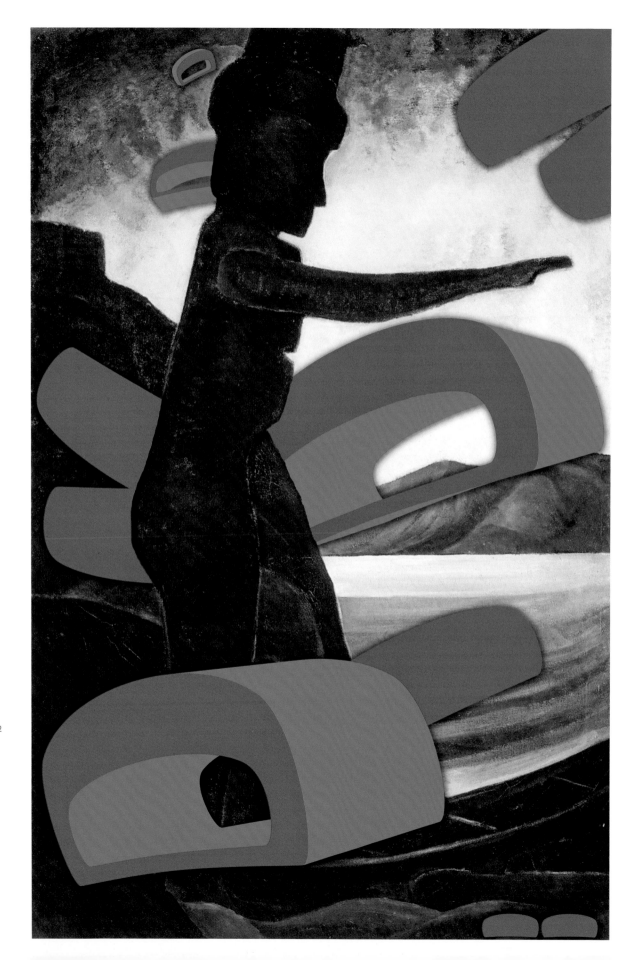

172

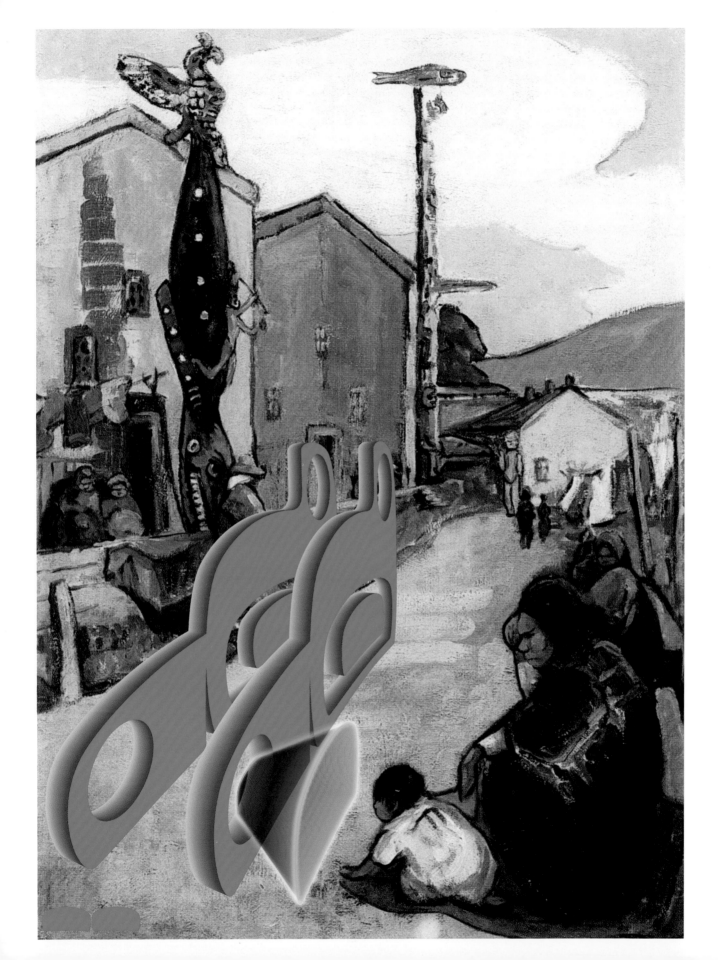

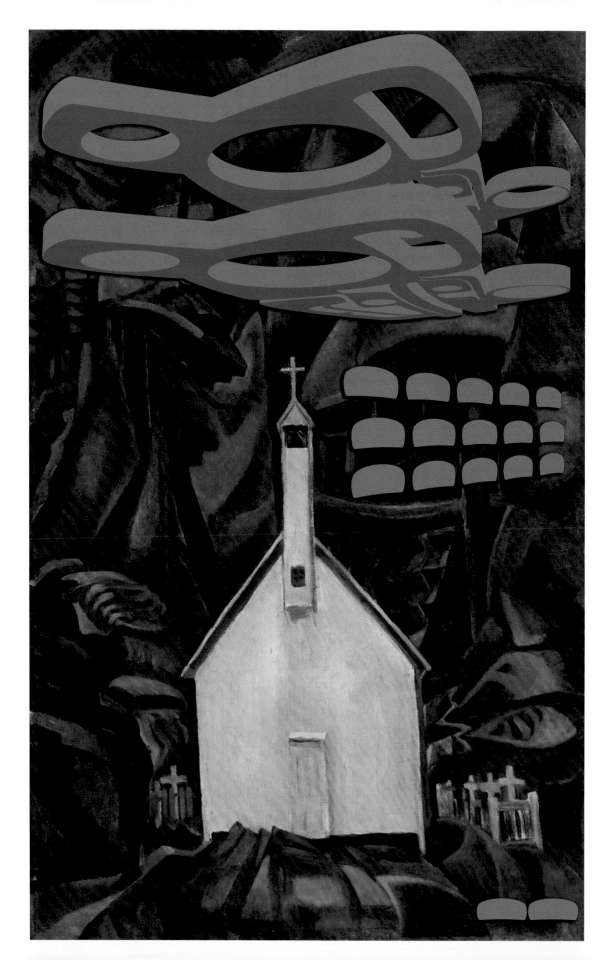

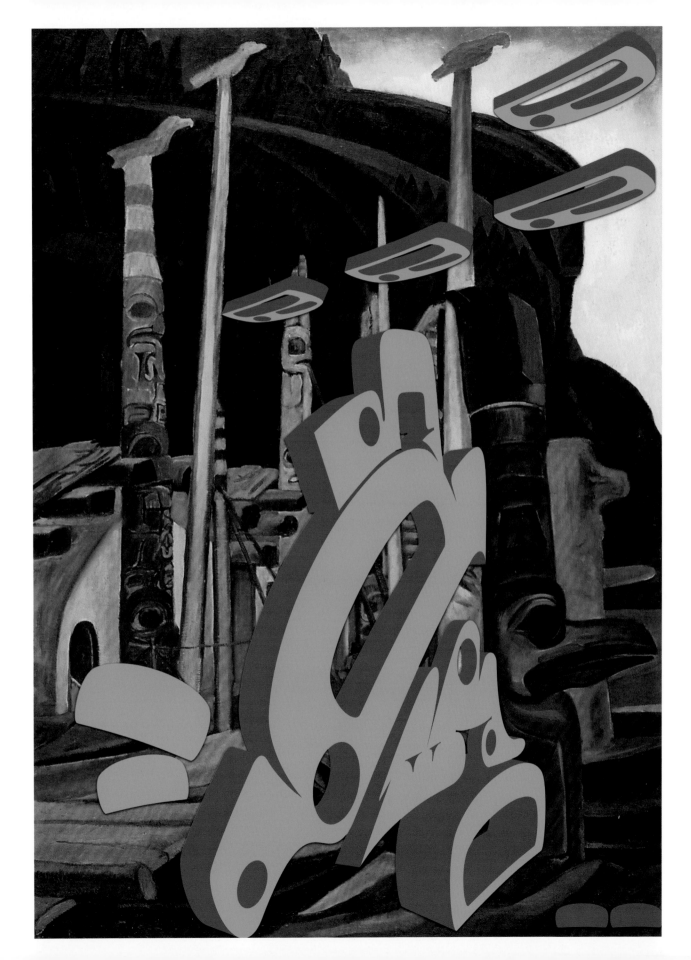

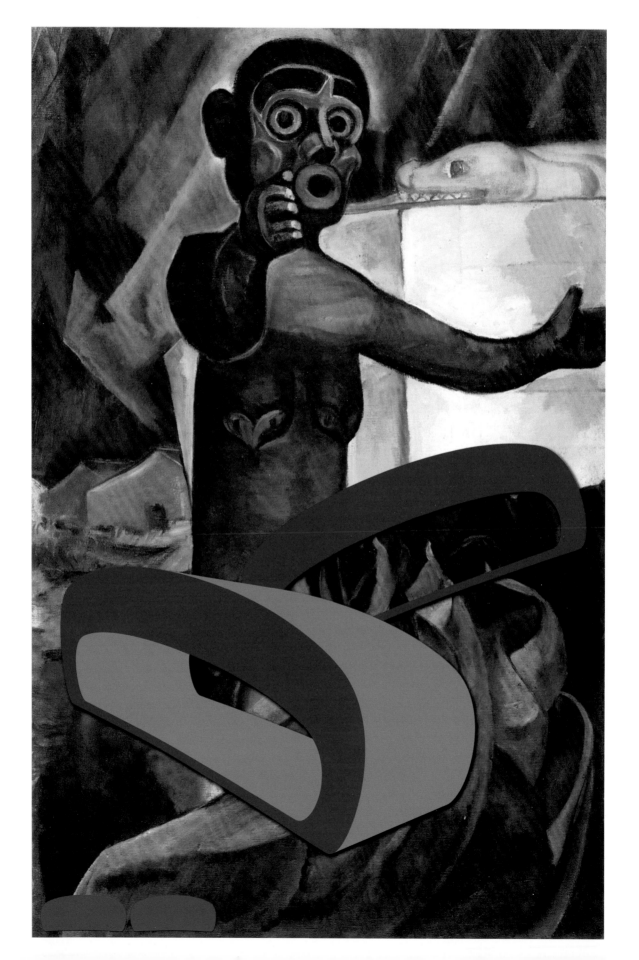

"I see the ovoid as having a presence. From a traditionally informed Kwakwa̱ka'wakw perspective, the ovoid is but one part of a whole. It comes together with the s-shapes, u-shapes, and formline to create culturally significant narratives. Through this intervention, as in many of the images in this series, the ovoid itself demands a presence. It not only acts as a 'tag' or a 'UF-Ovoid' to disrupt the colonial narrative, but it forcibly asserts and inserts itself into the conversation as an entity unto its own."

—SONNY ASSU, 2014

← PAGE 174 *Re-invaders,* 2014, digital intervention on an Emily Carr painting (*Indian Church*, 1929), archival pigment print, 22.5 x 35.5 inches SONNY ASSU

PAGE 175 *Spaced Invaders,* 2014, digital intervention on an Emily Carr painting (*Heina*, 1928), archival pigment print, 22.5 x 31.5 inches SONNY ASSU

OPPOSITE *#photobombing the Dzunu̱k'wa. She's gonna be mad.,* 2014, digital intervention on an Emily Carr painting (*Guyasdoms D'Sonoqua*, 1930), archival pigment print, 22.5 x 34.5 inches SONNY ASSU

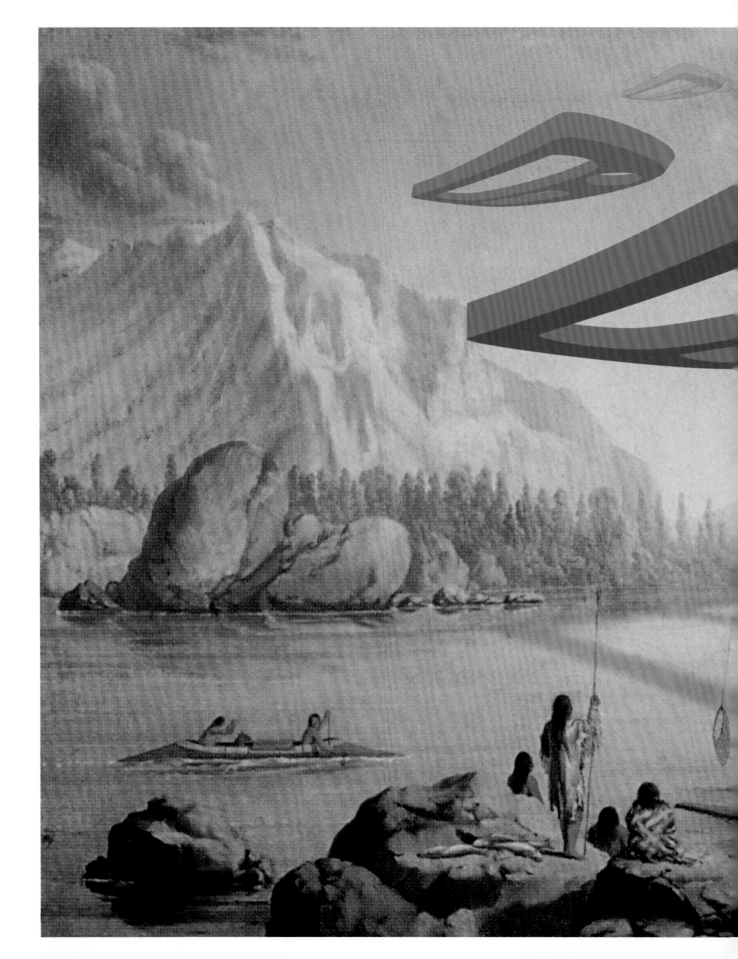

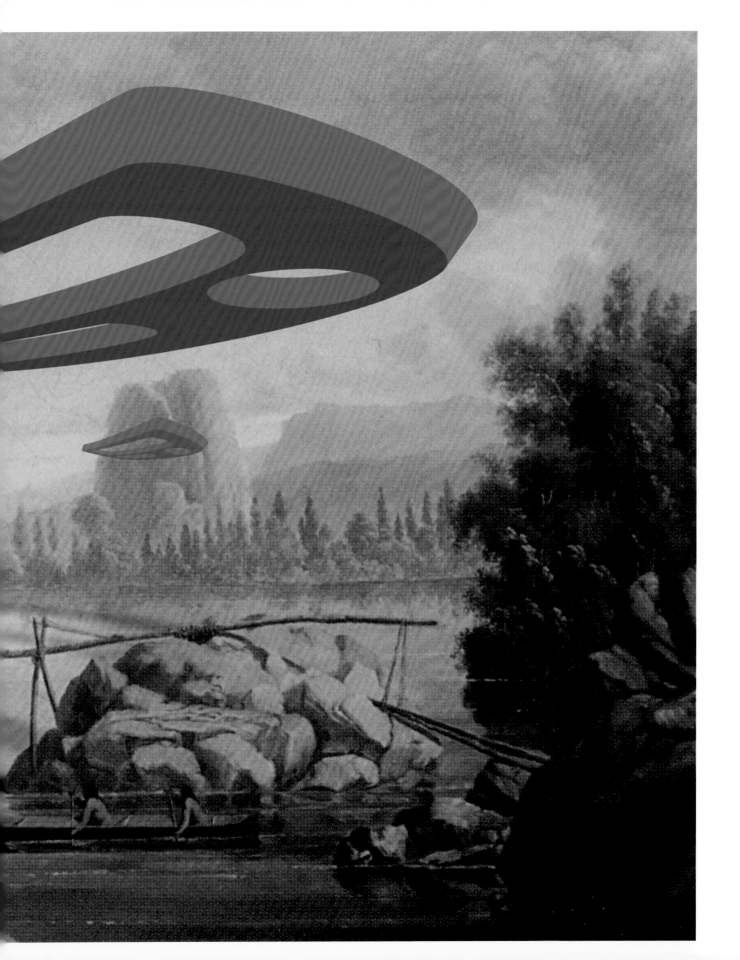

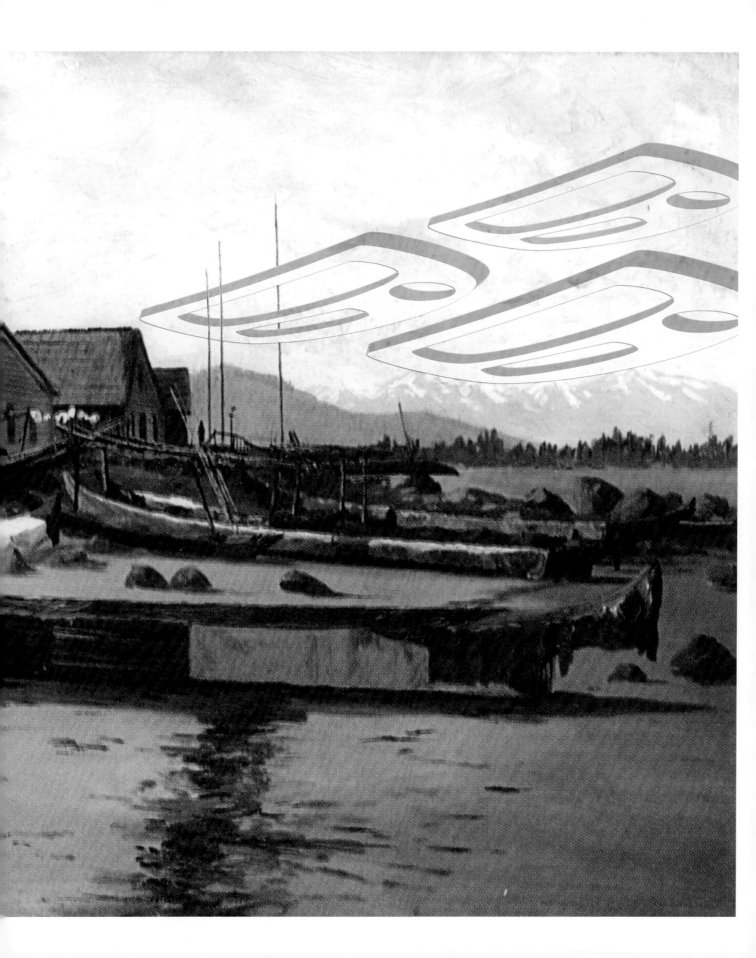

182

↑ PAGES 178–179 *Home Coming,* 2014, digital intervention on a Paul Kane painting (*Scene near Walla Walla, 1848–52*), archival pigment print; 36.25 x 22.5 inches SONNY ASSU

↑ PAGES 180–181 *Tell Chakotay that we'll brb,* 2014, digital intervention on a James Everett Stuart painting (*Extreme End of Indian Town, Sitka, 1891*), archival pigment print, 40.5 x 22.5 inches SONNY ASSU

→ RIGHT *You mess with me, you mess with my cousins,* 2014, digital intervention on a Frederick Alexcee painting (*Battle between Tsimshian and Haida at Old Fort Simpson c. 1843, 1896*), archival pigment print, 22.5 x 27.25 inches SONNY ASSU

Drawing by E. A., at Hudson B. Co.
FORT SIMPSON

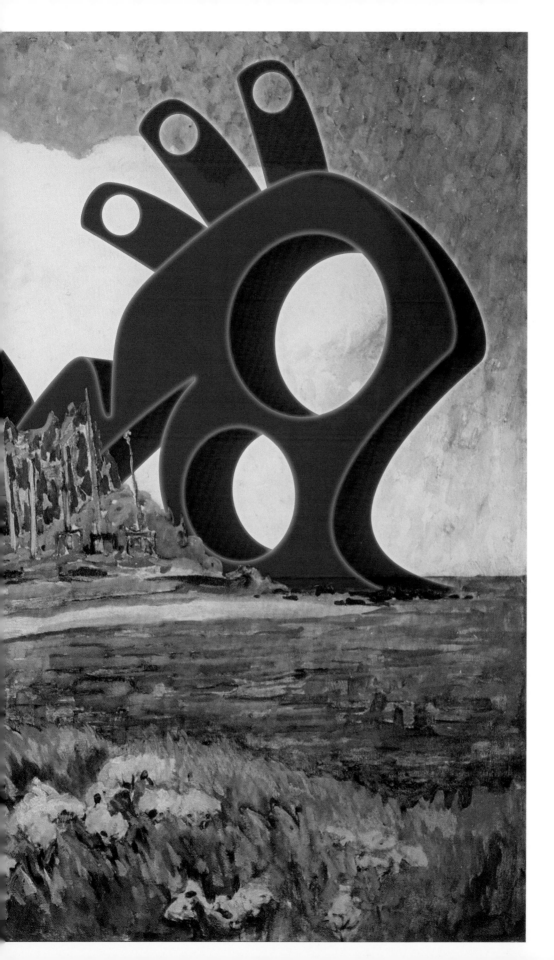

← *Making a b-line to HaidaBucks, Salmonberry Frap #ftw #starbucksFAIL #lol,* 2016, digital intervention on an Emily Carr painting (*Yan, Q.C.I.*, 1912), archival pigment print, 33 x 22 inches
SONNY ASSU

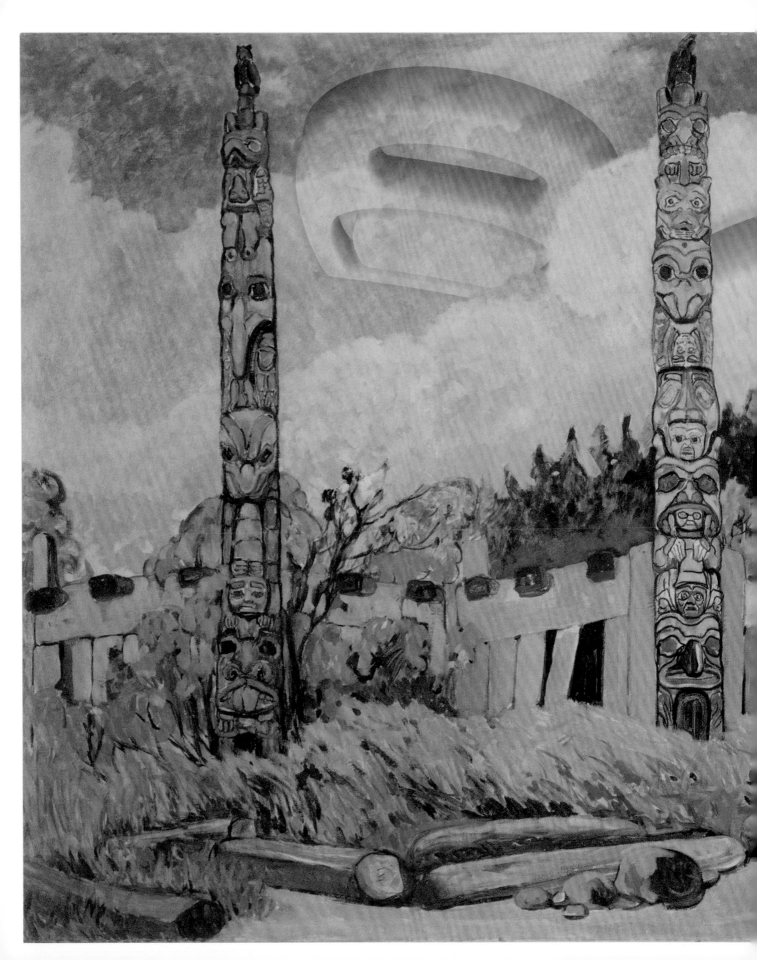

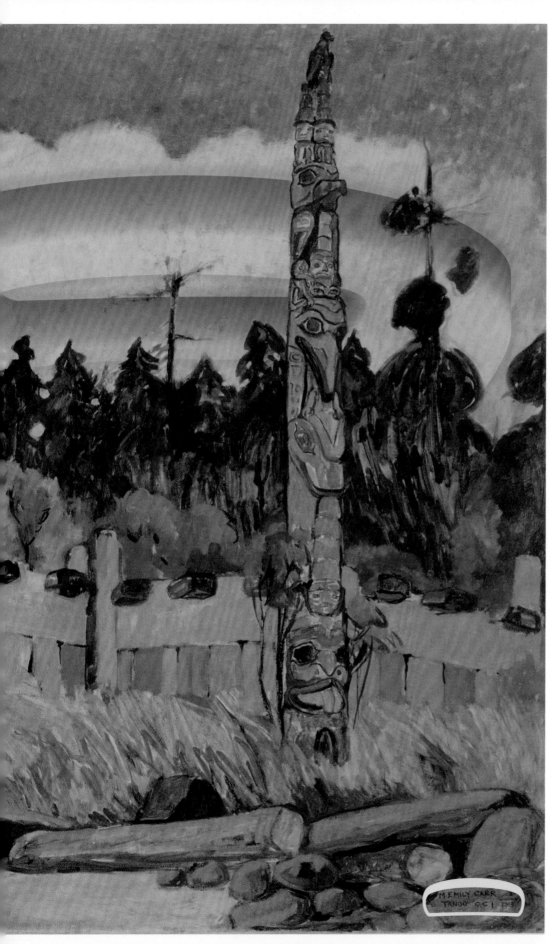

PRESERVER ONE: *Well, looks like we got them all. See, don't you feel GREAT knowing that these people will never experience the effects of colonization?* PRESERVER TWO: *O_o,* 2016, digital intervention on an Emily Carr painting (*Tanoo*, 1913), archival pigment print, 22 x 33.5 inches SONNY ASSU

"This intervention draws upon my appreciation of *Star Trek* and the love of understanding my culture and family history. Emily Carr's *Cape Mudge: An Indian Family with Totem Pole* (1912) is a painting of my home village, and that of my grandfather and his grandfather, Chief Billy Assu. The personal connection I have to the source material for this work has made this intervention particularly satisfying."

—**SONNY ASSU,** 2016

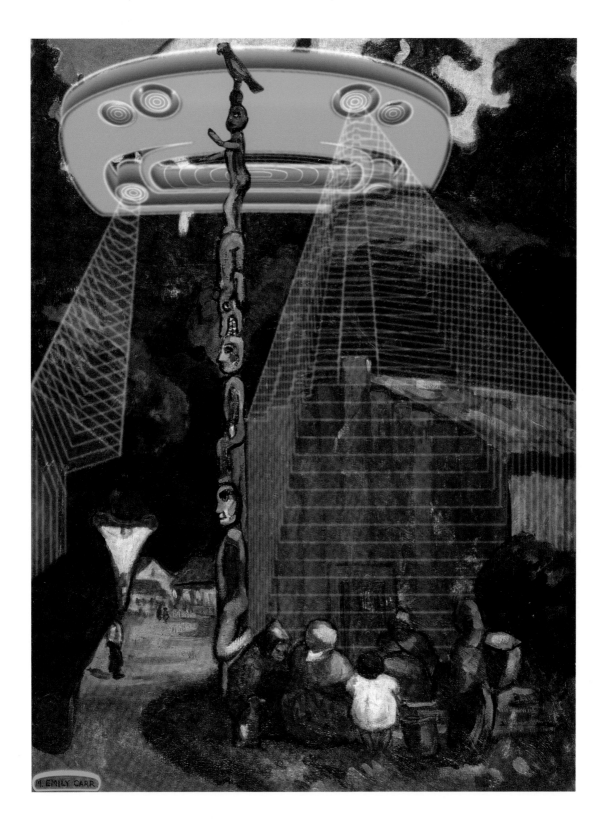

↑ *Yeah . . . shit's about to go sideways. I'll take you to Amerind. You'll like it, looks like home.,* 2016, digital intervention on an
Emily Carr painting (*Cape Mudge: An Indian Family with Totem Pole*, 1912), archival pigment print, 22 x 29.5 inches SONNY ASSU

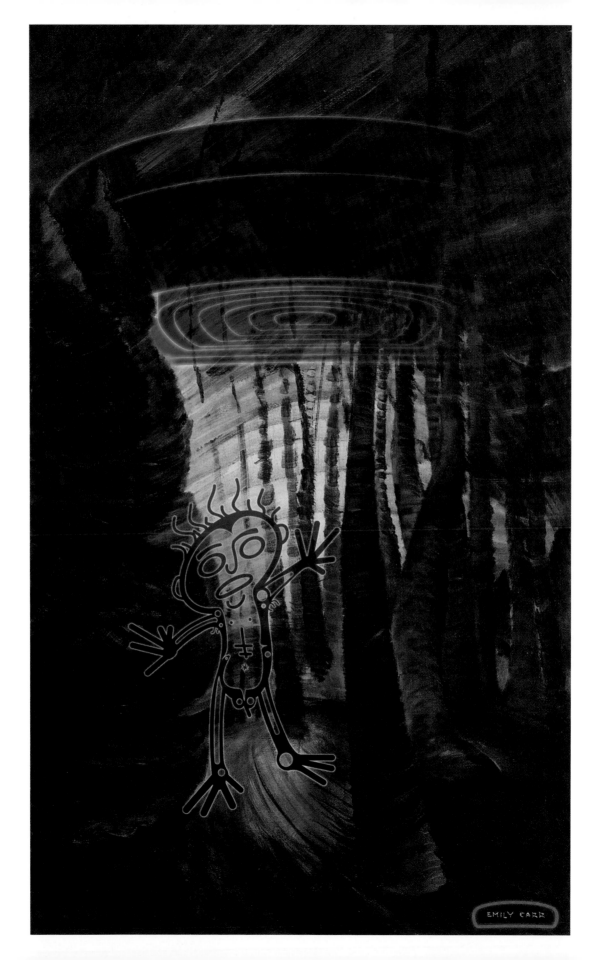

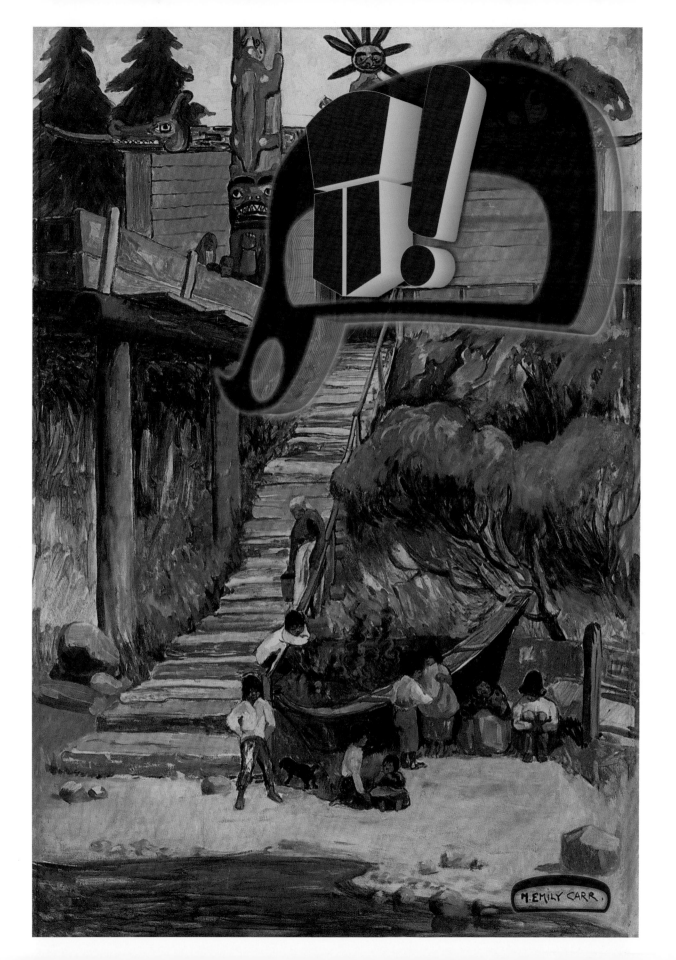

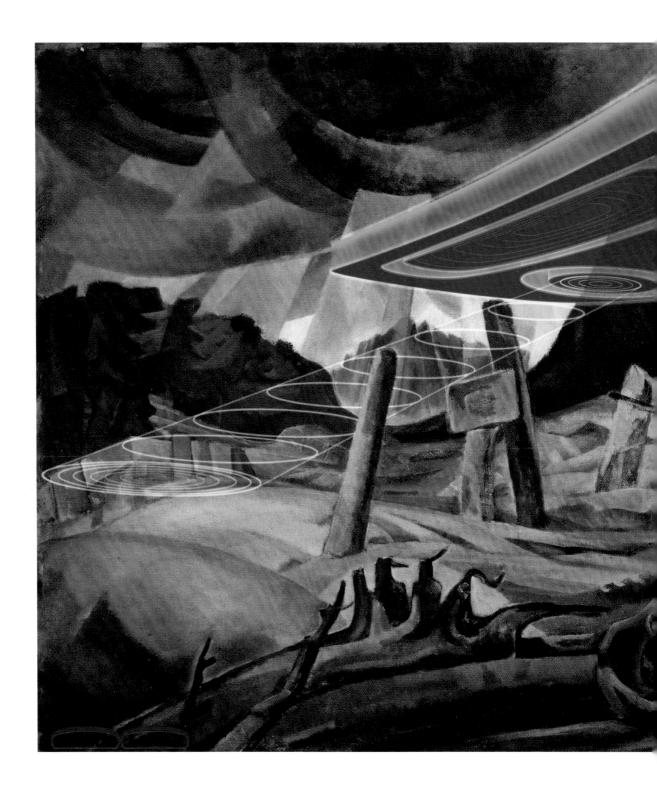

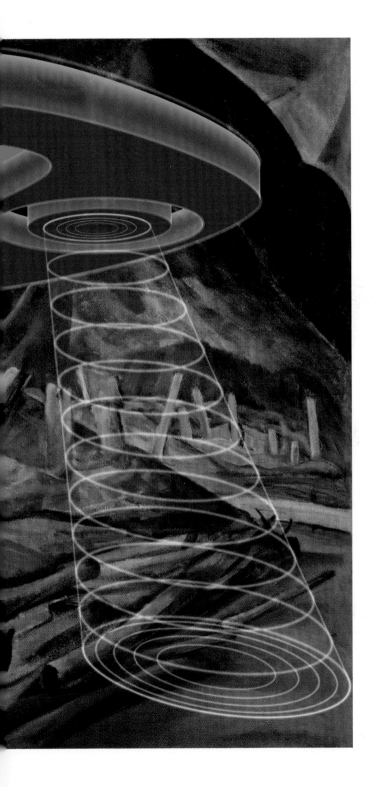

↑ PAGE 190 *Beware of the intentions of well meaning Aliens,* 2016, digital intervention on an Emily Carr painting (*Sombreness Sunlit*, 1938), archival pigment print, 36 x 22 inches SONNY ASSU

PAGE 191 *The Value of Comic Sans,* 2016, digital intervention on an Emily Carr Painting (*Memalilaqua, Knights Inlet*, 1912), archival pigment print, 32 x 22 inches SONNY ASSU

← LEFT *The Away Team Beams Down to What Appears to Be an Uninhabited Planet,* 2016, digital intervention on an Emily Carr painting (*Vanquished*, 1930), archival pigment print, 22 x 33 inches SONNY ASSU

"The Paradise Syndrome series uses scanned marine navigation charts and geographic maps to look at the invisible boundaries that are used to define yet are meant to separate us. The series takes its name from a 1968 episode of the original Star Trek TV series in which the crew of the USS *Enterprise* happen upon a planet inhabited by displaced Native Americans. Perhaps the removal of these fictional Native Americans from Earth had been done to protect them from the inevitable colonial onslaught that was to come. Or perhaps the concoction of this plot was a way for the 1960s TV writers to ease their sense of white guilt, albeit through the use of tropes and stereotypes."

—SONNY ASSU, 2016

→ *The Paradise Syndrome, Voyage #32,* 2016, archival pigment print, 21 x 36 inches SONNY ASSU

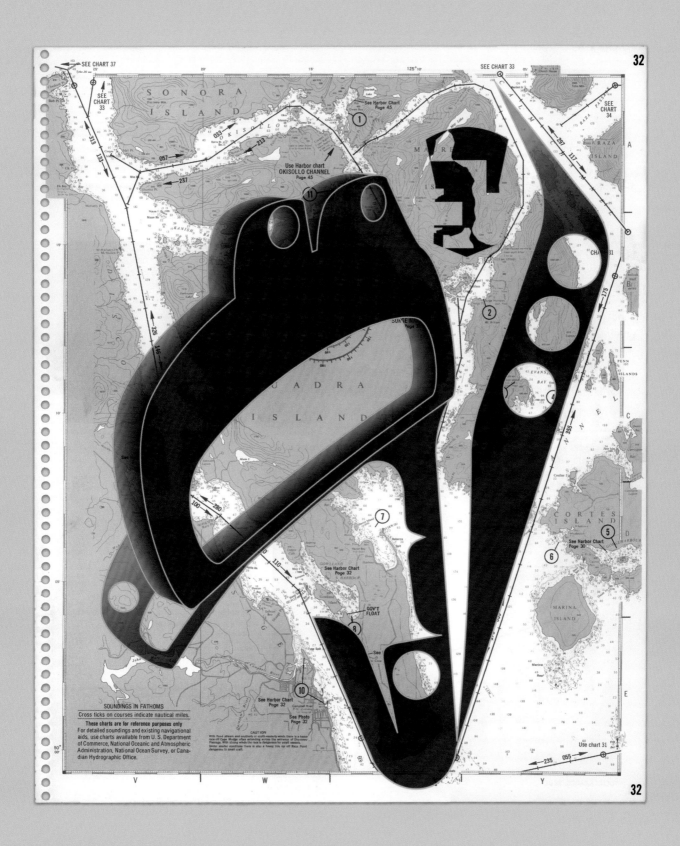

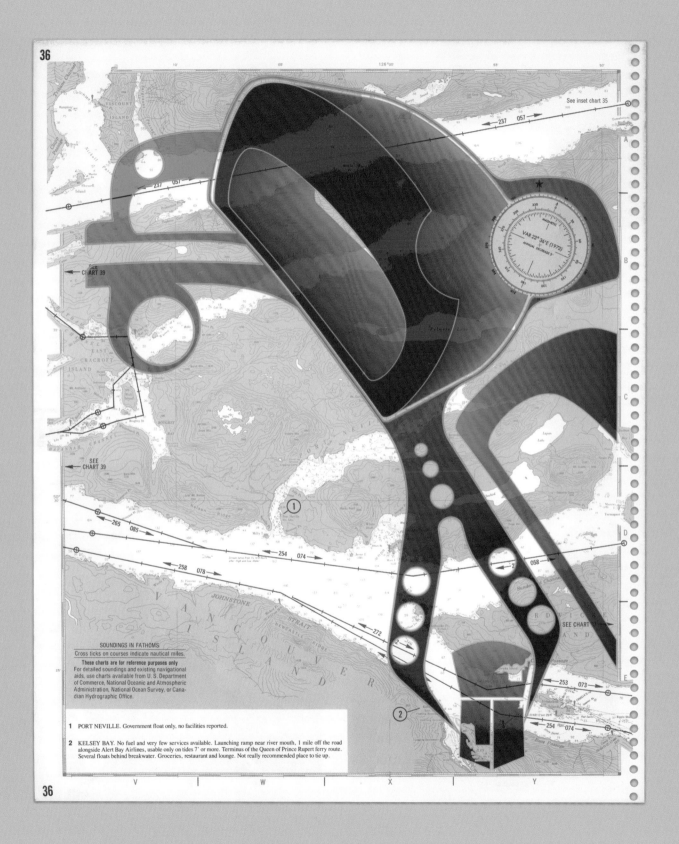

↑ *The Paradise Syndrome, Voyage #36,* 2016, archival pigment print, 21 x 36 inches SONNY ASSU

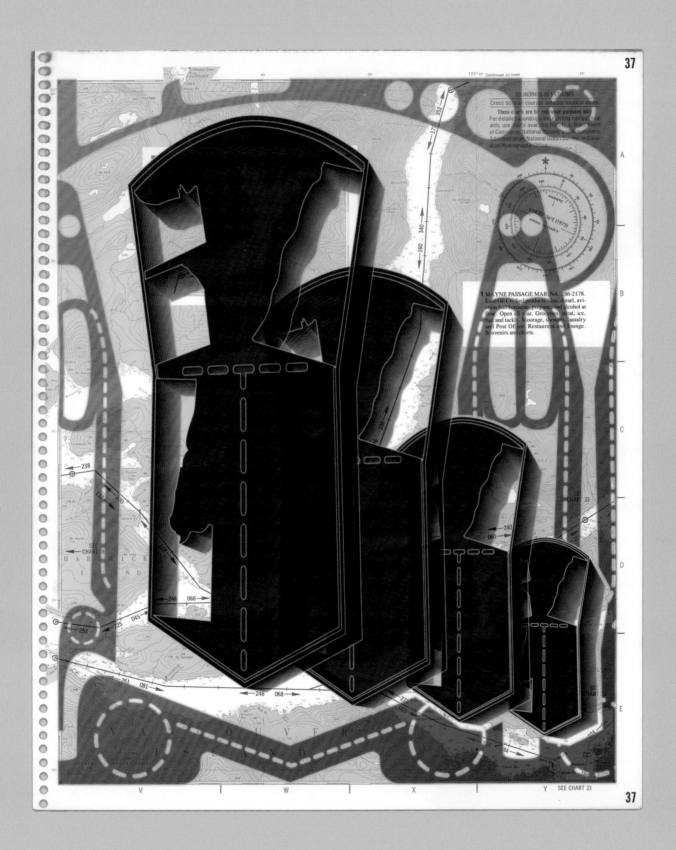

↑ *The Paradise Syndrome, Voyage #37,* 2016, archival pigment print, 21 x 36 inches SONNY ASSU

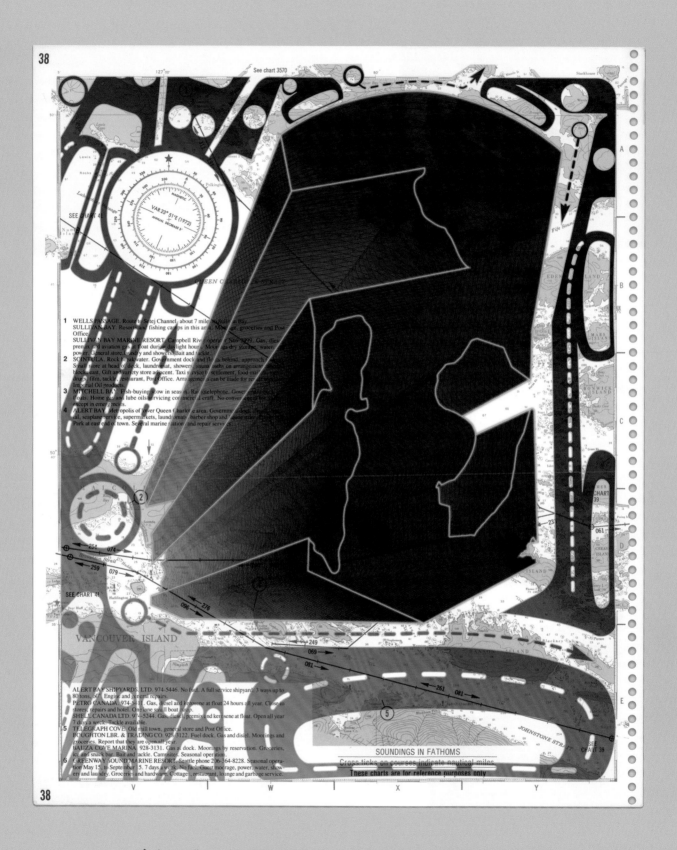

↑ *The Paradise Syndrome, Voyage #38,* 2016, archival pigment print, 21 x 36 inches SONNY ASSU

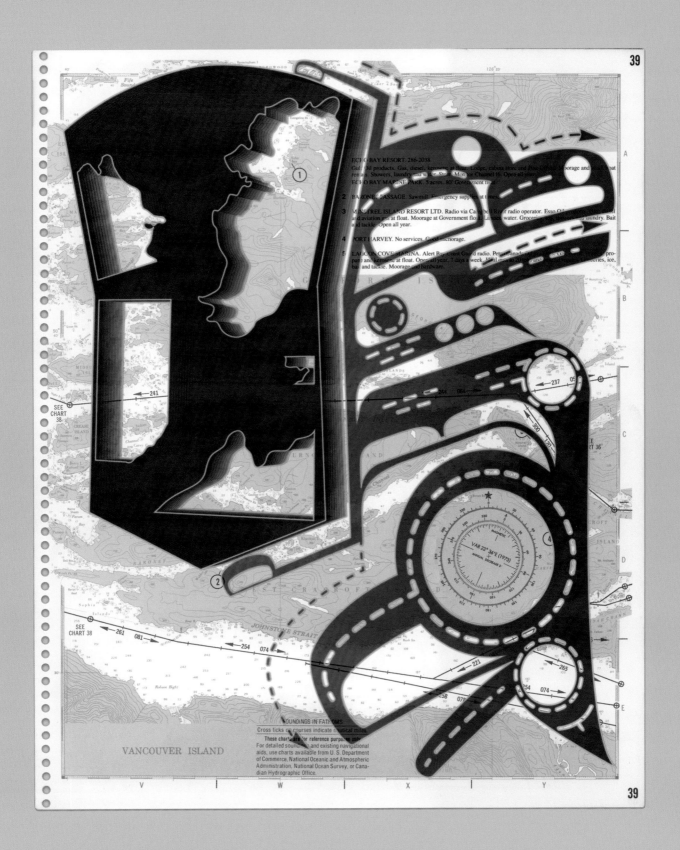

↑ *The Paradise Syndrome, Voyage #39,* 2016, archival pigment print, 21 x 36 inches SONNY ASSU

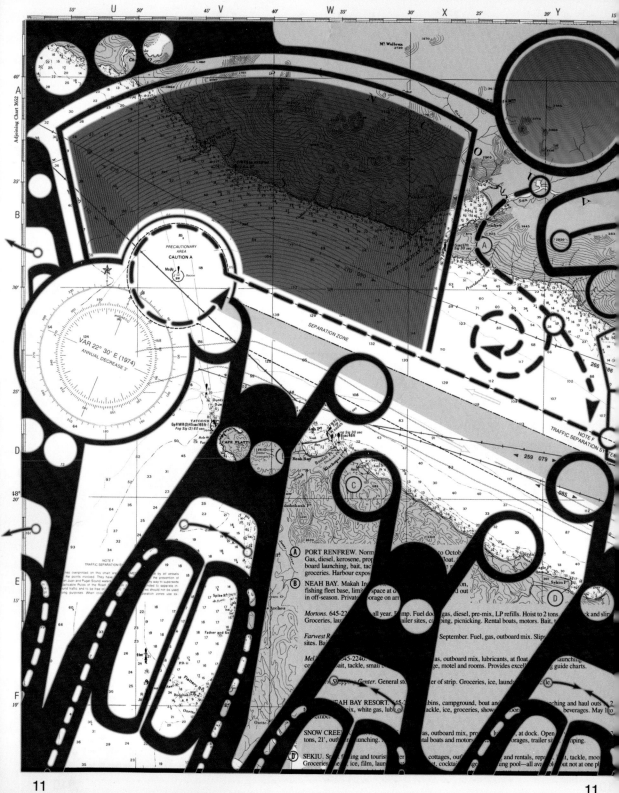

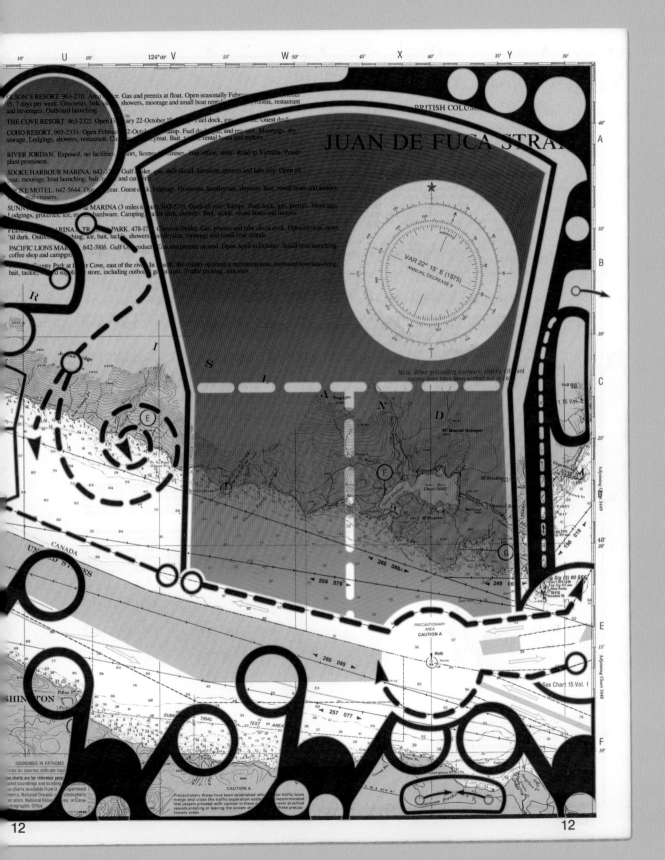

↑ *The Paradise Syndrome, Voyages #11 and 12,* 2016, archival pigment print, 42 x 36 inches SONNY ASSU

"As a painting and collage series, Speculator Boom forms a deeper investigation of the importance of comic books in my life and in my work. I've recently begun to explore pop culture again as a way to not only express my identity as a purveyor of pop, a watcher of sci-fi, and a collector of nerdy things, but also to find a cathartic experience in the breaking of my childhood memorabilia. Through this, I'm finding a new understanding of the attribution of wealth by the deconstruction of something sacred to create something new."

—SONNY ASSU, 2017

← *We All Must Deal with the Monster Within,* 2017, acrylic paint, acrylic ink, acrylic medium, Marvel comic book pages on panel, 33 x 51 inches SCOTT MASSEY, SITE PHOTOGRAPHY

↑ *You Have Betrayed the Dream,* 2017, acrylic paint, acrylic ink, acrylic medium, Marvel comic book pages on panel, 33 x 51 inches SCOTT MASSEY, SITE PHOTOGRAPHY

↑ *Subscribe Now and Save!,* 2017, acrylic Ink, Marvel comic book
pages on paper, 33 x 51 inches SCOTT MASSEY, SITE PHOTOGRAPHY

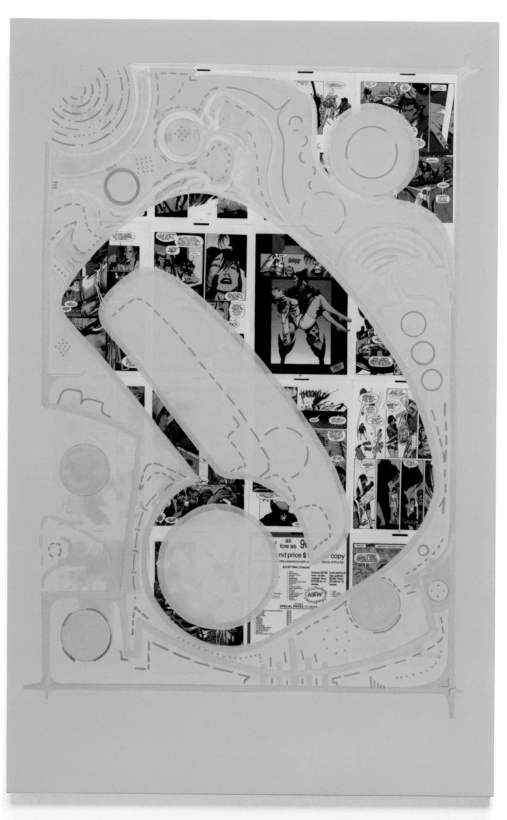

↑ *SNIKT,* 2017, acrylic paint, acrylic ink, acrylic medium, Marvel comic book pages on panel, 33 x 51 inches SCOTT MASSEY, SITE PHOTOGRAPHY

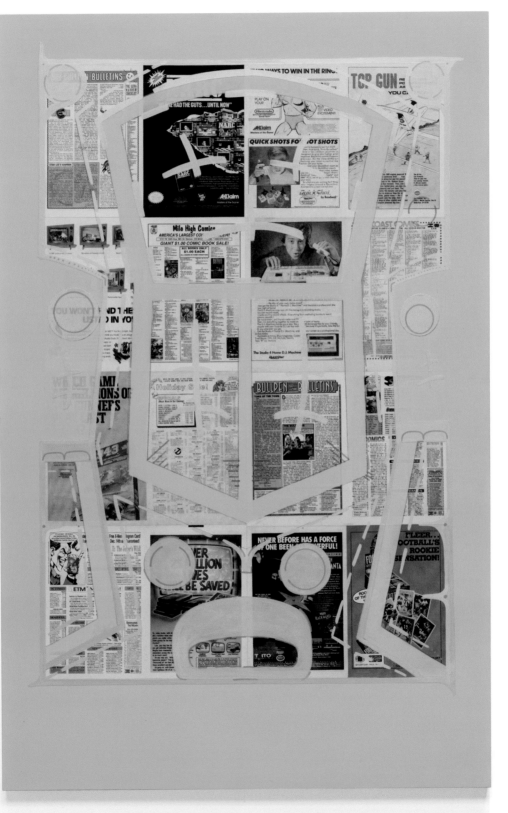

↑ *C.O.D.,* 2017, acrylic paint, acrylic ink, acrylic medium, Marvel comic book pages on panel, 33 x 51 inches SCOTT MASSEY, SITE PHOTOGRAPHY

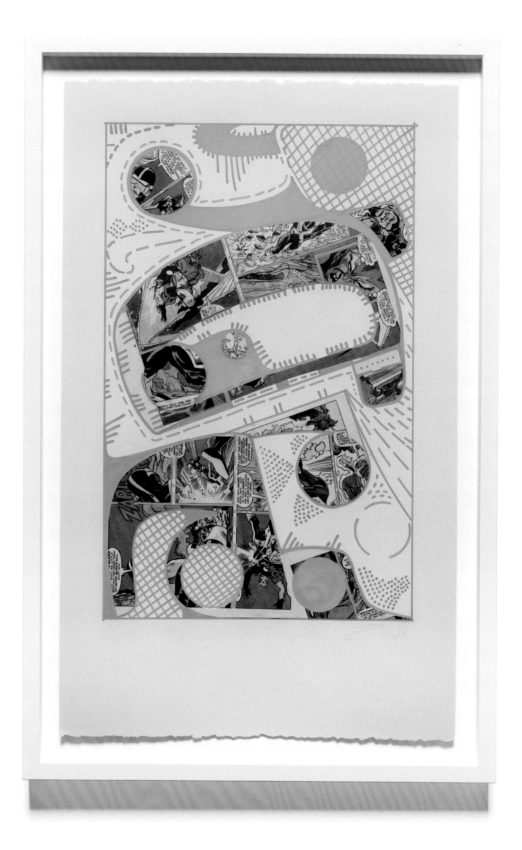

↑ *Giant Sized Speculator, #1,* 2017, acrylic Ink, Marvel comic book
pages on paper, 13.25 x 22 inches SCOTT MASSEY, SITE PHOTOGRAPHY

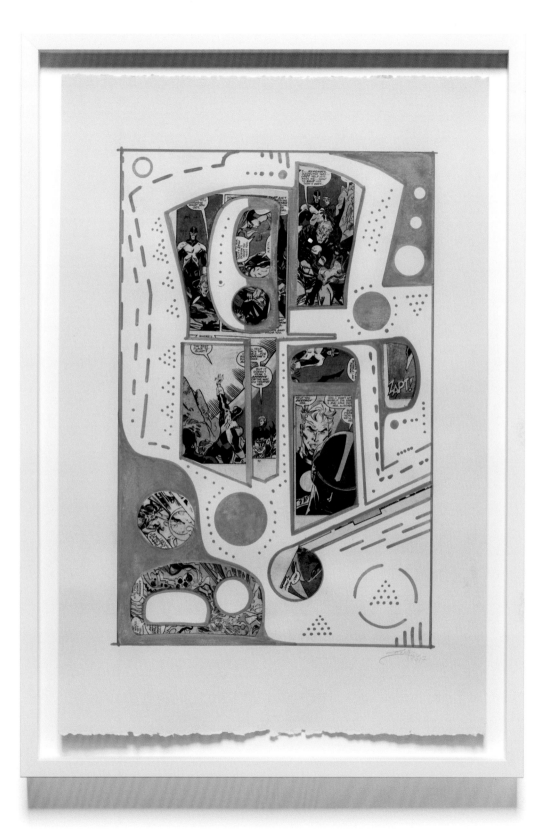

↑ *Giant Sized Speculator, #2,* 2017, acrylic Ink, Marvel comic book
pages on paper, 13.25 x 22 inches SCOTT MASSEY, SITE PHOTOGRAPHY

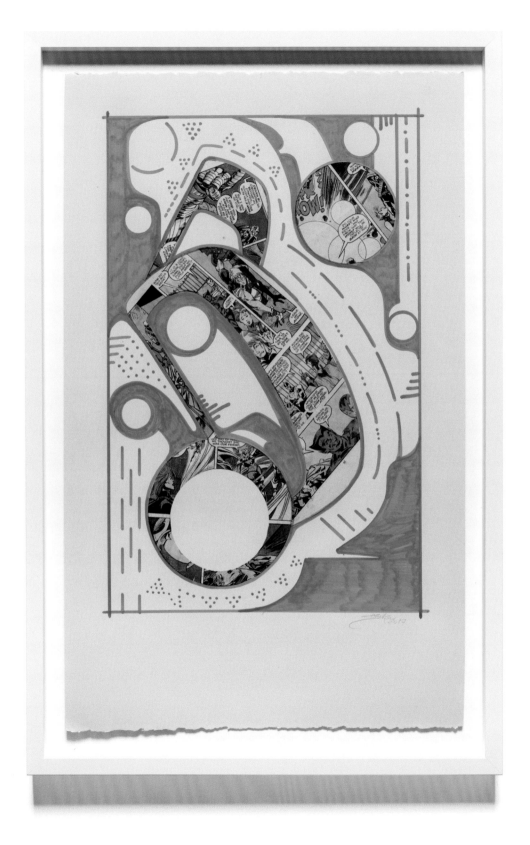

↑ *Giant Sized Speculator, #3,* 2017, acrylic ink, Marvel comic book
pages on paper, 13.25 x 22 inches SCOTT MASSEY, SITE PHOTOGRAPHY

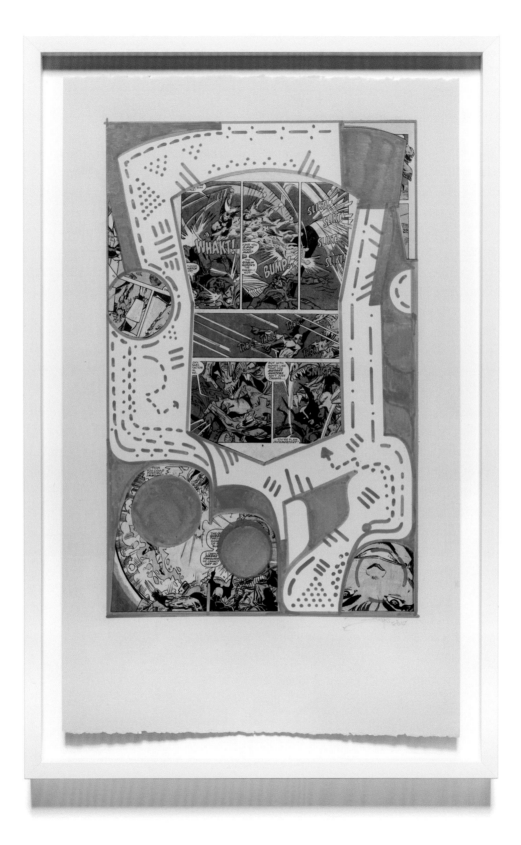

↑ *Giant Sized Speculator, #4,* 2017, acrylic ink, Marvel comic book
pages on paper, 13.25 x 22 inches SCOTT MASSEY, SITE PHOTOGRAPHY

ACKNOWLEGDEMENTS

The concept of this book changed a few times over the years, but from the outset, I wanted to have fellow artists, writers, academics, and curators write about my work. I've been fortunate over my career to have met so many wonderful people and I'm beyond ecstatic to have Janet Rogers, Marianne Nicolson, Candice Hopkins, Ellyn Walker, and Richard Van Camp writing about my work. I've had the opportunity to work with you all on multiple levels and I thank you for your support.

Lara Kordic, the editor of *A Selective History*, was the catalyst for making this book happen. Thank you for giving me the opportunity to share my work in such a way and helping shape the direction of this book.

There are a number of photographers in this book who have contributed their time and talent over the years in documenting my work. I'd expressly like to thank Chris Meier, Scott Massey, Eric Deis, and Dayna Danger for using their creativity and talent to document my work.

Around 2007, I got a call from Matthew Hills, the curator of my first solo exhibition in Vancouver (Thanks, buddy!). He told me that Andy Sylvester from the Equinox Gallery wanted to get in touch with me to talk about my work. I've been working with the amazing crew at the Equinox Gallery for over a decade now, and it's been a decade of creativity and opportunity. Andy, Sophie, Deirdre, Hannah, and Ron, thank you for all that you have done.

Finally, to Sara, my beautiful muse and partner in crime. You inspire me like no other. You've stood with me, in your unwavering support, painting by numbers in the studio and stating your profession as "muse" at openings and other art functions. I wouldn't be the person I am today without you. Here's to our future with Lily, Eli, and our rag-tag band of animals.

LIST OF WORKS

Cover, title page—*Grawlixes*
(diptych), 2013
acrylic on panel
11.5 x 36 inches each

6—*Live from the 'Latch,* 2012
archival pigment print
14 x 20 inches

8, 172—*We Come to Witness,* 2014
digital intervention on an Emily
Carr painting (*Silhouette No. 2,* 1930)
archival pigment print
22.5 x 34 inches

12—*The Paradise Syndrome,
Voyage #30,* 2016
archival pigment print
21 x 36 inches

15—*Silenced: The Burning,* 2011
acrylic on elk-hide drums
16- to 24-inch diameter each, height
variable
installation of 67

20, 175—*Spaced Invaders,* 2014
digital intervention on an
Emily Carr painting (*Heina,* 1928),
archival pigment print
22.5 x 31.5 inches

22, 119-20—*Ellipsis,* 2012
copper LPs
11.75 inches diameter each
installation of 136

24, left—*Leila's Desk,* 2013
vintage 1930s school desk (wood,
metal), vintage Lifebuoy soap,
copper leaf
33 x 22 x 26 inches

24, right—*Inherent,* 2014
vintage 1970s school desk
(wood, metal), copper leaf
25 x 19 x 30.5 inches

26, 167—*What a Great
Spot for a Walmart!,* 2014
digital intervention on an Emily
Carr painting (*Graveyard Entrance,
Campbell River,* 1912)
archival pigment print
22.5 x 33.25 inches

27, 189—*Yeah … shit's about to go
sideways. I'll take you to Amerind.
You'll like it, looks like home.,* 2016
digital intervention on an Emily
Carr painting (*Cape Mudge:
An Indian Family with Totem Pole,*
1912), archival pigment print
22 x 29.5 inches

28—*iDrum (Red)iscovery #2,* 2009
acrylic on cow hide
20 inches diameter

31—*iHamatsa: Disconnected,* 2006
acrylic on deer hide
18 inches diameter

33, 126-27—*Billy and the Chiefs: The
Complete Banned Collection,* 2012
acrylic on elk-hide drums
10 and 12 inches diameter each
installation of 67

34—*It's 2016!,* 2016
adhesive dry-erase wall vinyl
48 x48

37—*When Raven Became
Spider, Embrace,* 2004
Melton wool, cotton,
Akoya shell buttons
66 x 85 inches

42, 151—*Longing #16,* 2011
found cedar and brass
16.3 x 12.5 x 6.5 inches
photo: 15 x 19.25 inches

›››

50-51—*Coke-Salish,* 2006
duratrans and lightbox
24 x 35 inches

›››

Breakfast Series

52—*Salmon Loops,* 2006
digital print, foam-core
12 x 7 x 3 inches

53—*Bannock Pops,* 2006
digital print, foam-core
12 x 7 x 3 inches

53—*Treaty Flakes,* 2006
digital print, foam-core
12 x 7 x 3 inches

53—*Salmon Crisp,* 2006
digital print, foam-core
12 x 7 x 3 inches

53—*Lucky Beads,* 2006
digital print, foam-core
12 x 7 x 3 inches

›››

iPotlatch Series

55—*iPotlatch: 10,000
Ancestors in Your Pocket,* 2008
acrylic on panel
36 x 72 inches

56-57—*iPotlatch: 5,000
Ancestors in Your Pocket,* 2006
acrylic on panel
48 x 24 inches

58—*iHamatsa Rising,* 2009
archival pigment print
12.5 x 19.25 inches

59—*iHamatsa Dancer,* 2007
acrylic on panel
24 x 48 inches

60—*iHamatsa,* 2007
acrylic on panel
24 x 48 inches

61—*iPotlatch Ego,* 2007
acrylic on panel
24 x 48 inches

›››

62-63—*iDrum, Silenced, and
Disconnected Series,* Installation
at the Equinox Gallery, 2010

›››

iDrum Series

64—*iDrum,* 2006
acrylic on deer hide
16 inches diameter

109—*#Photobomb*, 2013
acrylic on panel
40 x 84 inches

110-11—*#NoFilter*, 2013
acrylic on panel
84 x 48 inches

112—*#PotlatchShadeOfGrey*, 2013
acrylic on panel
84 x 48 inches

112-13—*#museumselfie*, 2015
acrylic on panel
40 x 84 inches

114-15—*Status*, 2015
acrylic on panel
40 x 84 inches

>>>

116-17—*1884-1951*, 2009
67 spun copper cups, HBC blanket

>>>

22, 119-21—*Ellipsis*, 2012
copper LPs
11.75 inches diameter each
installation of 136

>>>

Gone Copper! Series

122—*Gone Copper! (1921)*, 2015
copper and maple
22 x 31 inches

123—*Gone Copper!
(Back to the Big House)*, 2015
copper and maple
22 x 31 inches

124-25—*Gone Copper!
(Giving It All Away)*, 2015
copper and maple
22 x 31 inches

>>>

Billy and the Chiefs Series

33, 126-27—*Billy and the Chiefs:
The Complete Banned Collection*,
2012
acrylic on elk-hide drums
10 and 12 inches diameter each
installation of 67

128—*Billy and the Chiefs:
Potlatch House #1*, 2013
acrylic on elk hide, wood
12 inches diameter

129—*Billy and the Chiefs:
Potlatch House #2*, 2013
acrylic on elk hide, wood
12 inches diameter

129—*Billy and the Chiefs:
Potlatch House #3*, 2013
acrylic on elk hide, wood
12 inches diameter

130—*Billy and the Chiefs:
Hidden Tracks #1*, 2013
acrylic on elk hide, wood
12 inches diameter

130—*Billy and the Chiefs:
Hidden Tracks #2*, 2013
acrylic on elk hide, wood
12 inches diameter

131—*Billy and the Chiefs: Everybody
Do the Round Dance*, 2013
acrylic on elk hide, wood
12 inches diameter

>>>

Propaganda Series

132—*Selective History*, 2012
archival pigment print
30.5 x 40.5 inches

134—*The Happiest Future #1*, 2012
archival pigment print
18.5 x 36.5 inches

134—*The Happiest Future #2*, 2012
archival pigment print
18.5 x 36.5 inches

134—*The Happiest Future #3*, 2012
archival pigment print
18.5 x 36.5 inches

134—*The Happiest Future #4*, 2012
archival pigment print
18.5 x 36.5 inches

134—*The Happiest Future #5*, 2012
archival pigment print
18.5 x 36.5 inches

134—*The Happiest Future #6*, 2012
archival pigment print
18.5 x 36.5 inches

135—*The Happiest Future #7*, 2012
archival pigment print
18.5 x 36.5 inches

135—*The Happiest Future #8*, 2012
archival pigment print
18.5 x 36.5 inches

135—*The Happiest Future #9*, 2012
archival pigment print
18.5 x 36.5 inches

135—*The Happiest Future #10*, 2012
archival pigment print
18.5 x 36.5 inches

136—*Strict Law V1 #1*, 2014
archival pigment print
19 x 41 inches

136—*Strict Law V1 #2*, 2014
archival pigment print
19 x 41 inches

136—*Strict Law V1 #3*, 2014
archival pigment print
19 x 41 inches

137—*Strict Law V1 #4*, 2014
archival pigment print
19 x 41 inches

137—*Strict Law V1 #5*, 2014
archival pigment print
19 x 41 inches

138—*Strict Law V2 #1*, 2014
archival pigment prints
19 x 41 inches

138—*Strict Law V2 #2*, 2014
archival pigment prints
19 x 41 inches

138—*Strict Law V2 #3*, 2014
archival pigment prints
19 x 41 inches

139—*Strict Law V2 #4*, 2014
archival pigment prints
19 x 41 inches

139—*Strict Law V2 #5*, 2014
archival pigment prints
19 x 41 inches

140—*Strict Law V3 #1*, 2014
archival pigment prints
19 x 41 inches

140—*Strict Law V3 #2*, 2014
archival pigment prints
19 x 41 inches

140—*Strict Law V3 #3*, 2014
archival pigment prints
19 x 41 inches

141—*Strict Law V3 #4*, 2014
archival pigment prints
19 x 41 inches

141—*Strict Law V3 #5*, 2014
archival pigment prints
19 x 41 inches

143—*There Is Hope,
If We Rise #1*, 2013
archival ink on rag paper
7 x 11 inches

144-45—*There Is Hope,
If We Rise #2*, 2013
archival ink on rag paper
7 x 11 inches

144-45—*There Is Hope,
If We Rise #3*, 2013
archival ink on rag paper
7 x 11 inches

144-45—*There Is Hope,
If We Rise #4*, 2013
archival ink on rag paper
7 x 11 inches

144-45—*There Is Hope,
If We Rise #5*, 2013
archival ink on rag paper
7 x 11 inches

144-45—*There Is Hope,
If We Rise #6*, 2013
archival ink on rag paper
7 x 11 inches

144-45—*There Is Hope,
 If We Rise #7*, 2013
archival ink on rag paper
7 x 11 inches

144-45—*There Is Hope,
If We Rise #8*, 2013
archival ink on rag paper
7 x 11 inches

144-45—*There Is Hope,
If We Rise #9*, 2013
archival ink on rag paper
7 x 11 inches

144-45—*There Is Hope,
If We Rise #10*, 2013
archival ink on rag paper
7 x 11 inches

144-45—*There Is Hope,
If We Rise #11*, 2013
archival ink on rag paper
7 x 11 inches

146—*Product (Res)#1*, 2013
digital print
24 x 48 inches

146—*Product (Res)#2*, 2013
digital print
24 x 48 inches

147—*Product (Res)#3*, 2013
digital print
24 x 48 inches

147—*Product (Res)#4*, 2013
digital print
24 x 48 inches

>>>

Longing Series

149—*Longing #1*, 2011
found cedar and brass
15.3 x 12 x 8 inches
Photo: 15 x 19.25 inches

150—*Longing #2*, 2011
found cedar and brass
12 x 14 x 6 inches
Photo: 15 x 19.25 inches

150—*Longing #5*, 2011
found cedar and brass
12 x 13 x 9.3 inches
Photo: 15 x 19.25 inches

150—*Longing #9*, 2011
found cedar and brass
13.5 x 12.3 x 8.5 inches
Photo: 15 x 19.25 inches

150—*Longing #7*, 2011
found cedar and brass
12 x 9.5 x 7.8 inches
Photo: 15 x 19.25 inches

151—*Longing #10*, 2011
found cedar and brass
12.3 x 13 x 9 inches
Photo: 15 x 19.25 inches

151—*Longing #13*, 2011
found cedar and brass
17.5 x 13 x 9 inches
Photo: 15 x 19.25 inches

151—*Longing #16*, 2011
found cedar and brass
16 x 14 x 7.5 inches
Photo: 15 x 19.25 inches

151—*Longing #14*, 2011
found cedar and brass
16 x 14 x 7.5 inches
Photo: 15 x 19.25 inches

>>>

Artifacts of Authenticity

152-53—*Museum of Anthropology*, 2011
archival pigment print
28 x 42 inches

154-55—*Roberts Gallery and Gifts*, 2011
archival pigment print
28 x 42 inches

156-57—*Equinox Gallery*, 2011
archival pigment print
42 x 28 inches

>>>

159-60—*The Value of What Goes On Top/
The Value of What Goes Within*, 2015
maple plywood, copper leaf, varnish
6 h x 12 w x 12 d inches; 18 h x 12 w x
12 d inches; 24 h x 12 w x 12 d inches;
and 32 h x 12 w x 12 d inches

>>>

162-63—*Leila's Desk*, 2013
vintage 1930s school desk
(wood, metal), vintage
Lifebuoy soap, copper leaf
33 x 22 x 26 inches

165—*Inherent*, 2014
vintage 1970s school desk
 (metal, wood), copper leaf
25 x 19 x 30.5 inches

The Speculator
Boom Series

202—*We All Must Deal with the Monster Within,* 2017
acrylic paint, acrylic ink, acrylic medium, Marvel comic book pages on panel
33 x 51 inches

204—*You Have Betrayed the Dream,* 2017
acrylic paint, acrylic ink, acrylic medium, Marvel comic book pages on panel
33 x 51 inches

205—*Subscribe Now and Save!,* 2017
acrylic ink, Marvel comic book pages on paper
13.25 x 22 inches

206—*SNIKT,* 2017
acrylic paint, acrylic ink, acrylic medium, Marvel comic book pages on panel
33 x 51 inches

207—*C.O.D.,* 2017
acrylic paint, acrylic ink, acrylic medium, Marvel comic book pages on panel
33 x 51 inches

208—*Giant Sized Speculator, #1,* 2017
acrylic ink, Marvel comic book pages on paper
13.25 x 22 inches

209—*Giant Sized Speculator, #2,* 2017
acrylic ink, Marvel comic book pages on paper
13.25 x 22 inches

210—*Giant Sized Speculator, #3,* 2017
acrylic ink, Marvel comic book pages on paper
13.25 x 22 inches

211—*Giant Sized Speculator, #4,* 2017
acrylic ink, Marvel comic book pages on paper
13.25 x 22 inches

COLLECTIONS

Collection of the Artist

Silenced: The Burning, 2011
Ellipsis, 2012
It's 2016!, 2016
When Raven Became Spider, Embrace, 2004
iPotlatch: 10,000 Ancestors in Your Pocket, 2008
iPotlatch: 5,000 Ancestors in Your Pocket, 2006
#IdleNoMore, 2013
Legacy, 2015
#museumselfie, 2015
Ellipsis, 2012
The Happiest Future, 2012
Strict Law, 2014
Product (Res), 2013
The Value of What Goes On Top/ The Value of What Goes Within, 2015
The Paradise Syndrome Series, 2016
The Speculator Boom Series, 2017

Private Collections

Grawlixes (diptych), 2013
iDrum (Red)iscovery #2, 2009
iHamatsa: Disconnected, 2006
iHamatsa Rising, 2009
iHamatsa Dancer, 2007
iHamatsa, 2007
iDrums, 2006–10
Disconnected #2, 2010
Disconnected #4, 2010
Disconnected #6, 2010
Disconnected #7, 2010
#PutABirdOnIt, 2013
Silenced #1, 2010
Silenced #2, 2010
Silenced #3, 2010
Silenced #4, 2010
Silenced #5, 2010
Longhouse #1, 2009
Ovoid as Language, 2009
Dialect, 2010
Consumption, 2010
Phonology, 2010
Likwala (diptych), 2013
Feast, 2015
Boastance, 2015
Emanating Dialogue, 2015

Hamatsa Be Trip'n, 2015
#Photobomb, 2013
#NoFilter, 2013
Status, 2015
Gone Copper! Series, 2015
Billy and the Chiefs: Potlatch House #1, #2, and #3, 2013
Billy and the Chiefs: Hidden Tracks, #1 and #2, 2013
Billy and the Chiefs: Everybody Do the Round Dance, 2013
The Happiest Future, 2012
Strict Law, 2014
There Is Hope, If We Rise, 2013

Public Collections

Live from the 'Latch
Edition of 67
Collection of the Museum of Anthropology at UBC

Coke-Salish, 2006
Edition of 5
Collection of the Museum of Anthropology at UBC

Status Update, 2011
Collection of the National Gallery of Canada

Breakfast Series, 2006
Collection of the National Gallery of Canada
Collection of Seattle Art Museum—Edition of 6/8

Selective History, 2012
Collection of the Canada Council Art Bank—A/P Edition 1/2

Disconnected #3, 2009
Collection of City of Seattle, Office of Cultural Affairs

Silenced: The Hidden, 2011
In the Collection of the Audain Art Museum

1884–1951, 2009
In the Collection of the Audain Art Museum

Museum of Anthropology, 2011
Collection of Art Gallery of Greater Victoria— A/P Edition 1/2

Roberts Gallery and Gifts, 2011
Collection of Art Gallery of Greater
Victoria— A/P Edition 1/2

Equinox Gallery, 2011
Collection of Art Gallery of Greater
Victoria— A/P Edition 1/2

Longing #20, #26, and *#30,* 2011
Collection of Art Gallery of
Greater Victoria

Longing #23, #24, #25, #26, and
#28, 2011
Collection of the
Vancouver Art Gallery

Leila's Desk, 2013
Collection of the Vancouver Art
Gallery, purchased with pro-
ceeds from the Audain Emerging
Artists Acquisition Fund

Inherent, 2014
Collection of the Vancouver Art
Gallery, purchased with pro-
ceeds from the Audain Emerging
Artists Acquisition Fund

#PotlatchShadesofGrey, 2013
Collection of Burke Museum of
Natural History & Culture

*Billy and the Chiefs: The Compete
Banned Collection,* 2012
Collection of the Thunder Bay
Art Gallery

Choke on an Ovoid, 2014
In the collection of TD Bank
Group—Edition 1/5

What a Great Spot for a Walmart!,
2014
In the collection of TD Bank
Group—Edition 2/5

Spaced Invaders, 2014
In the collection of TD Bank
Group—Edition 1/5

Longing #2 (photo)
Collection of Dunlop Art
Gallery Regina Public Library—
Edition 3/10

Longing #10 (photo)
Collection of Hydro-
Quebec—Edition 3/10
Collection of Art Gallery of Greater
Victoria—A/P Edition 1/2

Longing #16 (photo)
Collection of Hydro-
Quebec—Edition 3/10

Longing #18 (photo)
Collection of Art Gallery of Greater
Victoria—A/P Edition 1/2

Longing # 19 (photo)
Collection of Loto-
Québec—Edition 4/10
Collection of Hydro-
Quebec—Edition 3/10
Collection of Art Gallery of Greater
Victoria—A/P Edition 1/2

Longing #20 (photo)
Collection of Loto-
Québec—Edition 4/10
Collection of Hydro-
Quebec—Edition 3/10
Collection of Art Gallery of Greater
Victoria—A/P Edition 1/2

Longing #21 (photo)
Collection of Hydro-
Quebec—Edition 3/10
Collection of Art Gallery of Greater
Victoria—A/P Edition 1/2

Authentic Aboriginal, 2010
Collection of the City of
Richmond, BC

SELECTED EXHIBITIONS

Solo Exhibitions

2006 · *Sonny Assu: As Defined by the Indian Act*, Belkin Satellite Gallery, Vancouver, BC

2007 · *iPotlatch*, Art Gallery of Southwestern Manitoba, Brandon, MB

2009 · *iDrums*, Equinox Gallery, Vancouver, BC

2010 · *Sonny Assu*, Equinox Gallery, Vancouver, BC

2011 · *Silenced*, Equinox Gallery, Vancouver, BC
· *Longing*, West Vancouver Museum, West Vancouver, BC
· *Anthropological Intervention*, Museum of Anthropology, Vancouver, BC

2012 · *The Happiest Future*, Gallery Fukai, Vancouver, BC
· *Offcuts*, The Langham Cultural Centre, Kaslo, BC

2013 · *Sonny Assu: Possession*, Oakville Galleries (Centennial Square), Oakville, ON
· *#neveridle*, Art Mur, Montreal, QC
· *There Is Hope, If We Rise*, Gallery Vertigo, Vernon, BC

2014 · *Interventions on the Imaginary*, FOFA Gallery (York Vitrines), Montreal, QC
· *Echoes*, Two Rivers Gallery, Prince George, BC
· *There Is Hope, If We Rise*, Urban Shaman, Winnipeg, MN

2015 · *Day School*, Equinox Gallery, Vancouver, BC
· *Continuum*, Thunder Bay Art Gallery, Thunder Bay, ON
· *The Value of What Goes Within*, SIGHTINGS 13, Galerie Leonard & Bina Ellen, Montreal, QC

2016 · *Home Coming*, Campbell River Art Gallery, Campbell River, BC
· *1UP*, Surrey Art Gallery's UrbanScreen, Surrey, BC
· *We Come to Witness: Sonny Assu in Dialogue with Emily Carr*, Vancouver Art Gallery, Vancouver, BC

2017 · *Interventions on the Imaginary*, Art Mur, Montreal, QC

Group Exhibitions

2003 · *Thinking Textile*, Richmond Art Gallery, Richmond, BC

2005 · *Evolution (Alumni Exhibition)*, Emily Carr University, Vancouver, BC

2006 · *Past to Present*, Equinox Gallery, Vancouver, BC

2007 · *SAM at 75*, Seattle Art Museum. Seattle, WA

2008 · *INFLUENCE*, Equinox Gallery, Vancouver, BC
· *World Histories*, Des Moines Art Center. Des Moines, IA
· *Comic Relief*, National Gallery of Canada, Ottawa, ON

2009 · *Continuum: Vision and Creativity on the Northwest Coast*, Bill Reid Gallery of Northwest Coast Art, Vancouver, BC
· *Blue Like an Orange*, Ottawa Art Gallery, Ottawa, ON
· *How Soon Is Now?* Vancouver Art Gallery, Vancouver, BC
· *Pop Goes the World*, The Red Shift Gallery, Saskatoon, SK

2010 · *Alternorthern*, The LAB, San Francisco, CA
· *Seattle City Light Portable Works: Part III*, Seattle Municipal Tower Gallery, Seattle, WA

2011 · *Shore, Forest and Beyond: Art From the Audain Collection*, Vancouver Art Gallery, Vancouver, BC
· *(Be)longing*, Kirkland Arts Center, Kirkland, WA

2012 · *Carrying on "Irregardless,"* Bill Reid Gallery of Northwest Coast Art, Vancouver, BC
· *Material Wealth: Revealing Landscape*, Harbourfront Centre, Toronto, ON
· *Ebb and Flow*, Naniamo Art Gallery, Nanaimo, BC
· *Throw Down*, Art Gallery of Greater Victoria, Victoria, BC
· *A Stake in the Ground: Contemporary Native Art Manifestation*, Art Mur, Montreal, QC

2013 · *Qui suis-je ? L'identité autochtone au 21e siècle*, Maison des Jésuites de Sillery, Quebec, QC
· *Ghost Dance*, Ryerson Image Centre, Toronto, ON
· *Sakahàn: International Indigenous Art*, National Gallery of Canada, Ottawa, ON
· *The Violent Bear It Away*, Biola University Art Gallery, La Mirada, CA
· *Artist Poster Show*, Burnaby Art Gallery, Burnaby, BC

2014 · *Here & Now: Native Artists Inspired*, Burke Museum, Seattle, WA
· *Tragedy Plus Time*, Dunlop Art Gallery, Regina, SK

2015 · *Into the Wild*, Hamilton Artists Inc., Hamilton, ON
· *The Rebel Yells*, FOFA Gallery, Montreal, QC
· *Hip Hop*, Institut du Monde Arabe, Paris, France
· *Indigenous Beauty*, Seattle Art Museum. Seattle, WA
· *Coming to the Fire*, Talking Stick Festival, Vancouver, BC

2016 · *Rencontres Improbables (The Secret Encounters of Kusama Kalthoum),* oqbo, Berlin, Germany
· *Neon NDN*, SAW Gallery, Ottawa, ON
· *INDIAN ACTS: Truths in the Age of Reconciliation,* Katzman Contemporary, Toronto, ON
· *Canadian Belonging(s),* The Art Gallery of Mississauga, ON
· *Culture Shift,* Art Mur, Montreal, QC
· *When Raven Became Spider,* Dunlop Art Gallery, Regina, SK
· *Re-mixed: Reconfiguring the Imaginary,* Union Gallery, Queen's University,
· *Kingston ON*

2017 · *Awakening Memory,* Open Space, Victoria, BC
· *Coyote School,* McMaster Museum of Art, Hamilton, ON
· *An Absolute Movement,* Or Gallery, Vancouver, BC
· *Ready Player Two: Sonny Assu and Brendan Tang,* The Reach Gallery and Museum, Abbotsford, BC
· *Raise a Flag: Works from the Indigenous Art Collection* (2000–2015), Onsite Gallery, Toronto, ON
· *Modern Legends,* ACT Art Gallery, Maple Ridge, BC
· *Future Memories (Present Tense),* Illingworth Kerry Gallery, Calgary, AB
· *L'Offre,* DHC/ART, Montreal, QC

Touring Exhibitions

2004-5 · *Futuristic Regalia,* Campbell River Art Gallery (Campbell River, BC); Alternator Centre for Contemporary Art (Kelowna, BC); grunt gallery (Vancouver, BC)

2005-8 · *Changing Hands: Art without Reservation, 2,* Tucson Museum of Art (Tuscon, AZ); Anchorage Museum of History & Art

(Anchorage, AK); Weisman Art Museum (Minneapolis, MN); Naples Museum of Art (Naples, FL); Eiteljorg Museum of American Indians and Western Art (Indianapolis, IN); Institute of American Indian Arts Museum (Santa Fe, NM); Museum of Arts & Design (New York, NY)

2009 · *Beat Nation,* grunt gallery (Vancouver, BC); Galerie SAW Gallery (Ottawa, ON)

2011-12 · *Don't Stop Me Now,* National Gallery of Canada (Ottawa, ON); Esplanade Arts and Heritage Centre (Medicine Hat, AB)

2011-15 · *Decolonize Me,* Tom Thomson Art Gallery (Owen Sound, ON); The Reach Gallery Museum (Abbotsford, BC); Thunder Bay Art Gallery (Thunder Bay, ON); Foreman Art Gallery of Bishop's University (Sherbrooke, QC); Ottawa Art Gallery (Ottawa, ON); The Robert McLaughlin Gallery (Oshawa, ON)

2012-14 · *Beat Nation: Art, Hip-Hop and Aboriginal Culture,* Musée d'art contemporain de Montréal (Montreal, QC); Kamloops Art Gallery (Kamloops, BC); Mackenzie Art Gallery (Regina, SK); Dalhousie Art Gallery and Saint Mary's University Art Gallery (Halifax, NS); The Power Plant (Toronto, ON); Vancouver Art Gallery (Vancouver, BC)

2013 · *Stocked: Contemporary Art from the Grocery Aisles,* Scottsdale Museum of Contemporary Art (Scottsdale, AZ); Ulrich Museum of Art (Wichita, KS)

2014 · *Storytelling,* Ottawa School of Art (Ottawa, ON); Art Mur (Montreal, QC)

2015-16 · *The Fifth World*, Kitchener-Waterloo Art Gallery (Kitchener, ON); Mendel Art Gallery (Saskatoon, SK)

2016 · *When Raven Became Spider,* The Art Gallery of Sudbury; Ottawa Art Gallery; Dunlop Art Gallery, Wanuskewin Heritage Park (Saskatoon, SK)

Public Art Projects

2012 · *Kingsway Trail,* Commissioned Public Art, Vancouver, BC

2013 · *Tag,* Commissioned Public Art Work for Onni Development and the City of Vancouver

2014 · *Reconciliation,* Commissioned Public Art (Temporary) for the City of Vancouver

CONTRIBUTOR BIOGRAPHIES

Candice Hopkins is a curator and writer who has held curatorial positions at the National Gallery of Canada, the Western Front, and the Walter Phillips Gallery. She is currently the chief curator at the AIA Museum of Contemporary Native Arts in Santa Fe, New Mexico. Hopkins holds an MA from the Center for Curatorial Studies, Bard College. Her writings on history, art, and vernacular architecture have been published by MIT Press, BlackDog Publishing, Revolver Press, New York University, *The Fillip Review* and, the National Museum of the American Indian, among others. She lives in Albuquerque, New Mexico.

Marianne Nicolson ('Tayagila'ogwa) is an artist of Scottish and Dzawaḏa'enuxw First Nations descent. Her training encompasses both traditional Kwakwa̱ka'wakw forms and culture and Western European–based art practice. She has completed a bachelor of fine arts from Emily Carr University of Art and Design (1996), a master's in fine arts (1999), a master's in linguistics and anthropology (2005), and a PhD in linguistics, anthropology, and art history (2013) at the University of Victoria. She has exhibited her artwork locally, nationally, and internationally; has written and published numerous essays and articles; and has participated in multiple speaking engagements. Her practice engages with issues of Aboriginal histories and politics arising from a passionate involvement in cultural revitalization and sustainability. She lives in Victoria, BC.

Janet Rogers is a Mohawk/Tuscarora writer from the Six Nations band in Ontario. She was born in Vancouver and has been living on the traditional lands of the Coast Salish people in Victoria, British Columbia, since 1994. Janet works in the genres of poetry, spoken-word performance poetry, video poetry, recorded poetry with music, and script writing. From 2012 to 2014, Janet served as poet laureate of Victoria. Janet has published three poetry collections to date: *Splitting the Heart* (Ekstasis Editions, 2007), *Red Erotic* (Ojistah, 2010), and *Unearthed* (Leaf Press, 2011). Her poetry CDs *Firewater* (2009), *Got Your Back* (2012), and *6 Directions* (2013) all received nominations for Best Spoken Word Recording at the Canadian Aboriginal Music Awards, the Aboriginal Peoples Choice Music Awards, and the Native American Music Awards. Janet hosts *Native Waves Radio* on CFUV and *Tribal Clefs* on CBC Radio One in Victoria. Her radio documentaries *Bring Your Drum: 50 Years of Indigenous Protest Music* and *Resonating Reconciliation* won Best Radio at the imagineNATIVE Film and Media festival in 2011 and 2013.

Richard Van Camp is a member of the Dogrib (Tlicho) Nation from Fort Smith, Northwest Territories. He is a graduate of the En'owkin International School of Writing, the University of Victoria's creative writing BFA Program, and the master's program in creative writing at the University of British Columbia. He is an internationally renowned storyteller and best-selling author who began his career as an intern on the writing staff of the acclaimed CBC TV series *North of 60*, and continued on as a script and cultural consultant for four seasons. His novel *The Lesser Blessed* was adapted into a film and premiered in 2012 at the Toronto International Film Festival. Richard has also published several short story collections, including *Night Moves* and *The Moon of Letting Go*; children's books, including *What's the Most Beautiful Thing You Know About Horses?* with artist George Littlechild and *Little You* with artist Julie Flett; and graphic novels, including *Three Feathers* with artist Krystal Mateus. He has taught creative writing at the University of British Columbia, worked as a creative writing and storytelling instructor with the Emily Carr Institute, and was the writer in residence at the University of Alberta for 2011 and 2012 and at MacEwan University in 2013 and 2014. He lives in Edmonton, Alberta.

Ellyn Walker is a curator and writer based in the place now known as Toronto, where her work engages with the politics of representation, inclusion, and social justice work in the arts. Her writing has been widely published, as seen in *Prefix Photo Magazine*, *PUBLIC Journal*, *The Journal of Curatorial Studies*, *Inuit Art Quarterly*, *RACAR Journal*, and most recently in the anthology *Desire/Change: Contemporary Feminist Art in Canada*, edited by Heather Davis, published by McGill-Queen's Press. Ellyn was awarded the 2016 Thematic Exhibition of the Year Award by the Ontario Association of Art Galleries for her curated exhibition CANADIAN BELONGING(s) presented by the Art Gallery of Mississauga. She is currently a PhD candidate in the Cultural Studies program at Queen's University.

Sonny Assu was raised in North Delta, BC, over 250 kilometres away from his ancestral home on Vancouver Island. At the age of eight, he discovered his Kwakwa̲ka'wakw heritage, which would later become the conceptual focal point of his contemporary art practice. Assu graduated from Emily Carr University in 2002 and was the recipient of their distinguished alumni award in 2006. He received the BC Creative Achievement Award in First Nations art in 2011 and was long-listed for the Sobey Art Award in 2012, 2013, and 2015. He completed his MFA at Concordia University in 2017. His work has been accepted into the National Gallery of Canada, Seattle Art Museum, Vancouver Art Gallery, Museum of Anthropology at UBC, Burke Museum at the University of Washington, Audain Art Museum in Whistler, Art Gallery of Greater Victoria, Hydro Quebec, Lotto Quebec, and various other public and private collections across Canada, the United States, and the UK. In 2016, Assu and his family moved "home" to unceded Ligwiłda'xw territory (Campbell River, BC). For more information, visit sonnyassu.com.